Conten

6 Acknowledgements
Walter Gubert and Carolyn Kinder Carr

8 Introduction
Charles Saumarez Smith

10 The American Face
John Updike

12 Portraiture's Many Faces
Carolyn Kinder Carr

26 Paintings
Ellen G. Miles and Carolyn Kinder Carr

168 Photographs
Lesley Levene

286 Index

288 Picture Credits

It is with great pleasure that I introduce this catalogue accompanying the *Americans* exhibition that JPMorgan is proud to sponsor at the National Portrait Gallery. The exhibition, on loan from the Smithsonian National Portrait Gallery in Washington, DC, is a celebration of Americans from all walks of life and includes portraits of artists, poets, musicians, statesmen, philanthropists, scientists and business leaders. Familiar names include twentieth-century icons such as John F. Kennedy, Tennessee Williams and Louis Armstrong, as well as more historical figures – for example, Benjamin Franklin and Mark Twain.

These paintings and photographs will give you the opportunity to experience the history of a nation through portraiture, from 1727 to the present day. These portraits provide a view of significant historical figures with one thing in common: the positive impact they have had on people and communities at both a national and an international level.

As the investment bank of one of the world's leading financial organisations, JPMorgan has long been a supporter of the arts. We believe art plays a vital role in society and have, for many years, sponsored a number of exhibitions throughout Europe. Clear evidence of our commitment to the arts is the extensive art collection that we have acquired, comprising nearly 20,000 works in 350 locations around the world.

I feel that our collection will provide a great deal of pleasure to a wide and varied audience through the diversity of artists and styles included. In order to continue to reach out more widely, JPMorgan has extended the sponsorship to an educational project encouraging a deeper involvement with the exhibition.

I very much hope that the diversity and depth of *Americans* will leave you with a lasting impression of achievement and inspiration – features shared by all those who appear in it.

Americans

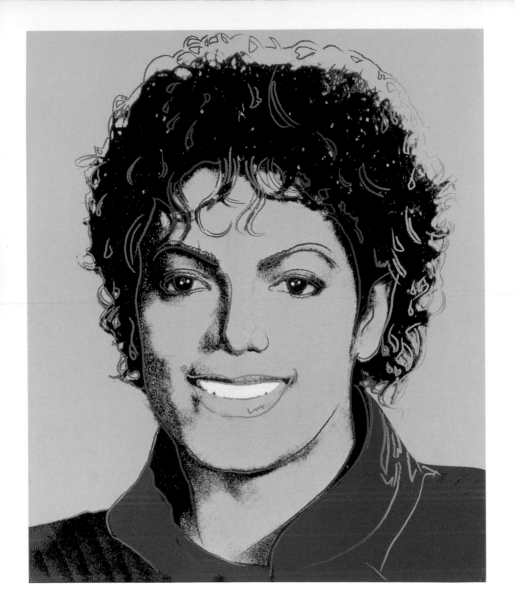

Americans

Paintings and Photographs
from the National Portrait Gallery,
Washington, DC

Foreword by John Updike
Introduction by
Charles Saumarez Smith
Essay by Carolyn Kinder Carr

National Portrait Gallery, London

Published in Great Britain by National Portrait Gallery Publications, National Portrait Gallery, St Martin's Place, London WC2H 0HE

To accompany the exhibition *Americans: Paintings and Photographs from the National Portrait Gallery, Washington, DC,* held at the National Portrait Gallery, London, from 10 October 2002 to 12 January 2003.

For a complete catalogue of current publications, please write to the National Portrait Gallery at the address above, or visit our website at www.npg.org.uk/publications

ISBN pb 1 85514 500 6 A catalogue record for this book is available from the British Library.

Publishing Manager: Celia Joicey

Senior Editor: Anjali Bulley

Editor and Researcher: Lesley Levene

Editorial Assistant: Kate Martin

Editorial Intern: Susan George

Production: Ruth Müller-Wirth

Design: NB: Studio

Printed in Italy

Interactive support from the Biography Channel

Frontispiece:
Michael Jackson
(b.1958)
Singer
Andy Warhol, 1984
Oil on silkscreen
on canvas,
761 x 661mm
(29⅞ x 26")
Time cover,
19 March 1984
Gift of *Time* magazine
©Andy Warhol
Foundation for the
Visual Arts/ARS,
New York
NPG.86.TC14

Sponsored in London by

Acknowledgements
Carolyn Kinder Carr

It is an honour to share this book with John Updike and Charles Saumarez Smith, and I have the pleasure of thanking them for their insightful contributions.

All exhibitions and books are complex projects, and at the National Portrait Gallery in Washington, DC, I owe thanks to numerous colleagues, in particular Director Marc Pachter, who has enthusiastically championed our collaboration with the National Portrait Gallery, London, and Curator of Painting and Sculpture Ellen G. Miles, who has served as co-curator of *Americans* and co-author of the catalogue *A Brush with History* that formed the inspiration for this book. In recognition of their editorial contributions, I would like to thank Publications Manager Dru Dowdy; Historian Fred Voss; Associate Curator of Painting and Sculpture Brandon Fortune; Curator and Assistant Curator of Photographs, respectively Ann Shumard and Frank Goodyear; Rights and Reproductions Manager Yvette Stickell and Administrative Assistant Kathryn Evans. In addition, I am indebted to those in the Exhibitions and Collections Management Department – Beverly Cox, Claire Kelly and Molly Grimsley – as well as to conservators Cindy Lou Molnar and Rosemary Fallon. I wish also to express my gratitude to former director Alan M. Fern and also to Libby H. O'Connell, Vice-President of Educational Initiatives at A&E Television Network, who, as we were planning ways to amplify the history and meaning of American portraiture for new audiences, brought to the project the resources of the Biography Channel.

At the National Portrait Gallery, London, I would like to thank Celia Joicey, who commissioned and compiled this book, and Ruth Müller-Wirth, who produced it. Lesley Levene deserves credit for refashioning our photographic research into lively entries and making useful edits to my text, while NB: Studio is to be commended for the design. Beatrice Hosegood, Robert Carr-Archer, Jude Simmons, and the staff of the Public Relations and Development Department, particularly Pim Baxter and Hazel Sutherland, have also played a significant role.

I am grateful to have had the opportunity to organise *Americans* and I hope that this book will encourage new audiences to explore further the rich collection of the National Portrait Gallery, Washington, DC (www.npg.si.edu).

I first visited the National Portrait Gallery in Washington, DC, in April 1994, towards the end of the showing of the exhibition *Master Drawings from the National Portrait Gallery, London*. Alan Fern, the then Director, was extraordinarily friendly and I remember being slightly overawed as a neophyte director by the immense sense of grandeur of the elders of the Smithsonian Institution, who greeted me as if from the top of Mount Olympus.

I have always liked, and been attracted by, the National Portrait Gallery in London for its informality, its sense of the creative ad hoc, its absence of ceremonial pomposity, and its commitment to the art of today. The National Portrait Gallery in Washington, DC, by contrast, struck me as an institution with a very different sense of historical mission. In part, this is owing to the context of Pierre L'Enfant's grand plan for the city of Washington, DC, and to the fact that the National Portrait Gallery occupies the site that L'Enfant designated as a pantheon. In part, it is owing to the fact that the Greek Revival architecture of the old Patent Office building in which the National Portrait Gallery is housed creates a mood of commemorative celebration. I cannot imagine that we would ever have a gallery of prime ministers in the way that the American National Portrait Gallery has its Hall of Presidents. The difference between the two institutions is like the difference between 10 Downing Street and the White House.

Throughout the 1990s, I always hoped that we might be able to work closely with our friends and allies at the National Portrait Gallery in Washington, DC. We would often consider the idea of collaboration. Then one day I received a letter asking if we would like to show an exhibition of some of the major works of the National Portrait Gallery in Washington, DC, when its building closed for renovation.

Of course, I agreed. The paintings and photographs in the exhibition provide a fascinating and unique opportunity to compare and contrast the two collections, as well as the two rival schools of portraiture on either side of the Atlantic. There are obvious points of comparison. For example, the exhibition opens with a portrait of George Berkeley by John Smibert. We possess a version of this portrait. We ourselves own a portrait of George Washington which, for reasons I have

never quite understood, we display as if he were British. In fact, it is possible to regard the early works in the exhibition as belonging, as indeed they do, to the traditions of British eighteenth-century painting.

But, with the portrait of Benjamin Franklin by Joseph Siffred Duplessis, we meet a different mood. Franklin was a cosmopolitan who sat for his portrait to Duplessis in Paris. It exudes a rather different sense of Americans as citizens of the world. Sequoyah represents the Cherokee nation, which was broken up and almost destroyed in his lifetime. And once we get to the portrait of Davy Crockett, we meet a representative of the frontier spirit that has become a central part of the myth of American nation-building.

These are the people who created America's independence as a country, its strong sense of patriotism, its belief in its destiny as a nation.

But, so far as I am concerned, the great discovery of the exhibition is its inclusion of so many late-nineteenth- and early-twentieth-century portraits. In Britain, knowledge of American twentieth-century art is tied up with modernism and the avant-garde. We are not nearly so familiar with the traditions of American realism. So, for many people, the later portraits will be a revelation of an art that emerged from the great cities of the east coast, from the clubs and academies of New York, Philadelphia and Boston. Here one finds William James, the older brother of the novelist Henry James, painted in Newport, Rhode Island, by John La Farge. Richard Watson Gilder, a founding member of the Author's Club and the Society of American Artists, sat to Cecilia Beaux in her New York studio. H. H. Richardson, the architect of the wonderful Romanesque Trinity Church in Boston, was painted by Sir Hubert von Herkomer, the British artist who worked in Cambridge, Massachusetts.

Perhaps my favourite work in the whole exhibition is the portrait of Lincoln Kirstein by Jamie Wyeth. Kirstein was the first American grandee that I met on a visit to New York as a student. Here is an image that runs entirely counter to the idea still held by many British people of America as a nation dominated by Hollywood and McDonald's. It shows a great figure of the New York art world turning his hawkish face away from the viewer. This is only one of a number of portraits that will, I hope, help Britain to gain a better understanding of American history and culture.

Is there an American face? If there is, it began to form when those stern-visaged English Puritans landed in New England and improvised arrangements with the rocky, forested land and the population of Native Americans, as they have come to be, correctly, called. A few so-called Indians have made it into this present array of portraits, painted and photographed by palefaces whose ethnography was animated by a rueful awareness that the vanquished race and its ruddy, unsmiling warriors embodied something – a shadowy history, a patient lifestyle – lost when Europeans invaded the continent. An Indian stoicism invaded the European faces; the frontier, whether in central Massachusetts or far Montana, was a hard place, demanding of its settlers practical resolve and ascetic virtue. We find in these portraits little of the pampered cheek and arrogant downward glance of English aristocrats as rendered by Van Dyck and Gainsborough, and little of the robust lower-class jollity recorded by the genre painters of the Lowlands. Dickens, in his *American Notes* of 1842, wrote of my fellow countrymen:

They certainly are not a humorous people, and their temperament always impressed me as being of a dull and gloomy character...I was quite oppressed by the prevailing seriousness and melancholy air of business: which was so general and unvarying, that at every new town I came to, I seemed to meet the very same people whom I had left behind me, at the last. Such defects as are perceptible in the national manners, seem, to me, to be referable, in a great degree, to this cause: which has generated a dull, sullen persistence in coarse usages, and rejected the graces of life as undeserving of attention.

The first American that Dickens's Martin Chuzzlewit meets in the New World is indeed unprepossessing: 'a sallow gentleman, with sunken cheeks, black hair, small twinkling eyes', wearing a broad-brimmed hat and an expression between a leer and a frown – 'a mixed expression of vulgar cunning and conceit'. Americans took root by an effort of will; they came to make themselves anew, and high hopes and practical shifts narrowed their faces, perhaps, to a certain fierceness – see Calhoun and Sherman, for example. Or John Brown's photographed glare, a contrast with

Lincoln's weary smile. The laborious settlement of the endless territories, the bloody war to purge slavery from the American system, the ascent of industrialism with its wage slavery – these worked to keep our expressions stern, though, as with peoples everywhere, moments of joy, of song, of love, of family cherishing lightened the travail of living. A dominant Calvinism minimised 'the graces of life' while, paradoxically, it esteemed worldly prosperity as a hint of heavenly election. Enterprise was given a blessing, and the freedom to extend itself as best it could.

And yet what could be more dandified than Copley's languid, red-lipped, silver-haired self-portrait, or Charles Sprague Pearce's profile of his fellow Parisian artist Paul Wayland Bartlett? Expatriatism in Europe created a tribe of hyper-aesthetic Americans who lived pleasantly on their strong dollars and helped hatch modernism. In this exhibition, the portraits that could be called 'iconic' are of Franklin and Washington, engraved versions of which are enshrined on our paper currency; they remind us that the United States was the political creation of the eighteenth-century Enlightenment, embodying its liberated thinking and realistic appraisal of human nature.

By the twentieth century, popular culture promoted the spread of images of elegance and sensuality. Movies out of Hollywood, on a new scale of art manufacture, flickered above the formerly dull and gloomy citizenry; we are left with stills of Garbo's unfocused gaze, Audrey Hepburn's focused one, Louis Armstrong's laugh and Marilyn Monroe's rising skirt. Lena Horne, Michael Jackson, Lincoln Kirstein, Thomas Hart Benton and his wife – their painted portraits attain a certain Apollonian grandeur, built of all-American materials. The native Puritanism lingers, perhaps, as an air we might call spiritual: such grave and distinguished portraits as those by Eakins and Sargent strive, like the heads of medieval statuary, to read a soul into the human visage, and seem to offer a judgement, not merely a depiction, of their subjects.

A portrait can tell many stories. It can inform the viewer about the physical appearance of a subject; it can say something about the subject's social position or profession; and it can often allude to his or her character and psychological make-up. Collectively, portraits created during a certain period can address the history of that time, defining its issues and highlighting those who shaped it. A portrait also reflects upon the artist. It sends a message both about the artist's skill and about the aesthetic values of the era in which it was produced. The information gleaned from a portrait can vary, depending on the concerns of the viewer or the context in which the image is placed. Whether painted, sculpted, drawn, printed or photographed, however, a portrait's importance lies not only in its artistic merit but also in the fulsomeness of the information embedded within.

Every portrait represents a three-way relationship between the sitter, the artist and the audience. Some works were intended from the beginning for a private audience, others as a public statement. The impetus behind the portrait of Benjamin Franklin by Joseph Siffred Duplessis, which was given to Mme Brillon de Jouy, Franklin's neighbour in Passy when he was American minister to the French court, served as a memento of their friendship (p.41). The same is true of the regal 1796 portrait of George Washington by Gilbert Stuart, which was commissioned by Pennsylvania senator William Bingham and sent as a gift to the Marquis of Lansdowne for his support of the American cause during the Revolution (fig.1). By contrast, Rembrandt Peale's painting of actress Juliana Westray Wood was intended as a public image and was engraved for *The Mirror of Taste*, a Philadelphia periodical (p.50). Daniel Huntington's portrait of his good friend Gulian Verplanck was painted for the Commissioners of Immigration as a public recognition and celebration of Verplanck's service on this board and his commitment to the welfare and education of immigrants (p.82).

Similar motivations can be found in the twentieth century. The portraits of Marianne Moore by her friend Marguerite Zorach and Eliot Porter by his brother Fairfield appear to have been initiated to celebrate the close relationship between artist and sitter (pp.130, 158). By contrast, Betsy Graves Reyneau's portrait of scientist George Washington

George Washington (1732–99)

Gilbert Stuart, 1796
Oil on canvas,
2476 x 1587mm
(97½ x 62½")
National Portrait
Gallery, Smithsonian
Institution; acquired
as a gift to the nation
through the generosity
of the Donald W.
Reynolds Foundation
NPG.2001.13

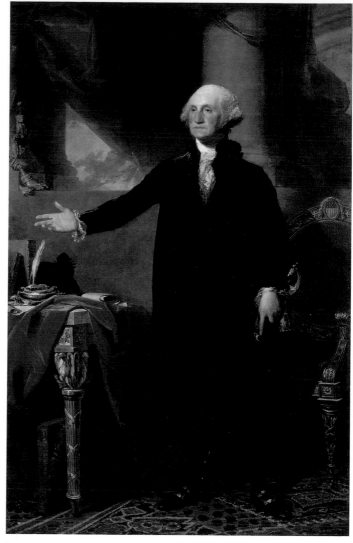

1

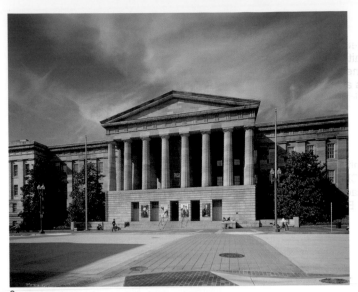

National Portrait Gallery, Washington, DC

National Portrait Gallery, Smithsonian Institution

Since 1968 the collection of the National Portrait Gallery, Washington, DC, has been housed in the Old Patent Office Building, the third-oldest federal building in the city. President Andrew Jackson laid the first stone in 1836 and the building served as a hospital during the Civil War.

2

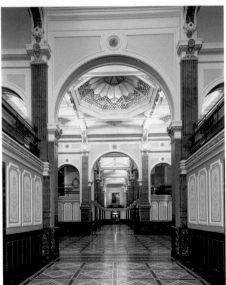

3

Carver was painted in recognition of Carver's reputation as a leading African American scientist (p.141). Andy Warhol's portrait of Michael Jackson, commissioned as a *Time* magazine cover, was always intended to reach a mass audience (p.165).

This triangular relationship also extends to photographic portraits. Where little or nothing is known about the circumstances of a sitting, pose can serve as a major signifier of intent. In all likelihood, Jonas Chickering had his daguerreotype made as a family keepsake, while P. T. Barnum, whose name is synonymous with promotion, undoubtedly had his portrait taken with his most popular exhibit, Tom Thumb, for public display (pp.181, 177). Ralph Steiner probably photographed fellow photographer Paul Strand sleeping merely to amuse himself, while mass distribution was the generative force behind the splendid portraits of actor Paul Robeson, film stars Audrey Hepburn and Marilyn Monroe, and labour organiser Cesar Chavez (pp.229, 222, 265, 266, 278).

Portraits in a museum

Regardless, however, of the original reason for a portrait, those in the collection of the National Portrait Gallery in Washington now play a public role, manifesting the Gallery's mission, which, like that of its English counterpart, is to recognise those who have played a significant part in shaping the country's history and culture. In the decades since the Gallery was chartered by the United States Congress in 1962 and opened to the public in 1968 in the third-oldest federal building in Washington, these portraits have, as a group, also told numerous stories about important events in American history, from the Revolutionary War to the Civil War to the civil rights movement (figs.2, 3).

Traditionally, when a work is acquired for the Gallery, a sitter's significance takes precedence over the object's artistic merit. In *Americans* – an exhibition and book occasioned by the renovation of the glorious 1836 neoclassical structure that houses the museum – the selection of images was guided instead by the desire to address issues related to the history of portraiture of Americans from an artistic point of view. Each subject's history informed the selection – indeed a conscious effort was made to include a cross-section of the lively people whose diverse occupations and accomplishments are so fundamental to the vitality of the American nation – but these contributions are not paramount. Instead they form the platform upon which comments can be made about the aesthetic interests, concerns and preferences of artists and their patrons.

Many more works from the Gallery's collection than those present in this book could have illuminated the subject of portraiture in America. Ultimately, the choice of works for *Americans* was determined both by practicalities, such as conservation concerns and a concurrent travelling exhibition of presidents' portraits and also by issues of chronology, occupation, gender and ethnicity. Thus when Ellen Miles, co-curator of this exhibition, and I were faced with difficult choices between equally wonderful images, we sought both a relatively even distribution of portraiture across the centuries represented in the museum's collection and a cross-section of the people – statesmen, military leaders, inventors, industrialists, financiers, writers, actors, artists, musicians, scientists – who have contributed to the diversity of the American nation.

European influence

Foremost among the observations that can be made about portraiture of Americans is the pervasive foreign influence. Until the mid-twentieth century, the number of wholly home-grown painters who undertook portraits of the leaders of their time – Thomas Badger, Henry Inman and William S. Elwell among them – was equalled or even outweighed by the number who studied abroad. In the early years, Britain was the preferred location for further study. John Singleton Copley left for England in 1774 and, after touring Italy briefly, settled there permanently in 1776. His lushly painted self-portrait expresses all the exuberance of a young man happy to be in the centre of the art world (p.37). Copley had been preceded by Charles Willson Peale and was followed by Gilbert Stuart, both of whom sought instruction from American expatriate Benjamin West (pp.33, 38).

Paris only slowly claimed the loyalties of American painters. After working in Gilbert Stuart's American studio, John Vanderlyn studied there, first in the late 1790s and then again between 1803 and 1815 (p.56). Beginning around 1850, but particularly in the last three decades of the nineteenth century, the French capital became the favourite city for American painters studying abroad, with only minor competition from Munich and various Italian cities. James McNeill Whistler found his way there in 1855 before settling in London; Thomas Eakins braved the waters of the Atlantic to work briefly in the studios of Jean-Léon Gérôme and Léon Bonnat; Bostonian Charles Sprague Pearce, also a Bonnat pupil, arrived in 1873, never to return to New England; and John Singer Sargent, born in Florence to American parents and the quintessential bi-continental artist,

received his training in Paris from Carolus-Duran in the early 1870s (pp.97, 109, 113, 111). Mary Cassatt, who became an integral part of the Impressionist circle in Paris, made only two short trips back to America once she settled in Paris in 1874; Cecilia Beaux, a graduate of the Pennsylvania Academy of the Fine Arts, furthered her training there; and John White Alexander, who took classes in Munich in the late 1870s, sampled life in Paris in the 1890s (pp.101, 115, 117). This groundswell led the witty and observant Henry James to note, 'It sounds like a paradox, but it is a very simple truth, that when today we look for "American art" we find it mainly in Paris. When we find it out of Paris, we at least find a good deal of Paris in it.'[1]

An American look

In the early years of the twentieth century, young American artists such as Lee Simonson and Marguerite Zorach continued to flock to Paris to further their artistic training (pp.121, 131). Now, however, their masters were not the academic artists associated with the Salon; instead younger, more radical painters became their idols and inspiration – Paul Cézanne, the Cubists and those affiliated with the Fauves. After the First World War, while Paris remained the capital of the art world, fewer Americans took training abroad, perhaps because of the changing economic and political climate or possibly because of the growing professionalism of art schools in America's major cities. The impulse to study abroad may also have been affected by a growing desire among many artists in the late 1910s and early 1920s to develop an 'American look' in painting. Thomas Hart Benton was among the earliest advocates of this position, which came to full fruition in

the years after the Second World War with the advent of Abstract Expressionism as the dominant style of American art (p.129).

Patronage

While some chose to have their portraits painted by artists who had trained abroad, others among those who have impacted on American history opted for portraits by foreign artists while living abroad. Bishop Berkeley's portrait (similar to the one in the National Portrait Gallery, London) was painted in about 1727 by Scottish artist John Smibert, whom the sitter had befriended long before coming to America (p.29). The fascinating twist in this story is that while Berkeley returned to England when his dream of a college in Bermuda failed to materialise, Smibert remained in Boston, becoming one of the first professional artists in America. William Mackay Low had just returned to London from Georgia with his new bride, Juliette Gordon, when he commissioned her portrait from Edward Hughes, known for his representations of the royal family and their circle of friends (p.106). Writer of Western adventure tales Bret Harte found the cosmopolitan world of London to his taste as well and there befriended the Scottish-trained painter John Pettie (p.102). Eight-year-old Edith Wharton was in Paris with her family when she was painted by Englishman Edward Harrison May, who had studied in America before furthering his education in Paris. Decades later, at Wharton's suggestion, Henry James succumbed to the brush of Frenchman Jacques-Émile Blanche (pp.94, 119). As the portraits of Tallulah Bankhead by Augustus John and General George S. Patton by Boleslaw Jan Czedekowski attest, the tradition of being painted abroad continued well into the twentieth century (p.134; fig.4).

The fondness of Americans travelling or living abroad for having their portraits painted by non-Americans was probably less a matter of pure convenience than a deliberate choice, reflecting to a large extent both their attitude towards native artists and the status and cachet associated with being 'done' by a European painter. European artists quickly capitalised on this taste for the continental and, in the late nineteenth century in particular, artists such as Anders Zorn and Sir Hubert von Herkomer, as well as John Singer Sargent (depending on the nationality you assign him!) found a ready market for their services – not merely because they were talented, but because they carried the unspoken credentials of continental training and origin (pp.123, 105, 111).

To a large extent, this transatlantic traffic ended with the upheavals caused by the Great Depression and the Second World War, Philip Alexius de Lászlo being one of the last to ply his trade among the wealthy (p.127). The more familiar pattern of European artists coming to America in the 1930s and 1940s was exemplified by René Bouché. He arrived as an émigré, rather than as a short-term visitor, with a mission to cater to those who looked to fill the walls of their mansions with pictorial testimonies to their success (p.149).

After the Second World War

The years immediately after the Second World War saw a change in American art that profoundly affected portraiture in America. Abstract Expressionism, exemplified by the work of artists such as Jackson Pollock, Willem de Kooning, Franz Kline and Mark Rothko, became the pre-eminent force in American

art. Fundamental to the work of those associated with Abstract Expressionism was the belief that subject matter should be sought primarily in the internal rather than the external world and that the act of painting was of primary importance. Thus portraiture, which demands that the artist deal with an object in the visible and tangible world – the sitter – essentially had little or no place within the philosophical context of America's most avant-garde painters.

Although portraiture did not find a home in most avant-garde artistic thinking of the late 1940s and early 1950s, the demand for likenesses remained. American artists devised numerous strategies to respond to requests for portraits. Peter Hurd's answer to mainstream abstraction was to work in egg tempera, a medium favoured by fifteenth-century Flemish painters such as Hubert and Jan Van Eyck who used it to create meticulously detailed images of their sitters (p.155).

Jamie Wyeth, Hurd's nephew, used oil, but this same sense of careful craftsmanship is apparent in his dramatically posed portrait of art patron and ballet enthusiast Lincoln Kirstein (p.157). Expressionist Alice Neel merely ignored the rhetoric of the 1950s and persisted with her commitment to 'the human comedy' (p.160).

On the other hand, Elaine de Kooning sought to reconcile the seemingly irreconcilable demands of portraiture and Abstract Expressionism. In the portrait of her friend the art critic Harold Rosenberg, de Kooning, who had made a previous drawing of Rosenberg, worked from memory and, with quick, sweeping, gestural brushstrokes, depicted his tall, looming presence and magnetic charm on the large unstretched canvas she had laid on the floor. Her psychological involvement in the act of painting

Rosenberg's portrait as she circled the mural-sized canvas was thus not too different from Pollock's approach to making his wholly abstract work (p.146). Fairfield Porter, also a close friend of many Abstract Expressionists, created the portrait of his brother Elliot using broad patches of vivid colour, reminding the viewer that both he and Mark Rothko shared an interest in the inherent ability of colour to evoke an emotional and psychological state of mind. What separates the two is not only Porter's delight in the specific rather than the sublime, but also his willingness to suppress abstraction in order to give priority to recognizable form (p.158).

In the 1960s a number of younger artists, Alex Katz and Andy Warhol among them, sought to challenge the philosophical hegemony of Abstract Expressionism. To prove that one could be avant-garde without being abstract, they developed a variety of pictorial strategies to make cutting-edge art incorporating the figure. Neither sought a psychological interpretation of the subject and both were concerned with ways of painting that stressed the flat surface of the canvas, a notion fundamental to much modernist art of the twentieth century. Katz created likenesses using broad planes of paint as he translated perceptual information to the canvas (p.162). Warhol employed a photograph rather than a person as the source of his portrait image, because it had already transformed the three-dimensional world into a two-dimensional format (p.165).

Collecting photographs

The instant acceptance of photography by a wide audience in the 1840s, comparable to that of the Internet in the late twentieth century, says something about its intrinsic value to individuals.

George S. Patton
(1885–1945)

Boleslaw Jan
Czedekowski, 1945
Oil on canvas,
1270 x 1016mm
(50 x 40")
National Portrait
Gallery, Smithsonian
Institution; Gift
of Major General
George S. Patton,
USA, Retired, and
the Patton Family
NPG.99.5

Henry David Thoreau
(1817–62)

Benjamin D. Maxham,
1856
Daguerreotype,
63 x 47mm
(2½ x 1⅞")
National Portrait
Gallery, Smithsonian
Institution; Gift of an
anonymous donor
NPG.72.119

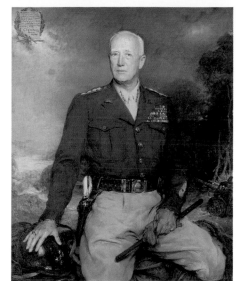

4

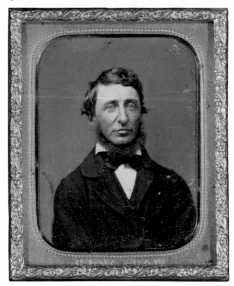

5

Yet this accessible, democratic art form, which can fix forever a memory in time and place – and without which the history of America could not be told – was not among the media the Smithsonian's National Portrait Gallery was initially permitted to collect. The 1962 legislation establishing the Gallery specified that the term 'portraiture', for purposes of Public Law 87-443, 'shall mean painted and sculptured likenesses'.

Behind this wording was a heated debate engendered by the Library of Congress, which feared that the Gallery – the new kid on the museum block – would destroy its then eminent position in the field of photography. Those at the Library also feared that competition for choice items would raise the price of objects that had so far been purchased for minimal amounts – little suspecting that the mania for photographs among all museums and private individuals would send the price of desirable images skyrocketing in the last quarter of the twentieth century.

As the director and commissioners of this fledgling institution soon discovered, many men and women of note never had their portrait painted, sculpted, drawn or engraved during their lifetime, and the images of those who did were often already well ensconced in other public collections. Motivated by offers of important works – among them a daguerreotype of philosopher Henry David Thoreau – all of which, when accepted, had to be relegated to the ignominy of the study collection, the Gallery began to build a case for photography (fig.5). Success came in 1976, when Congress amended the founding legislation to permit the Gallery to collect 'portraits in all other media formerly and presently in use, including photography as well as any which hereafter may be developed'.

Twenty-five years later, nearly 4,000 photographs and 5,000 glass-plate negatives by Mathew Brady grace the National Portrait Gallery's collection of some 18,500 portraits in all media.

From canvas to camera

American leaders, as was also true of ordinary men and women, grasped the significance of photography and, shortly after word of Louis-Jacques-Mandé Daguerre's invention reached America in 1839, they were eager to have their portraits taken. John Quincy Adams, fifth President of the United States, sat for his daguerreotype portrait in 1843 in the little-known studio of Bishop and Gray in Utica, New York. When he became the first ex-president to be photographed, little did he or anyone else suspect that this medium, as it evolved over the next century, would become the one by which those who occupied the White House were best known to the people they governed.

Others as diverse in temperament and profession as abolitionist John Brown, historian and statesman George Bancroft, showman and entrepreneur P. T. Barnum and piano manufacturer Jonas Chickering were also attracted by the magic of the new science (pp.173, 174, 177, 181). Even the maker of many of these remarkable silver images, Mathew Brady, could not resist the temptation to fix in time himself, his wife, Juliette, and a Mrs Haggerty, believed to be his sister (p.178). Over the years, those who created these images – Englishman John Mayall, who learned the daguerreotype process in Philadelphia before returning to his native country; African American Augustus Washington, who had a studio in Hartford, Connecticut, before he set sail for Liberia; Samuel Root, who with his brother Marcus established galleries in Philadelphia

(they bought Mayall's former studio), Saint Louis, New York (where Barnum's image was presumably fixed), and Washington, DC; Bostonians Albert Sands Southworth and Josiah Johnson Hawes; and even Brady – have, like their subjects, become known as leading practitioners in their chosen field of endeavour.

The shift in America from daguerreotypes to prints on paper – most often albumen prints made using the wet collodion process – in the years preceding the Civil War is reflected in the fact that the National Portrait Gallery possesses images in the new technique of more than 500 leaders from this chaotic epoch in American life, including both Confederate general Robert E. Lee and Union general William Tecumseh Sherman, whose victorious march through Georgia left a trail of devastation from Atlanta to Savannah (pp.190, 195). Many of these individuals are represented in the large number of glass-plate negatives by Mathew Brady in the collection originally assembled at the beginning of the twentieth century by New Yorker Frederick Hill Meserve (1865–1962) while searching for photographs to illustrate his father's Civil War diaries. Among the carte-de-visite negatives by Brady, who cemented his place in the photographic pantheon with his portraits of civilian and military leaders taken in his New York and Washington, DC, studios, were those of such diverse political persuasions as First Lady Mary Todd Lincoln and Jefferson Davis, president of the Confederacy (fig.6).[2] The most important single photographic print in this collection is the portrait of Abraham Lincoln taken by Brady's former assistant Alexander Gardner about six weeks before the President was assassinated in 1865. It is a unique impression, because the cracked collodion glass plate, which had been reassembled to develop this photograph, was subsequently destroyed (p.194).

The Wild West

When the Civil War subsided into memory in 1865, those with a camera turned to a new battlefield, the West. They found in this relatively uncharted frontier men of diverse interests, among them Clarence King and other scientists on a geological expedition to explore northern California as well as Smithsonian ethnologist Frank Hamilton Cushing, whose fascination with Native Americans, particularly the Zuni Pueblo, fed his intellectual curiosity as well as his collecting habits (pp.189, 198). Even bandits such as the Wild Bunch, the outlaws whose leaders gained notoriety as Butch Cassidy and the Sundance Kid, succumbed to the lure of the lens (p.201). Ironically, until the later decades of the nineteenth century, Native Americans, who had originally populated this area, tended to be photographed in the East, often in conjunction with a trip to Washington, DC, to plead their case for fair treatment.

Pictorialism and 'straight' photography

At the end of the nineteenth century and into the first decades of the twentieth, avant-garde photographers began to eschew the pleasure found by earlier practitioners in sharp, crisp, detailed images and instead explored ways of making a more painterly effect. The soft-focus aesthetic of pictorialism finds its reflection in a large number of the Gallery's early-twentieth-century portraits, such as those of architect Stanford White by Gertrude Käsebier, photographer Edward Steichen by his friend Heinrich Kühn, photographer Alfred Stieglitz by fellow photographer Alvin Langdon Coburn, artist Katharine

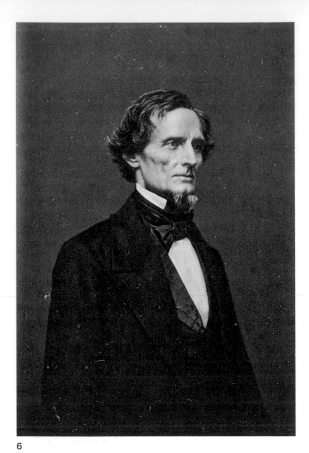

Jefferson Davis
(1808–89)

Mathew Brady studio,
*c.*1860
Modern albumen silver
print from a collodion
glass-plate negative,
93 x 62mm
(3¾ x 2½")
National Portrait
Gallery, Smithsonian
Institution
NPG.81.M81

Alfred Stieglitz
(1864–1946)

Alvin Langdon Coburn,
*c.*1906
Photogravure,
diameter 16mm
(6½")
National Portrait
Gallery, Smithsonian
Institution
NPG.76.92

*The National Portrait
Gallery, Washington,
DC, was restricted
from collecting
photography until
1976 due to fear of
competition for the
same portraits with
the Library of Congress.
There are now more
than 9,000 photographs
and glass plate
negatives in the
collection.*

6

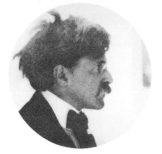

7

Nash Rhoades by Stieglitz and dancer Irene Castle by Baron Adolph de Meyer (pp.204, 206; fig.7; pp.209, 213). The equally abrupt rejection in the late 1910s and early 1920s of the manipulated print and the preference for 'straight' photography are chronicled in the Gallery's portraits of artist Georgia O'Keeffe by Paul Strand, labour leader Andrew Furuseth by Dorothea Lange, dancer Carmelita Maracci by Edward Weston, and exotic dancer Gypsy Rose Lee by Ralph Steiner (pp.210, 225, 233, 245).

Transatlantic exchange

While the European influence on photographs of Americans is not as pervasive as it is in painting, numerous Americans were photographed by Europeans while living abroad. In addition to the previously mentioned daguerreotype of Bancroft, the collection also includes an 1844 calotype of statesman Edward Everett, who at the time was American minister to the Court of St James. He was one of three Americans photographed by Scots Robert Adamson and David Octavius Hill while in York at an annual meeting of the British Association for the Promotion of Science (p.170). Julia Margaret Cameron photographed two Americans, poet Henry Wadsworth Longfellow and publisher and editor of the *Atlantic Monthly* James T. Field (fig.8; p.197). Both were introduced to her by her neighbour Alfred, Lord Tennyson, Britain's Poet Laureate. Financier and philanthropist George Peabody sat in Paris for André Adolphe-Eugène Disdéri in about 1862, while George Eastman, the founder of Kodak, sat for Paul Nadar, his agent in France, in 1890 (figs.10, 9).

In the 1920s and early 1930s Europe, and Paris in particular, was a mecca for American photographers, among them Berenice Abbott and Man Ray, the latter making his living in the French capital through fashion photography for *Vogue* and *Harper's Bazaar*. Attracted by his skill in this area, American patron and art collector Peggy Guggenheim, who had moved abroad in 1920, asked him in 1924 to photograph her wearing a favourite Paul Poiret dress (p.217). Hungarian-born Geyula Halász Brassaï photographed American writer Henry Miller in Paris and his compatriot André Kertész took his 1929 portrait of American sculptor Alexander Calder when the artist still lived in France (p.221). The German Leni Riefenstahl recorded the great American athlete Jesse Owens at the 1936 Berlin Olympics.

Various European photographers made extended journeys to America, among them Henri Cartier-Bresson and Cecil Beaton, photographing the likes of writer William Faulkner and *Vogue* editor Carmel Snow (p.249). However, by the early 1940s the history of portrait photography in the United States was being affected by the number of Europeans who came to America to escape the war, Kertész, Philippe Halsman and Hans Namuth among them. In America, Halsman became known for portraits that appeared on the covers and in features for *Life* magazine, while Namuth established his reputation with his 1950 portraits of Jackson Pollock painting (p.245). After the Second World War the role of magazines in shaping the work and conditioning the careers of Irving Penn, Richard Avedon and Arnold Newman cannot be underestimated.

Women photographers

Like painting, photography is not the exclusive preserve of men, and the National Portrait Gallery's collection

is enhanced by a large number of portraits by women photographers. Frances Benjamin Johnston (who worked briefly for the Smithsonian Institution), Alice Boughton, Laura Gilpin (known for her work in the Southwest), Clara Sipprell, Doris Ulmann (who developed her reputation in part as a photographer of the people of Appalachia), Imogen Cunningham, German-born Gisèle Freund and Lotte Jacobi, who, like Viennese-born Lisette Model, emigrated to America, as well as Rosalind Solomon and Rollie McKenna, are among the names one can add to the list of distinguished photographers previously mentioned.

The future of portraiture

In the nineteenth century, many feared that photography, because of its ability to capture a faithful likeness, would destroy the need for painted portraits. But clearly this did not happen. On the contrary, not only did the two media successfully coexist, but the last decades of the nineteenth century were the glory days of grand-manner portraiture. The painted likeness continued to be revered not merely as a way of honouring America's heroes and notable citizens, but also as a symbol of personal achievement. Similarly, in the last half-century, with abstraction in its heyday and portraiture banished from the art-historical mainstream, the making of likenesses not only survived but flourished. Nowhere is this more evident than in the collection of the National Portrait Gallery.

No one can see into the future, so no one can predict the nature of portraiture in the current century. In all likelihood, technologies not even available today will be put in the service of portraiture. But painting and photography will undoubtedly survive. Just as they have been used successfully in the past to describe the personality and accomplishments of an individual, they will undoubtedly be used by future generations for the same purposes. While the manner in which artists will rival their predecessors by making images that capture the notables of their time in the style of their time is uncertain, the continuing demand for likenesses is not.

Footnotes
1. Henry James, 'John S. Sargent' (1893) in John L. Sweeney, ed., *The Painters Eye: Notes and Essays on the Pictorial Arts by Henry James* (Rupert Hart-Davis, London, 1956), p.216.

2. The National Portrait Gallery commissioned modern albumen silver prints in the 1980s and 1990s to exhibit Brady's images.

Henry Wadsworth Longfellow
(1807–82)

Julia Margaret
Cameron, 1868
Albumen silver print,
342 x 268mm
(13½ x 10½")
National Portrait
Gallery, Smithsonian
Institution
NPG.82.61

George Eastman
(1854–1932)

Paul Nadar, 1890
Albumen silver print,
152 x 241mm
(6 x 9½")
National Portrait
Gallery, Smithsonian
Institution; Gift of George
Eastman House
NPG.68.11

George Peabody
(1795–1869)

André Adolphe-Eugène
Disdéri, 1862
Albumen silver print,
199 x 232mm
(7¾ x 9⅛")
National Portrait
Gallery, Smithsonian
Institution
NPG.95.371

*The European influence
on American photography
in the late nineteenth
century was not as
extensive as in painting,
yet many important
Americans were keen
to be photographed
by Europeans while
they were abroad.*

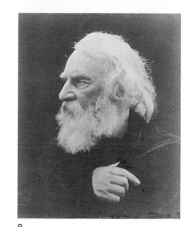

8

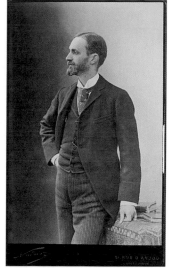

9

10

Paintings

George Berkeley
(1685–1753)
Clergyman

John Smibert, 1727?
Oil on canvas,
1029 x 756mm
(40½ x 29¾")
Gift of The Morris
and Gwendolyn
Cafritz Foundation
NPG.89.25

Anglican clergyman George Berkeley was widely respected for his intellect. Born in Ireland and educated at Trinity College, Dublin, he spent time in England and Italy before being appointed Dean of Derry in 1724. Despairing of corruption in Europe and anticipating a bright future for the New World, he advocated establishing an American missionary college in his *Proposal for the Better Supplying of Churches in Our Foreign Plantations...By a College to be erected in the...Isles of Bermuda* (1725). His 'Verses on the Prospect of planting Arts and Learning in America' (1726) end by predicting greatness for North America:

> Westward the Course of
> Empire takes its Way;
> The four first Acts already past,
> A fifth shall close the Drama
> with the Day;
> Time's noblest Offspring is the last.

He sailed for Rhode Island in 1728 with a small group of supporters, intending to proceed to Bermuda once enough money had been raised. However, lack of funds forced him to return to London, and he donated his American farm and large library to Yale College. In 1734 he was appointed Bishop of Cloyne.

Scottish artist John Smibert (1688–1751) met Berkeley in Italy in 1720, and they were reacquainted in 1726 in London. Having studied in Edinburgh, London and Rome, Smibert had a painting style that was more precise and less dramatic than that of many contemporaries and he did 'very good business'. Berkeley invited Smibert to join his American venture as artist and teacher of art. This portrait, painted in London before they left for Rhode Island, shows Berkeley pointing to a promontory believed to represent Bermuda, a place that neither man would ever see. The portrait exists in two versions: the first belongs to the National Portrait Gallery, London; this is the second. They are probably the works listed in Smibert's notebook as 'Mr. Dean Berkeley K C 25-4-0' (June 1726) and 'Doctor Berkeley Dn. of Dy. Cop o.s. [Copy, odd size] 12-12-0' (June 1727). Smibert settled in Boston, one of the first professionally trained portrait painters to practise in the colonies. He influenced a number of local artists, including John Greenwood and John Singleton Copley.

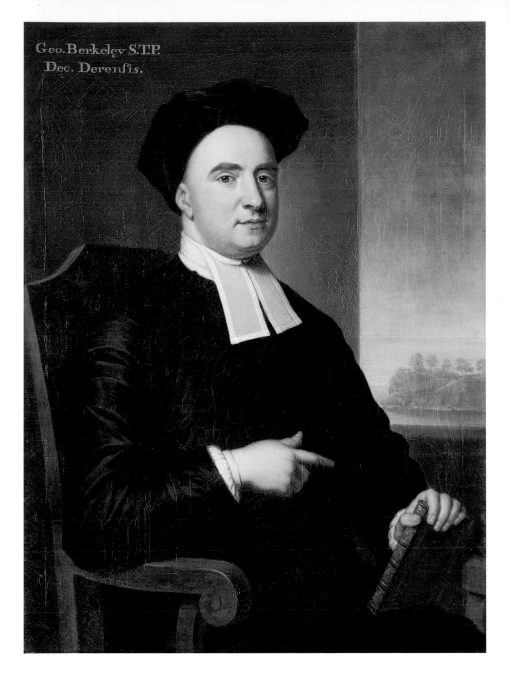

Geo. Berkeley S.T.P.
Dec. Derensis.

29

John Singleton
Copley, c.1758
Oil on copper,
121 x 102mm
(4¾ x 4")
NPG.78.218

In this portrait, John Singleton Copley (1738–1815) reveals his talent for capturing likenesses. Andrew Oliver looks as stern as his formal wig, direct gaze and arched eyebrows suggest. The twenty-year-old colonial artist painted Oliver's portrait in oil on copper, a form of miniature he employed at this early stage of his career, following the example of John Smibert. It is one of three miniatures he painted of Oliver at about this time. The other two are smaller and are paired with miniatures of Oliver's wife, Mary Sanford. The larger size may indicate that this matched a similarly scaled oil on copper miniature of Oliver's deceased brother Daniel Oliver Jr, painted by an unidentified British artist in 1727. The portrait is in its original frame and probably had a glass cover.

Andrew Oliver was the son of Boston merchant Daniel Oliver and his wife, Elizabeth, the sister of Massachusetts governor Jonathan Belcher. After graduating from Harvard College, he became a successful merchant, marrying twice and fathering seventeen children. An active member of city and church committees, he was Boston delegate to the House of Representatives for three terms. He served on the Massachusetts Council, the governor's advisory body, beginning in 1746, and was appointed secretary of the province in 1756, shortly before Copley painted this portrait. Together with his brother Peter and his brother-in-law, Thomas Hutchinson, Oliver was an ally of the British crown in the events leading to the American Revolution. He was made distributor of tax stamps following the British Parliament's passage of the Stamp Act in 1765 and, despite his personal opposition to the tax, became its most visible symbol. When Bostonians rose up in protest against it, a mob strung his effigy from the city's newly designated Liberty Tree. In 1770, as secretary of the province, he wrote an account of the Boston Massacre that was politically unacceptable to the radical members of the council, which reprimanded him. In 1771 he became lieutenant governor of the colony when Hutchinson was made governor. The subject of continued verbal attacks about his allegiance to the crown, he died three years later.

Anne Green
(c. 1720–75)
Printer, publisher

Charles Willson
Peale, c.1769
Oil on canvas,
921 x 711mm
(33¼ x 28")
Gallery purchase
with funding from the
Smithsonian Collections
Acquisitions Program
and gift from the
Governor's Mansion
Foundation of Maryland
NPG.91.152

Anne Catharine Hoof Green became publisher of the *Maryland Gazette* in 1767, on the death of her husband, Jonas Green, who had published the weekly since 1745. She also managed his printing shop and was soon appointed official printer of documents for the colony of Maryland. One of a small number of women in the printing trade in colonial America, she ran the business for eight years, at times in partnership with one of two sons. Under her editorship, Maryland's only newspaper published local, colonial and overseas news, plus advertisements, and served as a forum for debate about the political future of the colony. In this portrait she holds a copy with the colophon on the last page legible: 'ANNAPOLIS: Printed by'.

During completion of the work, Charles Willson Peale (1741–1827) repositioned her right hand. The original, slightly raised position is indicated by the shadow-like traces of the first two fingers, which have become visible over time. Circumstances suggest that this undated portrait was among the earliest Peale painted after coming back from London in 1769. He listed it first in an itemised account of works produced between his return and his move to Philadelphia at the end of 1775, and in 1788, when he cleaned the painting for Green's son Frederick, he recalled that he had painted it 'about 18 or 19 yrs. past'.

The relationship between the Peales and the Greens began in 1740, when Jonas paid the bond for the marriage licence of Peale's father, Charles, to Margaret Triggs. Later, Charles Peale advertised his Chestertown school in the *Gazette* and his son continued the contact, advertising as a saddler, his first profession, in 1762. On 8 June 1769 the paper noted Peale's return from London and a week later printed a notice about his engraving of his full-length painting of William Pitt. Three poems published in 1771 and 1773 praised portraits by him.

When Anne Green died, her obituary referred only to her personal traits: 'She was of a mild and benevolent Disposition, and for conjugal Affection, and parental Tendernes, an Example to her Sex.'

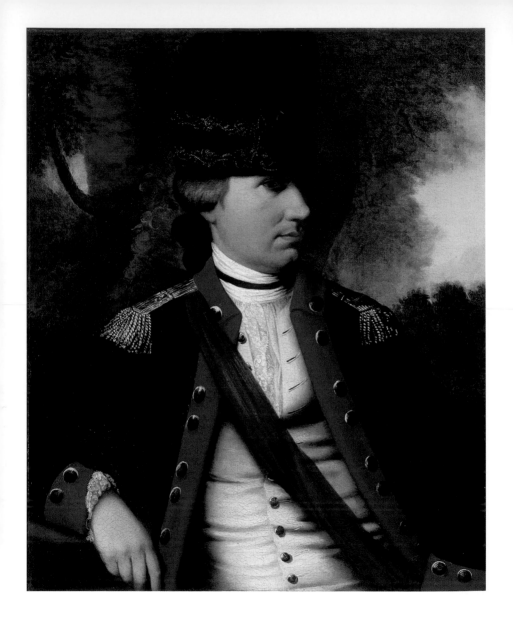

Charles
Cotesworth
Pinckney
(1746–1825)
Revolutionary
War officer,
statesman

Henry Benbridge,
c.1773
Oil on canvas,
762 x 635mm
(30 x 25")
NPG.67.1

Born in Charleston, South Carolina, Charles Cotesworth Pinckney moved with his parents to England in 1753. He was educated at Christ Church, Oxford, and studied law at the Middle Temple in London. He also attended the Royal Military Academy at Caen in France. Returning to Charleston in 1769, he was soon elected to the South Carolina Commons House of Assembly. In the growing discord with Britain, his allegiance was to the colonies. In 1775, as a member of the first Provincial Congress of South Carolina, he was appointed to a secret committee whose members seized munitions for the American forces. He became a captain in the First South Carolina Regiment and was promoted to colonel when the regiment became part of the Continental army in 1776. In 1780, when the British seized Charleston, he was imprisoned for two years. In 1783, at the end of the war, he was promoted to brigadier general. He served as a delegate to the Constitutional Convention of 1787 and as minister to France from 1796 to 1798. He was an unsuccessful candidate for the vice-presidency of the United States in 1800 and for the presidency in 1804 and 1808.

This portrait dates from about 1773, the year Pinckney married Sarah Middleton (Henry Benbridge also painted her at this time). A Philadelphian, Benbridge studied painting in Italy in 1765–9 and London in 1770 before returning to Pennsylvania. He moved to Charleston in 1772 to earn his living as a portrait painter. With his sophisticated knowledge of Italian colour and composition – and little competition – he was in great demand, painting numerous Charlestonians on the eve of the Revolution. Like Pinckney, he was imprisoned by the British when they captured Charleston in 1780. He was last documented there in the census of 1790.

Benbridge initially painted Pinckney in a scarlet coat trimmed with a black velvet collar and cuffs, the uniform of the Light Infantry Company of the Charleston militia. Pinckney became a lieutenant in the militia on 17 May 1773. Two years later, when he became a captain in the First South Carolina Regiment, the coat and trim were repainted, presumably by Benbridge, to represent the regiment's uniform: blue with red cuffs, collar and facings.

John Singleton
Copley
(1738–1815)
Artist

Self-portrait, 1780–84
Oil on canvas,
diameter 451mm
(17¾") (image size)
Gift of The Morris
and Gwendolyn
Cafritz Foundation
with matching funds
from the Smithsonian
Institution
NPG.77.22

Of the four self-portraits by John Singleton Copley, the talented American-born artist so admired for his realistic depictions of colonial sitters and important history paintings done in London, this is the only one in which he is depicted turned away from the viewer, looking off to the side. In the others, painted during his American years and in his first year in London, he poses self-consciously, looking out at the viewer, presenting an image that is elegantly dressed and coiffed. Here, instead, the composition focuses on the head, with the neckwear sketchily painted and the rest of the canvas unfinished. The air of confidence is still present, despite the change in composition.

By the late 1750s Copley had eclipsed the local talent in Boston with works such as his portrait of Andrew Oliver, and by 1771 his reputation had spread to New York and further south. His desire to study painting in Europe, coupled with increasing tension prior to the American Revolution, led to his departure for London and Italy in 1774. He spent the second half of his career in London, where, beginning in 1776, he produced important history paintings and portraits, exhibiting the narrative works in venues outside the Royal Academy to increase his reputation and income.

The pose and the strong highlighting and contrasting shadows of this self-portrait suggest that Copley was using himself as a model on which to practise technique. These stylistic features point to a date in the early 1780s, at a time when he was at work on some of the largest, most complex history paintings he had so far attempted. It is possible that as Copley adjusted to larger canvases with many figures, his more meticulous, careful colonial painting style evolved into a looser, broader technique, in keeping with British fashion in the 1780s, and that he followed this style in his own self-portrait. Perhaps he used two mirrors to achieve this dramatic pose; it would certainly be difficult to accomplish such an image with only one mirror, the usual method for making a self-portrait.

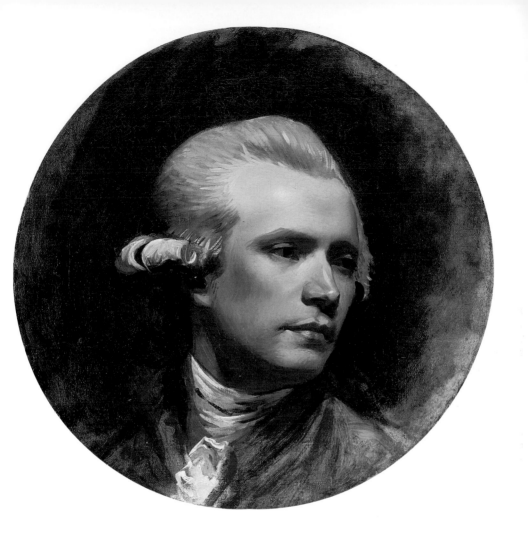

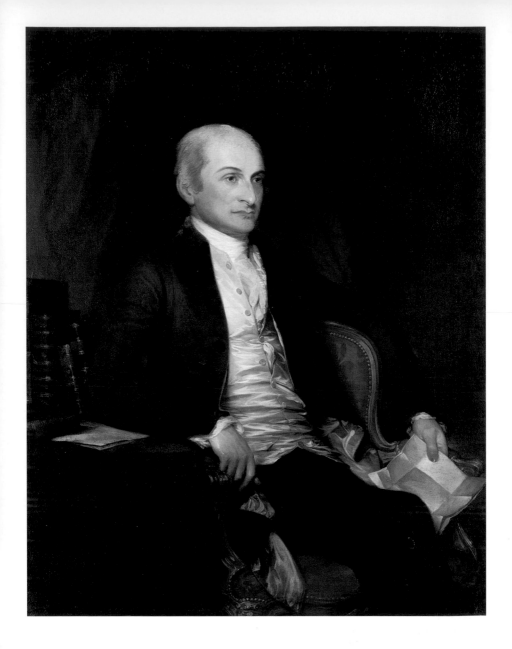

Gilbert Stuart and
John Trumbull,
begun in 1784 and
completed by 1818
Oil on canvas,
1283 x 1016mm
(50½ x 40")
NPG.74.46

A New York lawyer whose father was a wealthy merchant and landowner, John Jay served in the First and Second Continental Congress during the American Revolution and was appointed minister plenipotentiary to Spain in 1779. He was summoned to Paris in 1782 to act as joint commissioner, with Benjamin Franklin, Henry Laurens and John Adams, in negotiating the Treaty of Paris, which marked the end of the Revolution. When Jay visited London in the winter of 1783–4, he commissioned Gilbert Stuart (1755–1828) to paint two portraits. One would be for himself and the other a gift for his political ally William Bingham. However, Stuart completed only the heads.

In 1818 John Trumbull (1756–1843) told Horace Holley that the canvases had been languishing at a London broker's until Trumbull redeemed them for twenty guineas and finished them. (By 1818 one of them belonged to Jay and the other remained with Trumbull.) Suggestions as to when and where this happened range from about 1785 in London to 1794 or 1808 in the United States. The former is more likely for several reasons. Jay wears a frock coat with a pointed collar, tight sleeves and no lapel, a fashion of the 1780s;

Trumbull would have been unlikely to paint him so dressed at a later date. Stuart could have left the pictures unfinished in 1787, when he moved to Dublin. Trumbull could have completed them when he was in London from 1784 to 1789, although he was also there with Jay in 1794, serving as Jay's secretary during negotiations with Britain that led to Jay's Treaty.

In 1794 Stuart, who had arrived in New York from Dublin the previous year, completed a different portrait of Jay, showing him wearing red robes as Chief Justice. He also painted three portraits of Jay in a black suit that are similar to this work and are traditionally dated to the same year. Jay was appointed as the first Chief Justice of the United States in 1789, and served in this role until his election in 1795 as governor of New York, the position he held for the last six years of his public life.

Benjamin Franklin
(1706–90)
Author, statesman,
scientist, diplomat

Joseph Siffred Duplessis,
c.1785
Oil on canvas,
724 x 597mm
(28½ x 23½")
Gift of The Morris
and Gwendolyn
Cafritz Foundation
NPG.87.43

Born in Boston and apprenticed when twelve to his brother James, a printer, Benjamin Franklin set up a printing house in Philadelphia, bought the *Pennsylvania Gazette* and established himself as a journalist before he was thirty. From the mid-1740s he undertook research into the nature of electricity and in 1753 he became Deputy Postmaster-General for the colonies. In 1757–62 and 1764–75 he lived in London, where he represented the interests of several colonies, primarily Pennsylvania. In 1776 he helped formulate the Declaration of Independence and, to secure French aid in the war with Britain, went to Paris. There his skill as a negotiator and his personal popularity, helped by existing Anglo-French rivalry, led to a treaty of alliance in 1778. Having played a major part in negotiating the Treaty of Paris in 1783, which recognised American independence, he served as US minister in Paris until 1785. A member of the Constitutional Convention, he retired from public life in 1788.

This painting dates from Franklin's years in France, where his fame preceded his arrival in December 1776. His wit and disarming simplicity, combined with his keen intellect, made him a source of such fascination that there was brisk demand for his portrait. Joseph Siffred Duplessis (1725–1802), court painter to Louis XVI, first depicted him in a fur-collared red coat. Commissioned by Franklin's admirer Jacques Donatien Le Ray de Chaumont, who provided him with somewhere to live in Passy, near Paris, the work was exhibited in 1779 at the biennial Salon du Louvre. Pierre Samuel du Pont gave a contemporary assessment of Franklin's appearance: 'His large forehead suggests strength of mind and his robust neck the firmness of his character. Evenness of temper is in his eyes and on his lips the smile of an unshakeable serenity.' A second, similar pastel by Duplessis depicts Franklin in a grey coat. This Franklin gave to his friend Louis Guillaume Le Veillard, mayor of Passy, on his return to America. The portrait shown here resembles the pastel. Its early owner was Mme Brillon de Jouy, a talented musician who was Franklin's neighbour in Passy. Although Franklin was forty years her senior, they shared a flirtatious relationship throughout his time in France.

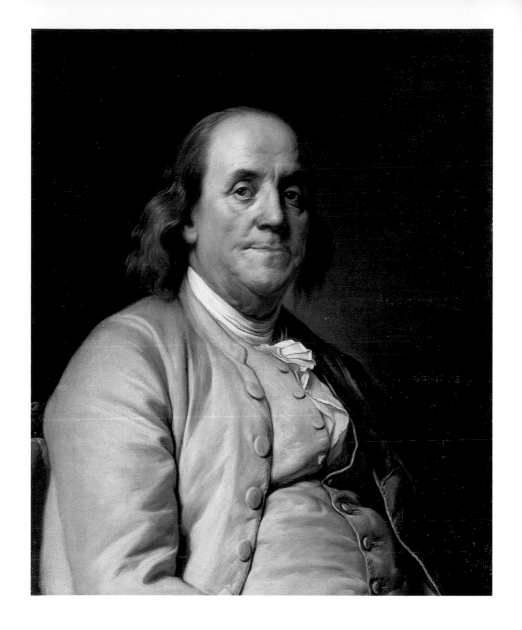

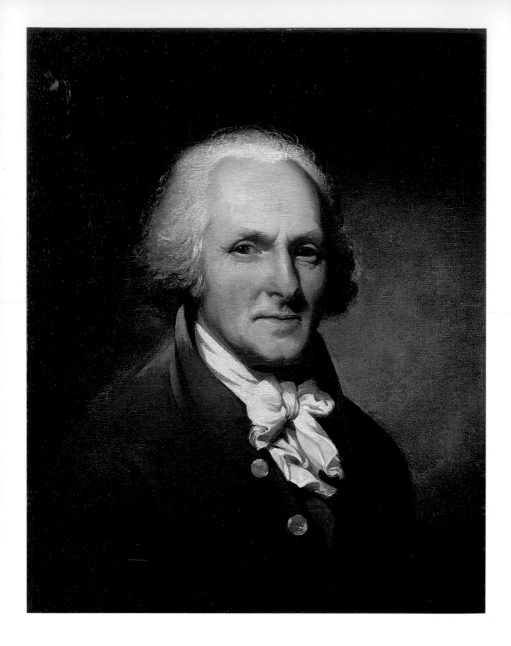

Charles Willson
Peale
(1741–1827)
Artist

Self-portrait,
c.1791
Oil on canvas,
651 x 517mm
(25⅝ x 20⅜")
NPG.89.205

Charles Willson Peale started work as a saddler's apprentice in Annapolis, Maryland, at the age of thirteen. After seven years, he left and tried his hand at a variety of trades, including painting signs and portraits. In 1766 a group of prominent Marylanders agreed to support him while he studied in London with the painter Benjamin West. He stayed in England until 1769, studying and visiting the studios of a number of important portrait painters. It was in London that he executed his first major commission, a full-length portrait of William Pitt.

In 1776 he and his wife, Rachel Brewer Peale (1744–90), settled with their two young children, Raphaelle and Angelica Kauffmann, in Philadelphia, where he would stay for the rest of his life. His profession of portrait painter led to commissions for miniatures of American army officers during the Revolutionary War and depictions of war heroes after it. He displayed his own collection of these heroes in a portrait gallery he opened in 1782 in an extension he built to his house on Lombard Street. By 1784 there were forty-four portraits, including images of John Jay, Horatio Gates, the Marquis de Lafayette, Benjamin Franklin, Thomas Paine and David Rittenhouse.

The portraits of George Washington and Conrad Alexandre Gérard were life-sized and full-length, but most works were in a bust-sized rectangular format, with the images framed in oval mats.

This self-portrait is similar in size. According to Charles Coleman Sellers, it can be dated to the early 1790s because, 'in costume, face, and hair', it resembles a profile drawing by the artist's brother, James Peale. Its early history is unknown, but it may have been painted for his new in-laws, the DePeysters of New York, at the time of Peale's marriage in 1791 to his second wife, Elizabeth DePeyster. Peale had begun painting images of himself as a young artist in the 1760s and continued for many years, but by the early 1790s he was starting to abandon his career as an artist. Painting then became the province of other members of the talented Peale family, while Charles turned to his second profession as administrator of his museum, with its growing collection of natural history specimens and portraits. In 1794 the museum moved from Lombard Street to the Philosophical Hall, Philadelphia.

George Washington
(1732–99)
First President of
the United States

Gilbert Stuart, 1796
Oil on canvas,
1219 x 940mm
(48 x 37")
Owned jointly with
Museum of Fine Arts,
Boston
NPG.80.115

When Americans chose their first president in 1789 under the new Constitution, the election of George Washington was a foregone conclusion. In the recent fight for independence, no one had been more crucial, and of the Founding Fathers none was more admired. A major in the Virginia militia at twenty, he commanded the colony's troops during the Seven Years War. He became a leader in the growing quarrel with Britain in the 1760s, and represented Virginia in the First Continental Congress in 1774. After fighting began against British troops in 1775, he was appointed commander-in-chief of the newly formed Continental army.

On 4 July 1776 the Congress approved the American Declaration of Independence. The ensuing six years of warfare ended in 1781 when American and French forces defeated the British at the Battle of Yorktown. In 1783, after the Treaty of Paris, Washington resigned his commission as commander-in-chief and retired to his home at Mount Vernon. In 1787 he presided over a convention called to devise a new framework of national government and his support for the resulting Constitution of the United States was key in winning approval for it from the requisite nine of the thirteen states. Two years later he was unanimously elected first President of the United States. Re-elected for a second term of four years in 1793, he retired to Mount Vernon in 1797.

This is the second life image of Washington by American portrait painter Gilbert Stuart (1755–1828). Preferring it to the earlier portrait, Stuart kept the unfinished painting as a model for numerous copies. The image became so well known that John Neal, an early-nineteenth-century writer and art critic, wrote:

> Stuart says, and there is no fact more certain, that he [Washington] was a man of terrible passions; the sockets of his eyes; the breadth of his nose and nostrils; the deep broad expression of strength and solemnity upon his forehead, were all a proof of this. Though a better likeness of him were shown to us, we should reject it; for, the only idea that we now have of George Washington, is associated with Stuart's Washington.

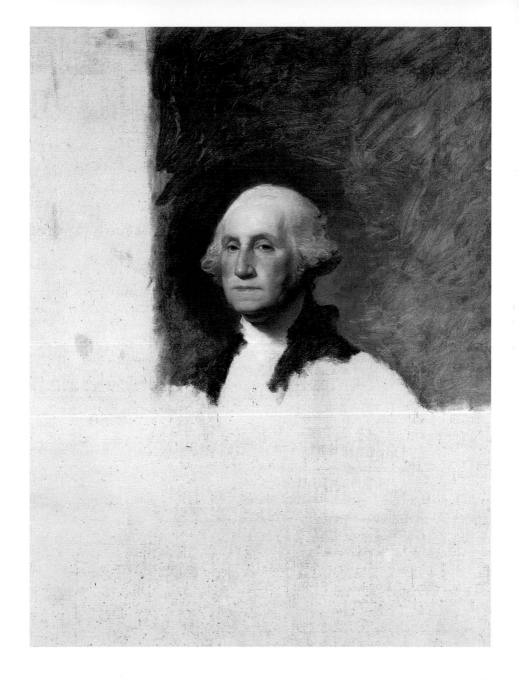

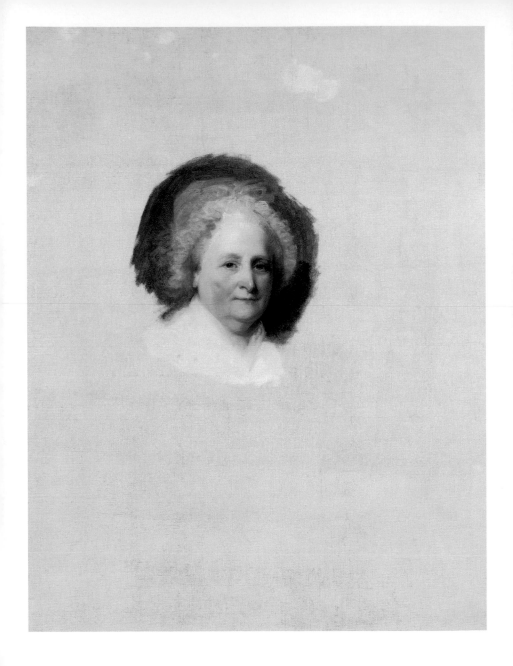

Martha
Washington
(1731–1802)
First Lady

Gilbert Stuart, 1796
Oil on canvas,
1219 x 940mm
(48 x 37")
Owned jointly with
Museum of Fine Arts,
Boston
NPG.80.116

Martha Dandridge Custis was a wealthy young widow with two children, John Parke Custis and Martha Parke Custis, when she married George Washington in 1759. The marriage resulted in no children, but Washington raised hers as his own and adopted the two youngest of John's four children, Eleanor Parke Custis and George Washington Parke Custis, after their father died in 1781 during the Revolutionary War. Although Martha Washington likened herself to a 'state prisoner' during her time as the nation's First Lady, she felt obligated to meet the responsibilities of her position, and for eight years she presided with gracious dignity over weekly receptions and state dinners. Shortly after she and her husband retired to their Mount Vernon estate in 1797, she expressed relief at being out of the public eye, describing herself in a letter as 'steady as a clock, busy as a bee, and happy as a cricket'.

In 1772 Martha Washington had commissioned the first of many portraits that were painted of her husband. By the 1790s Washington was reluctant to sit for any new portraits. She managed to convince him to sit for Gilbert Stuart (1755–1828) because, according to Charles Willson Peale's son Rembrandt, she 'wished a Portrait for herself; he therefore consented on the express condition that *when finished* it should be hers'. She commissioned this portrait of herself at the same time. However, when Stuart completed these life studies, he realized that it would be of great benefit to him if he could keep them, so as to be able to make replicas of Washington's portrait. The two unfinished paintings therefore remained in Stuart's studio throughout his lifetime, long after the deaths of George and Martha Washington. When the artist died, the portraits were acquired by the Boston Athenaeum, which continued to own them until 1980. Often referred to as the Athenaeum portraits, they are the best-known images of the first President of the United States and the First Lady.

Rembrandt Peale, 1807
Oil on canvas,
667 x 546mm
(26¼ x 21½")
Gift of Mrs James Burd
Peale Green and
Gallery purchase
NPG.86.212

Rubens Peale was one of the children of artist and naturalist Charles Willson Peale and his first wife, Rachel Brewer, who died when her son was still young. Like most of his siblings, he was named after a famous artist; in his case it was Peter Paul Rubens, the seventeenth-century Flemish painter.

Small for his age, Rubens Peale suffered from poor eyesight, which prevented him from following a career as an artist, like his brothers Rembrandt and Raphaelle. From an early age, however, he was remarkably successful in the field of plant and animal care, so he turned to managing the family's Philadelphia museum of art and science. He was its administrative proprietor by 1810 and in 1825 he established his own Peale Museum in New York City.

Firmly believing that museums should entertain as well as educate, he was keen to find new ways of attracting visitors and here again he proved very successful. In 1815, for example, with attendance lagging at the Philadelphia Museum, he introduced the novelty of gas lighting to its galleries and as a result increased receipts by nearly 50 per cent.

This is the second portrait of Rubens that his older brother Rembrandt painted. It shows him wearing lenses with strong magnification that noticeably enlarge the inner corner of his left eye and the outer area of his right eye. Like the earlier portrait, *Rubens Peale with a Geranium* (1801), it captures his quiet strength while also reflecting his brother's fondness for him. The portrait bears two inscribed dates, 1807 and 1821. The first is the actual date of the portrait; the second may have been added by a later member of the family because the earlier date was covered by a frame. The earlier date was only discovered when the painting was being cleaned in 1989, after it was acquired by the National Portrait Gallery.

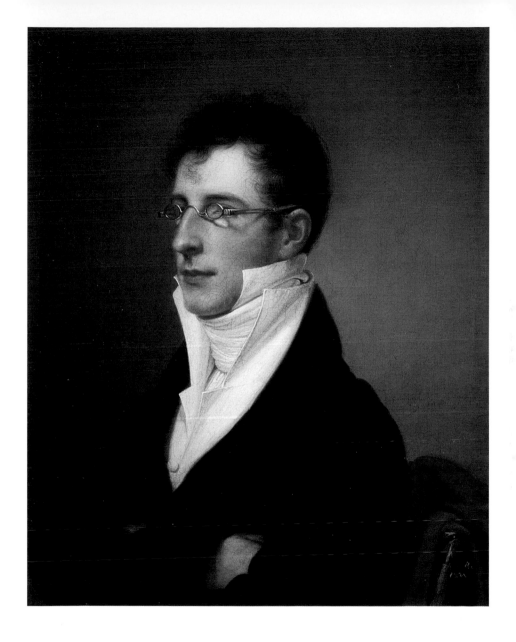

49

Juliana Westray
Wood
(1778–1836)
Actress

Rembrandt Peale,
c.1811
Oil on canvas,
762 x 635mm
(30 x 25")
NPG.81.120

Born in England, Juliana Westray came to the United States with her parents and two sisters, Ellen and Elizabeth, in 1796. She made her dramatic debut in 1797 at Boston's Haymarket Theatre. Soon after, all three sisters were appearing at the Park Theatre in New York City, where Juliana established a solid reputation in supporting roles in *The Merchant of Venice* and John Dent's *The Telegraph, or, A New Way of Knowing Things* (1795).

In 1803 she joined William Burke Wood, an actor, director and theatre manager in Philadelphia. As part of his company, she was soon playing lead roles to glowing reviews. In 1804 she and Wood married, and for the next twenty years Juliana Wood was one of America's pre-eminent actresses, best known for her performances in *Macbeth*, Sir Walter Scott's *The Heart of Midlothian* and Richard Sheridan's *The School for Scandal*.

This portrait was probably painted in 1811, soon after Rembrandt Peale's return from his second trip to Paris. David Edwin's engraving of the portrait was published in the March 1811 issue of *The Mirror of Taste, and Dramatic Censor*, a short-lived Philadelphia periodical that featured essays on the history of the stage, theatre reviews and the texts of plays. The engraving is one of several portraits of actors published there. Public interest in the private lives and morality of actors and actresses was hinted at in the text that accompanied it. Calling the image 'a striking likeness', the author noted that the portrait:

> will no doubt be acceptable to our subscribers, not only as a handsome specimen of American arts, but as a striking resemblance of a lady whose public talents and private virtues have raised her to a very high rank in public estimation.

Peale's painting shows Wood in front of a stage setting, with a curtain and ropes, as well as a landscape, visible behind her. Edwin's engraving, however, shows only the figure of the actress, perhaps underlining her private morality by removing visual references to the theatre.

Samuel F. B. Morse
(1791–1872)
Artist, inventor

Self-portrait, c.1812
Oil on millboard,
270 x 225mm
(10⅝ x 8⅞")
Acquisition made
possible by a generous
contribution from the
James Smithson Society
NPG.80.208

Best known as the inventor of the telegraph, Samuel Finley Breese Morse first pursued a career as an artist. After graduating from Yale in 1810, he went to England, where he studied with Washington Allston and Benjamin West. Soon after his arrival, he wrote to his parents on 30 January 1812 that he had completed five pictures, including a self-portrait, which is believed to be this painting: 'I have painted 5 pieces since I have been here, 2 landscapes and 3 portraits, one of myself, one a copy from Mr. West's copy from Vandyke, and the other a portrait of Mr. Leslie, who is also taking mine.' A larger version is thought to have been painted a year or two later. The profiles, unusual compositions for self-portraits, may result from the influence of Allston, who had painted a similar portrait of Francis Dana Channing in Boston in 1808–9. The cape or robe that he wears has not been identified.

On his return to the United States in 1815, Morse embarked on a successful career as a portrait painter. In 1824 New York City became his permanent home. Part of the younger generation of artists who objected to the pro-patron emphasis of the American Academy of the Fine Arts, he became a founder of the National Academy of Design in 1826. Among his most notable paintings were *The House of Representatives* (1822–3), which includes more than eighty portraits, and a full-length image of the Marquis de Lafayette (1825–6). His return to Europe in 1829 led to his painting *The Gallery of the Louvre*.

By the early 1830s Morse had turned from art to conducting a series of electrical experiments, culminating in 1838 with a model for the modern telegraph. By 1844 he was seated in the United States Capitol tapping out the first long-distance telegraph message – 'What hath God wrought!' – in a code that still bears his name today. Although his reputation now rests almost entirely on that accomplishment, art historians continue to regard him as a significant artist of America's romantic school.

Rufus King
(1755–1827)
Statesman

Gilbert Stuart, 1819–20
Oil on panel,
762 x 629mm
(30 x 24¾")
Acquisition made
possible by a generous
contribution from the
James Smithson Society
NPG.88.1

A leading member of the early conservative political coalition known as the Federalists, Rufus King was among the most persuasive orators at the Constitutional Convention of 1787. He was one of New York's first United States senators, after which he became America's minister to Great Britain. Serving in that capacity from 1796 to 1803, he was in Britain at a time when conflicts over maritime issues and trading rights threatened Anglo-American peace almost daily, and it was largely to his credit that this constant friction between the two countries never descended into open war. He returned to the Senate in 1813, and although he could claim no significant accomplishments during his last years in public office, his eloquence in debate continued to impress many.

Painted in 1819–20 by Gilbert Stuart (1755–1828), this portrait was commissioned as part of a portrait exchange between King and his friend Christopher Gore, also a longtime Federalist. A prominent lawyer and governor of Massachusetts for one term, Gore had been King's classmate at Harvard. Their friendship grew during the late 1790s, when both men held diplomatic appointments in Britain.

John Trumbull painted their portraits at that time. By 1819, Gore and King were among the Federalist Party's elder statesmen and, desiring likenesses of each other, they agreed to exchange portraits. In 1819, King sat for Stuart while visiting Gore in Boston. After seeing the portrait, Gore wrote to King:

> We have been highly gratified with your Picture – It is a good Picture, and on the whole a Likeness, though I think in this Respect subject to some Criticism – one Eye is drawn down as to give, in a small Degree, the appearance of squinting.

Stuart made two versions of the portrait. While the original went to Gore, the painting seen here, which is the replica, was acquired by King. The second half of the portrait exchange was effected when John Trumbull painted a portrait of Gore, but this is unfortunately no longer in existence, having been destroyed by fire in 1948 or 1949.

Samuel Ringgold
(1796–1846)
Mexican War officer

John Vanderlyn, c.1825
Oil on canvas,
711 x 588mm
(28 x 23⅛")
Gift of the William
Woodville Estate
NPG.96.93

Born in Washington, DC, Samuel Ringgold attended the United States Military Academy at West Point and in 1818 was a member of its first graduating class. He entered the army as a lieutenant of artillery, immediately being selected for General Winfield Scott's staff. After serving with Scott during the Florida Indian War of the late 1830s, he was cited for 'meritorious service' and promoted to major general. When the Mexican War broke out he was put in charge of the artillery regiments that were part of General Zachary Taylor's invading force. On 8 May 1846, in the first clash of the war, near the town of Palo Alto, he helped a much smaller American force win a decisive victory but, wounded in the battle, died three days later. News of his death created an explosion of national pride and he quickly became a hero.

This portrait, showing Ringgold in a staff officer's blue dress uniform, was made by New York artist John Vanderlyn (1775–1852) around 1825. The bullet or ball buttons, the herringbone twill fabric and the V-neck collar were all features in use from 1821 to 1827. The red collar of the cape might be an artillery designation, since that colour often indicated artillery. Vanderlyn trained with Gilbert Stuart and at the École des Beaux-Arts, Paris. After a brief return to the United States in 1801, he was in Europe from 1803 to 1815. When he went back to the United States, he hoped to be awarded a federal commission for a painting for the Capitol Rotunda. Instead, he met with failure in his self-financed attempts to exhibit historical works and large panoramic views called cycloramas. In the 1820s he set up a studio in New York City and began painting portraits to make a living. Young artillery officer Samuel Ringgold, in New York State as part of General Scott's staff, was one of his sitters. Ringgold owned the portrait until his death, when, following instructions in a will he wrote on the morning of the Battle of Palo Alto, it went with all his possessions to his sister, Mrs William Schley.

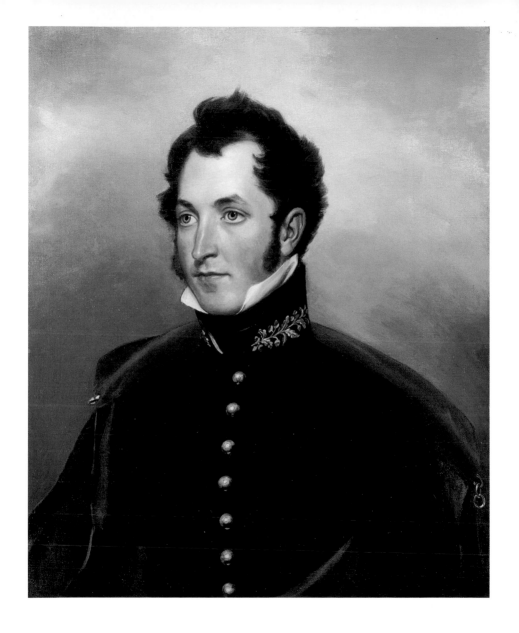

Thomas Paul
(1773–1831)
Clergyman

Thomas Badger, c.1825
Oil on panel,
203 x 162mm
(8 x 6⅜")
NPG.70.45

Thomas Paul, the founder of the African Baptist Church in Boston in 1805, began the movement towards independent black Baptist churches in the United States. Until that time, African Americans had worshipped as 'segregated brethren' within white congregations, but this was a situation that became more and more untenable in the wake of conservative reaction to the American Revolution and the increased migration of free blacks to the North. Paul's eloquence as a preacher brought him invitations to speak throughout the country and wherever African Americans were attempting to organise their own churches. In 1809 he helped to establish the Abyssinian Baptist Church in New York City, which later became the largest Baptist congregation in the world. He served as pastor of the First African Baptist Church until 1829, when he was forced to resign because of poor health.

This portrait is by miniaturist and portrait painter Thomas Badger (1792–1868). Born in South Reading, Massachusetts, Badger began painting portraits in Boston in 1814. He worked there for most of his career, but he also made painting trips to Maine. In 1857 Andrew Walker, a resident of Kennebunk, wrote that Badger was 'then called an excellent painter…and now is supposed to be as good if not the best artist in the city [of Boston]'. The portrait, which depicts Paul in the act of preaching, is listed in the artist's checklist of portrait commissions, kept in a notebook dated 1833. The notebook contains transcriptions from an earlier list, begun in Boston in 1814 and giving only the sitters' names, which includes, near the end, 'Revd. Thomas Paul'. The setting for the portrait could be the African Meeting House on Beacon Hill in Boston, which was constructed in 1806 by the First African Baptist Church. A portrait engraving by J. Hopwood Jr, after a drawing by J. Palmer, which was published in London in 1816, depicts Paul as a younger man in a similar interior and making the same gesture.

Henry Inman, after
Charles Bird King,
c.1830
Oil on canvas,
765 x 635mm
(30⅛ x 25")
NPG.79.174

Sequoyah became interested in developing an alphabet, or a table of characters, to represent the eighty-five or eighty-six syllables in the Cherokee language after he was crippled in 1809 following an accident while out hunting. The task was not an easy one, but by 1821 his work had been completed and the alphabet approved by the Cherokee chiefs, with the result that in a short time thousands of his people had learned to read and write. Having moved to Oklahoma with the western Cherokee of Arkansas, he encouraged the printing of books and a newspaper in Cherokee and became generally active in the political life of his tribe. Sequoyah's fame is perpetuated to this day in the genus name of California's giant redwood trees.

This portrait by Henry Inman (1801–46) is a copy of a painting by Charles Bird King that was made when Sequoyah was in Washington, DC, in 1828 in order to negotiate a treaty. It depicts the Cherokee leader holding a tablet on which his Cherokee alphabet can be read and wearing a peace medal around his neck. King's original portrait was part of the larger effort conceived by Thomas Loraine McKenney, the commissioner of Indian affairs from

1824 to 1830, to record information about the culture and prominent figures of the Native American tribes. Begun in 1822, McKenney's collection eventually grew to include more than 140 paintings of Native American leaders. Most of the portraits were reproduced for the three-volume *History of the Indian Tribes of North America, with Biographical Sketches and Anecdotes of the Principal Chiefs* (Philadelphia, 1838–44), compiled by McKenney with co-editor James Hall, which contained hand-coloured lithographs of 120 of them. Henry Inman copied the originals as part of the lithography process and McKenney was obviously very pleased with his work, declaring that the copies were 'more impressive than any thing I ever saw. Inman you know is a Master.' King's originals later belonged to the Smithsonian Institution in Washington, DC, where they remained on display until most of them were unfortunately destroyed by fire in 1865.

61

William Lloyd
Garrison
(1805–79)
Abolitionist

Nathaniel Jocelyn, 1833
Oil on panel,
760 x 632mm
(291%₆ x 24⅞")
Bequest of
Garrison Norton
NPG.96.102

There was no greater catalyst in the upsurge of northern opposition to slavery that began in the 1830s than William Lloyd Garrison, editor of the abolitionist newspaper *The Liberator*, which was first published in 1831. A key figure in the American Anti-Slavery Society, his unstinting dedication to the cause ended only with the abolition of slavery more than thirty years later. His militant stance initially inspired hostility even in his native New England, where a mob once came close to hanging him, but inevitably he was most feared and hated in the South. In fact in Georgia from 1831 a reward of $5,000 was permanently on offer for his capture.

This portrait by New Haven, Connecticut, painter and engraver Nathaniel Jocelyn (1796–1881) was commissioned by the artist's brother, Simeon Smith Jocelyn, who was also an engraver. Both men were ardent abolitionists, and Simeon wrote to Garrison in March 1833:

as the Lord has been pleased to give you a head bearing none of the *destructive disposition* which opposers ascribe to you, it may not be amiss to lead them by a view of the outward man to a more favorable examination of your principles.

Simeon was planning to sell copies of the engraving in order to raise money for the abolitionist cause, as well as to heighten Garrison's public image. Although Garrison was at first reluctant, he finally bowed to pressure. En route to England a little later, he wrote to his lifelong friend Harriet Minot about the portrait:

I think [Jocelyn] has succeeded in making a very tolerable likeness. To be sure, those who imagine that I am a monster, on seeing it will doubt or deny its accuracy, seeing no horns about the head; but my friends, I think, will recognize it easily.

He also wrote to abolitionist Robert Purvis in a similar tone: 'I am happy to inform you that Mr. N. Jocelyn had completed what is deemed a good likeness of the madman Garrison.' Purvis later commissioned Nathaniel Jocelyn to paint Cinque, the leader of the African mutineers aboard the *Amistad* in 1839.

Davy Crockett
(1786–1836)
Frontiersman

Chester Harding, 1834
Oil on canvas,
762 x 635mm
(30 x 25")
Future bequest of Ms
Katharine Bradford
L/NPG.1.88

Davy Crockett, the famous frontiersman from Tennessee, served in the House of Representatives for two terms from 1827 to 1831, quickly becoming well known for his self-promoting tall tales. He returned to the House in 1833 and in 1834 went on a speaking tour of eastern cities designed to promote the interests of the anti-Jacksonian Whig Party. While in Boston, he sat for his portrait to Chester Harding (1792–1866), the city's most popular portrait painter. Crockett arrived there on 3 May and:

> next morning I was invited by Mr. Harding to visit his gallery of paintings, where he had a great many specimens of the fine arts; and finally he asked me to sit for him until he could get my likeness, which I did, during my stay, and he has it now, hung up among the rest of the fine arts.

The sitting took place on 6 May, as reported in the *Boston Transcript*. The image agrees with a contemporary description:

> Colonel Crockett is an uncommonly fine looking man. His face has an exceedingly amiable expression

and his features are prominent and striking. He wears his hair which is black, (with a light shade of brown) parted down the centre of his forehead, combed back from his temples, and ending in a slight curl at the neck—not unlike the simple manner of many of the clergy.

Harding's portrait is one of five that Crockett sat for from 1833 to 1834, a testimony to his growing fame. At least two were intended to be reproduced in prints, indicating a popular market for Crockett's image. For one of these, a portrait by Samuel Stillman Osgood that was lithographed by the Philadelphia firm of Cephas G. Childs and George Lehman in 1834, Crockett wrote a testimonial as part of the caption on the plate: 'I am happy to acknowledge this to be the only correct likeness that has been taken of me. David Crockett.'

In 1836 Crockett met his untimely end at the Battle of the Alamo during the Texas war of independence from Mexico. A romantic figure in his own lifetime, he became a hero after his dramatic death.

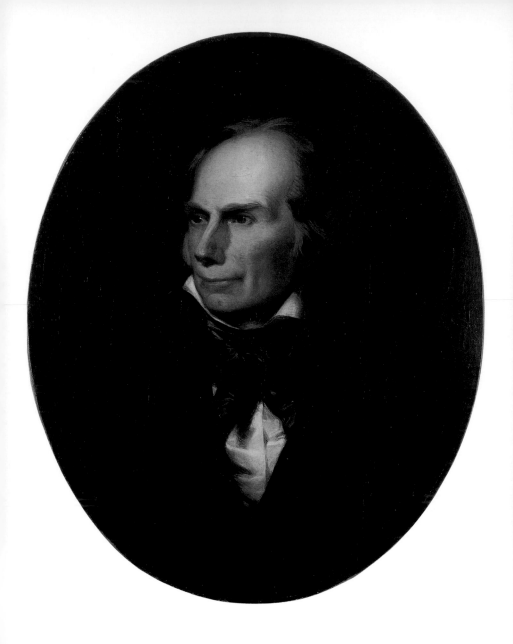

Henry Clay
(1777–1852)
Statesman

John Neagle, 1842
Oil on canvas,
700 x 545mm
(27½ x 21½")
NPG.93.476

Admirers called him 'Gallant Harry' and his charm made him one of the best-loved politicians of the day, but the real legacy of Kentucky's Henry Clay was his unstinting devotion to a strong American union. As Speaker of the House of Representatives he was the author of the Missouri Compromise in 1820, the first of the measures which earned him the title of 'The Great Pacificator'. In the early 1830s, South Carolina tried unconstitutionally to 'nullify' a federal tariff deemed to be detrimental to plantation economies. Clay orchestrated a compromise. In 1850, with the North and South on the verge of conflict over the extension of slavery into new western territories, he stepped in with proposals that temporarily appeased both sides.

In 1842 fifteen Philadelphia Whig supporters, who hoped Clay would be their party's presidential candidate in 1844, commissioned one of the city's leading portrait painters, John Neagle (1796–1865), to paint a full-length portrait. Clay gave Neagle several sittings at Ashland, his home in Kentucky. First the artist completed the bust portrait seen here, as well as a number of sketches. On the back of the portrait he wrote, 'Painted from life by John Neagle. November 1842. at Ashland.' He then used the portrait and sketches to complete a full-length of Clay, which was exhibited in Lexington and Frankfort the following spring, then brought to Philadelphia. Clay wrote to Neagle on 29 May 1843:

> it is the judgment of my family and friends that you have sketched the most perfect likeness of me that has been hitherto made. My opinion coincides with theirs. I think you have happily delineated the character, as well as the physical appearance, of your subject.

The men who had commissioned the portrait presented it to the National Clay Club at a public ceremony in Philadelphia. The imagery conveyed a summary of Clay's political accomplishments, and a widely distributed engraving of the work by John Sartain helped to promote his presidential candidacy, which was nevertheless unsuccessful. The portrait eventually became the property of the Union League of Philadelphia and hangs in its building to this day. A second version is at the United States Capitol.

Unidentified artist, *c.*1844
Oil on canvas,
699 x 571mm
(27½ x 22½")
NPG.74.45

Born into slavery in Maryland, Frederick Douglass escaped in 1838 and fled north, settling in Massachusetts. He joined the abolitionist movement and by the mid-1840s his eloquent first-hand testimony to the oppression of slavery had made him one of its most persuasive speakers. Recalling the figure that Douglass cut at abolitionist gatherings, Elizabeth Cady Stanton wrote, 'He stood there like an African prince, majestic in his wrath, as with wit, satire, and indignation he graphically described the bitterness of slavery.' His reforming zeal remained strong throughout his life and once the Civil War put an end to slavery, he continued to defend the rights of African Americans.

No one knows who painted this portrait. It was first recorded in 1902, when it was given to the Rhode Island Historical Society by Lewis Janes from the estate of his father, Alphonso Richard Janes. The elder Janes, a friend of Douglass's, was treasurer of the Rhode Island Anti-Slavery Society for many years. After its acquisition by the National Portrait Gallery, the painting was attributed to Elisha Hammond, a painter who lived in Florence, Massachusetts, the communal society Douglass visited in 1844. However, it

is now clear that this could not be Hammond's portrait, which Douglass owned until his death in 1895 and specifically bequeathed to his daughter, Rosetta D. Sprague.

The portrait here is very similar to the engraving that appeared as a frontispiece to Douglass's autobiography, *Narrative of the Life of Frederick Douglass, an American Slave* (Boston, 1845). It was probably based on the engraving, or on the unlocated daguerreotype from which the engraving was no doubt made. One possibility is that the painting is the work of African American artist Robert Douglass (1809–87), a Philadelphia portrait painter, daguerreotypist and illustrator. He exhibited a portrait of Frederick Douglass, who was not a relative, at the Pennsylvania Academy of the Fine Arts in 1878. None of his paintings have been located, but his portrait of Frederick Douglass was offered for sale in Philadelphia in 1894, making it unlikely that it was the painting in Janes's estate.

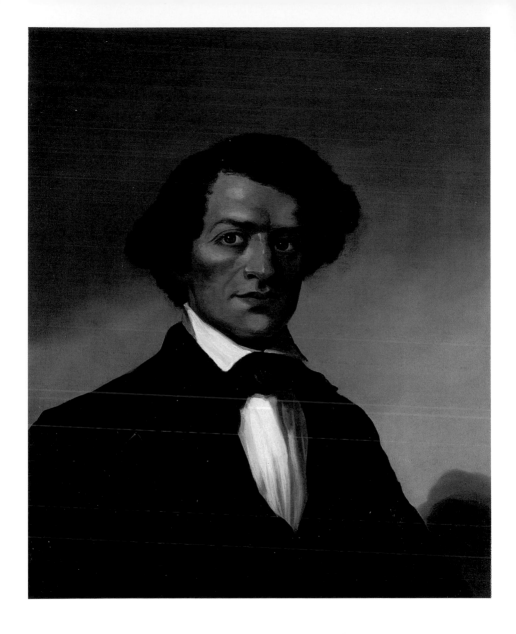

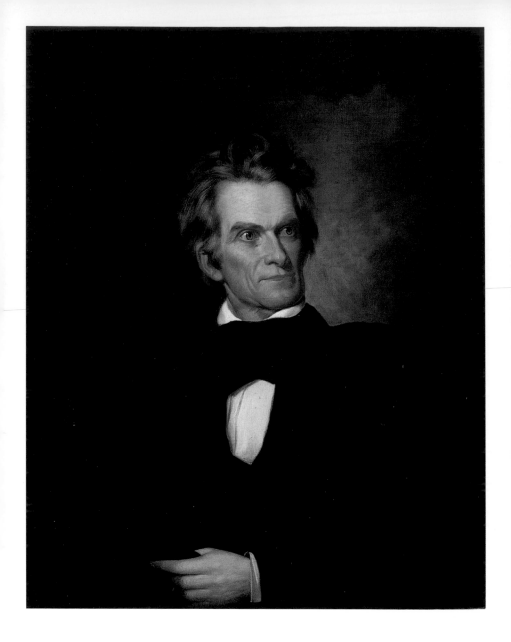

George Peter
Alexander Healy,
c.1845
Oil on canvas,
915 x 737mm
(36 x 29")
NPG.90.52

South Carolina's John Caldwell Calhoun was a formidable presence in American politics for nearly four decades. He served twice as vice-president – under John Quincy Adams and Andrew Jackson – and in two cabinets, but it was during his later years in the Senate that he had his greatest impact, championing southern interests and formulating the states'-rights theory of America's political union. But even as he defended the South against attempts to curb slavery and argued for the right of states to overrule federal policies, he sensed he was fighting a losing battle. His dying words were 'the South, the poor South'.

The austere, dark-eyed Calhoun began his career as an ardent nationalist, in league with Henry Clay, but by the mid-1830s his unswerving localism had driven the two men apart. Like many opponents, though, Clay had an abiding respect for his adversary, observing 'I was his senior…in years – in nothing else.'

Boston-born Healy (1813–94) enjoyed great success as a portrait painter in Paris. Accepting a commission from King Louis-Philippe for a series of portraits of American statesmen, he went to the United States in 1845 to paint former president Andrew Jackson, who was then near death. He probably painted the life portrait of Calhoun on the same trip; one of the four bust-length versions is signed and dated 1845. The second, painted for Louis-Philippe, is dated 1846. The third, which is undated, repeats the composition of the first two, while the Gallery's slightly larger version, also undated, is the only one that includes Calhoun's left arm and hand. Healy also used the image to paint a full-length portrait of Calhoun commissioned by Charleston City Council shortly after Calhoun's death. When he received that commission, Healy responded, 'With the greatest pleasure I accept this commission to paint a man for whom I entertained so deep an admiration, and in whose society I derived so much benefit.' The Gallery's portrait was given by Calhoun's widow to her husband's friend Henry Gourdin. Although the Gallery owns other likenesses of Calhoun, Healy's portrait is particularly successful in conveying Calhoun's fiery spirit.

Dolley Madison
(1768–1849)
First Lady

William S. Elwell, 1848
Oil on canvas,
762 x 635mm
(30 x 25") feigned oval
NPG.74.6

Dolley Payne Todd Madison served as White House hostess during the administrations of both the widowed Thomas Jefferson and her own husband, James, investing Washington's social life with an elegance and gaiety not seen before. Her effervescence provided a refreshing counterpoint to her husband's introspective nature and doubtless accounted in some measure for his popularity. When Madison's presidency ended in 1817, the couple returned to Montpelier, their Virginia home. Dolley helped her husband put his papers in order and, after his death in 1836, sold a portion of them to the United States Congress before moving back to Washington. She was frequently the guest of honour at the White House and continued her lavish entertaining, despite mounting debts.

William S. Elwell (1810–81), a gifted painter who never attained great fame, was from Brimfield, Massachusetts, and had studied with Chester Harding in Springfield. Apparently his first appearance in the South was in Richmond, Virginia, where he advertised as a painter in December 1847. His likeness of Dolley Madison, painted the following February in Washington, DC, is considered his best work. Elwell described her in his diary as:

> a very Estimable lady – kind & obliging – one of the Old School. Fluent in her conversation – interested in all the events of the day, as lively and as blooming as a Miss of 16. Tho this bloom was artificial, the *Rouge* being applied in a Most delicate & artistic manner.

During the sittings, Dolley expressed sympathy for 'the struggling artist' and offered to help 'if in her power'. Perhaps Elwell took up her offer, for by 1853 he was working in Washington as a clerk in the Treasury Department. However, two years later a stroke left him partially paralysed. In his diary, he noted that the portrait was 'afterwards sold to Mr Wm Seaton…for 100 dollars'. William Winston Seaton, a friend of Dolley's, had been editor and co-owner of the Washington *National Intelligencer* since 1812 and was mayor from 1840 to 1850. He inscribed the back of the portrait: 'Mrs. Madison aged 83 painted by W. S. Elwell in 1848. A faithful portrait W.W.S.'

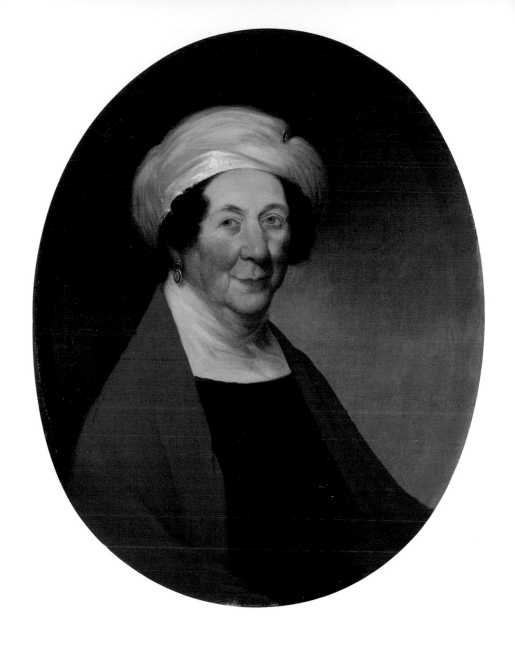

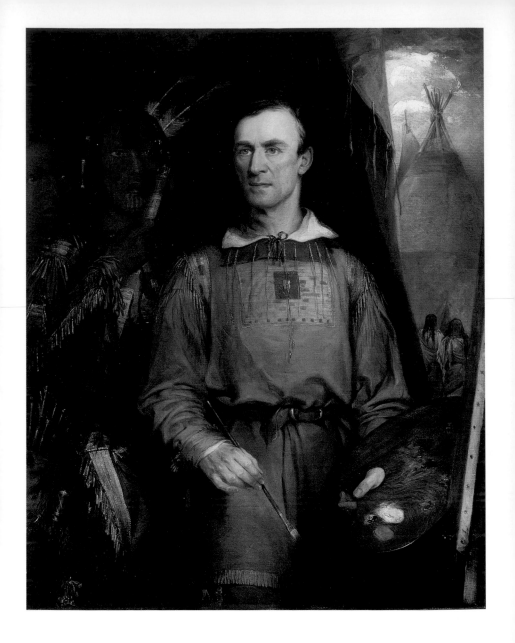

George Catlin
(1796–1872)
Artist

William Fisk, 1849
Oil on canvas,
1270 x 1016mm
(50 x 40")
Transfer from the
Smithsonian American
Art Museum; gift of
Miss May C. Kinney,
Ernest C. Kinney, and
Bradford Wickes, 1945
NPG.70.14

Having seen an Indian delegation on its way to Washington in the 1820s, George Catlin was haunted by the memory of these 'lords of the forest'. In 1830, determined to become their historian before white civilisation destroyed their way of life, he abandoned his career as a conventional portraitist and set out for the wilderness. Over the next six years, he devoted himself to painting Indian leaders and sketching tribal life. The pictorial record of his travels constitutes one of the most remarkable archives ever assembled, numbering around 500 paintings. It was Catlin's hope that his collection would become the nucleus of a federally financed national museum and, to win congressional approval for his plan, he exhibited his paintings in many eastern cities. Congress, however, proved indifferent and in 1839 he took his Indian gallery to Europe. There he published his two-volume *Letters and Notes on the Manners, Customs, and Condition of the North American Indians* (London, 1841), illustrated with engravings after his paintings. Despite great acclaim in London and Paris, mounting debts eventually forced him to sell most of his collection in 1852. The largest portion came into the hands of Philadelphia businessman Joseph Harrison, whose heirs donated the portraits to the Smithsonian Institution in 1870.

British artist William Fisk (1796–1872) painted this portrait of Catlin in England in 1849. The previous year Catlin had fled there from France with his Indian gallery after the overthrow of King Louis-Philippe. Although he was still well known in England at the time of this sitting, enthusiasm for his gallery had waned and he was making a living selling copies of his originals. Fisk was a popular painter of portraits and historical works. His likeness depicts Catlin as if he is in America at work on his paintings, with, to his right, the Blackfoot warrior Iron Horn and The Woman Who Strikes Many, also a Blackfoot. These images duplicate portraits Catlin had painted in 1832 at Fort Union, in present-day North Dakota. The resulting work brings to mind Catlin's younger days on the American frontier.

Harriet Beecher
Stowe
(1811–96)
Author, reformer

Alanson Fisher, 1853
Oil on canvas,
864 x 680mm
(34 x 26¾")
NPG.68.1

Harriet Beecher, the daughter of Congregationalist minister Lyman Beecher, was raised in Connecticut, where her literary abilities brought early recognition. The family moved to Cincinnati, Ohio, in 1832, when her father became president of the Lane Seminary. She worked as a teacher and in 1835 married Calvin Ellis Stowe, a professor at the Lane Seminary. When her husband accepted a position at Bowdoin College in 1850, they moved to Maine with their family.

As a resident of Cincinnati, she came into contact with slaves escaping northward and learned about their lives in the South. In response to passage of the Fugitive Slave Law in 1850, which guaranteed federal backing for the return of runaway slaves, she began writing Uncle Tom's Cabin, which was serialised in the National Era in 1851–2 before it was published as a book in 1852. It was an immediate success, selling more than 300,000 copies in its first year. When it was adapted for the stage in 1853, this portrait was commissioned by Alexander H. Purdy, owner of the National Theatre in New York, where the play was produced. According to the Evening Post (New York), 'the manager of the National

incurred the expense in consequence of the great success of Uncle Tom's Cabin'. The paper also quoted a letter from Stowe's husband which noted that he was:

better satisfied with Mr. Fisher's portrait of Mrs. Stowe than with any other attempt of the kind which he has seen. Every feature is exactly copied, and the general expression is pleasant, life-like and natural. On the whole, to his eye, it is a handsome picture and a good likeness.

Alanson Fisher (1807–84), a New York artist, painted the portrait in Andover, Massachusetts, where the Stowes lived. In 1854 he exhibited it at the National Academy of Design in New York, of which he was a member. Stowe's modest appearance was surprising to many. When she met Abraham Lincoln at the White House during the Civil War, in 1862, he reportedly said, 'So you're the little woman who wrote the book that started this great war!'

77

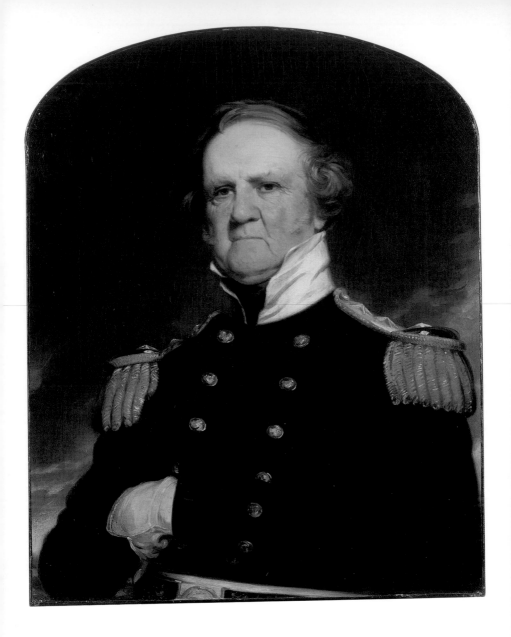

Robert Walter Weir,
c.1855
Oil on canvas,
864 x 692mm
(34 x 27")
NPG.95.52

Later called 'Old Fuss and Feathers' for his strict codes of military conduct and dress, Winfield Scott was, along with Andrew Jackson, one of the most capable military men of his time. Unusual in believing that force should be used only as a last resort, over the course of his career he transformed a ragtag army into a professional fighting force. Made general-in-chief of the army in 1841, he won great fame in the Mexican War, invading Mexico by sea in 1847 and taking Mexico City. In 1852 he was the Whig Party's unsuccessful candidate for president. When the Civil War began, though old and in poor health, he planned the strategy that eventually gave the North victory.

Robert Walter Weir (1803–89), a successful painter of portraits, landscapes and historical works, was professor of drawing at the United States Military Academy at West Point when he painted Scott's portrait for the second time in 1855. Scott had just been promoted to lieutenant general – the first person to hold the rank since George Washington. Weir was at work on the life portrait on 24 September 1855, when John Gross Barnard, the superintendent of West Point, wrote to Scott for permission to have Weir paint a copy for the academy:

> The features of one who has done so much for his country, and so much to illustrate, before that Country, the value of the Military Academy, should be familiar to every Cadet and had in remembrance by every Graduate, and I deem the present opportunity to obtain a delineation of them too favorable to be permitted to escape.

In addition to the academy's work, there are four similar versions. The largest – owned by the United States Soldiers' and Airmen's Home in Washington, DC, of which Scott was an early supporter – is almost a three-quarter-length composition, and includes a view in the background that may represent Mexico City. The other three are slightly smaller and virtually identical; which is the life portrait is not known. The freshness of execution and vividness of detail of the Gallery's version convey Weir's efforts to document the forceful personality of his sitter.

Bayard Taylor
(1825–78)
Author

Thomas Hicks, 1855
Oil on canvas,
622 x 756mm
(24½ x 29¾")
NPG.76.6

Bayard Taylor wrote popular travel books, as well as novels and poetry. As a student in Chester County, Pennsylvania, he studied foreign languages and literature. The publication of his first volume of verse in 1844 enabled him to travel to Europe on advances from a number of newspapers in exchange for publication rights to his letters. Returning to New York in 1846, he established a lasting relationship with Horace Greeley's *New York Tribune*, which sent him to California to cover the gold rush in 1849. In 1851 he went to the Middle East, India and China, and then to Japan as a member of Commodore Matthew Perry's expedition. Back in New York again, he published his most popular book of poetry, *Poems of the Orient* (1854), and the volumes that mark his zenith as a travel writer, including *The Lands of the Saracen; or, Pictures of Palestine, Asia Minor, Sicily, and Spain* (1855).

This portrait is by Taylor's friend Thomas Hicks (1823–90), nephew of Quaker artist Edward Hicks and a successful portrait painter in New York City. A member of the National Academy of Design, Hicks exhibited the work there in 1856 as *A Morning in Damascus*. He painted the city from Taylor's drawings. Taylor described his clothing, actually acquired in Egypt, when writing about Achmet, his servant on his Middle East travels:

I am now wearing one of his dresses: a green embroidered jacket, with slashed sleeves; a sort of striped vest, with a row of about thirty buttons from the neck to the waist; a large plaid silk shawl as belt; white baggy trowsers, gathered at the knee, with long, tight-fitting stockings and red morocco shoes.

While the painting was in progress, Taylor decided that Achmet should be included and borrowed a daguerreotype of him for Hicks to copy. Both artist and sitter were pleased with the portrait. Taylor proclaimed it 'one of the finest paintings you ever saw. Everybody is delighted with it, and I would not take any amount of money for it. [Hicks] says it is the best thing he has ever done.'

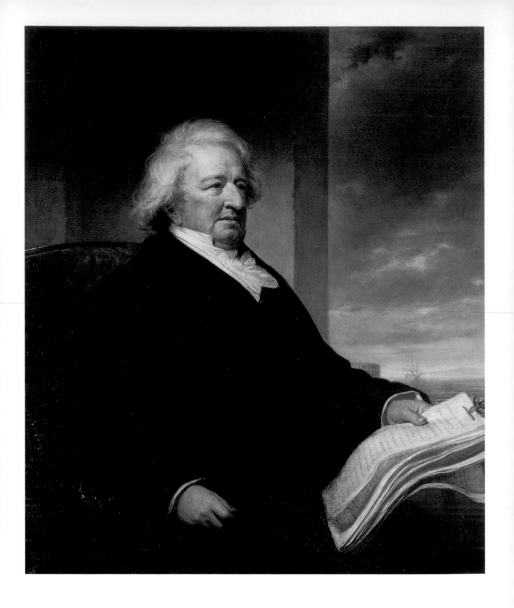

Gulian Verplanck
(1786–1870)
Author

Daniel Huntington,
1857
Oil on canvas,
1168 x 990mm
(46 x 39")
NPG.70.48

Politician and writer Gulian Verplanck, a descendant of early New York settlers, inherited considerable wealth. Having studied law, he was admitted to the bar in 1807. He was elected to the House of Representatives in 1824, served four terms and was pivotal in the 1831 establishment of improved copyright protection for authors. Unsuccessful as a mayoral candidate for New York City in 1834, he later returned to elected office when he served in the New York Senate from 1838 to 1841. A pre-eminent man of letters, he was a member of the Knickerbocker group of New York writers that included Washington Irving, James Fenimore Cooper and William Cullen Bryant, and with Bryant was co-editor of *The Talisman*, a literary magazine (1828–30). In 1847 he published his best-known work, *Shakespeare's Plays: With His Life*.

When Daniel Huntington (1816–1906) painted Verplanck's portrait, he was at the height of his career. Having studied with New York painters Samuel F. B. Morse and Henry Inman, he went to Europe, where he concentrated on portraiture and history painting before returning to New York in 1840. After a major exhibition of his paintings in 1850 had received critical praise, he increasingly took up portraiture, spending time in Europe again and especially Britain. A member of the National Academy of Design in New York from 1839, he was twice its president.

Huntington and Verplanck first met in about 1830, when they were members of the Sketch Club, an artists' group. More than twenty-five years later, Huntington painted Verplanck's portrait for the Commissioners of Immigration, the state board that oversaw immigration and provided relief for immigrants. Verplanck was one of the original commissioners and he served as president of the board from 1848 until his death. The portrait includes a view of New York harbour with Castle Garden, the primary point of arrival for immigrants. The first version of the portrait (whereabouts now unknown) was exhibited at the National Academy of Design. A replica Huntington made is probably the version exhibited at the *Exposition Universelle* in Paris in 1867. The Gallery purchased the replica from Verplanck's descendants.

William James
(1842–1910)
Philosopher

John La Farge,
c.1859
Oil on cardboard,
657 x 552mm
(25⅞ x 21¾")
Gift of William James IV
NPG.91.6

With a medical degree from Harvard (1869), William James began his working life as a teacher of physiology there. He gradually became interested in the new discipline of psychology and is generally regarded today as America's first psychologist. His leaning towards wide-ranging speculation drew him to philosophy as well and by the 1890s he was a leading exponent of the school of thought known as American pragmatism, which holds that truth can be derived only through experience and that, as human experience changes, so can truth.

From the spring of 1858 to September 1859, when the family was living in Newport, Rhode Island, William James and his younger brother Henry studied painting with American artist William Morris Hunt. In Hunt's studio they met John La Farge (1835–1910), who had recently been in Paris. Upon La Farge's arrival in 1859, William James reportedly told his brother, 'There's a new fellow come to Hunt's class. He knows everything. He has seen everything – paints everything. He's a marvel.' Henry James later wrote of La Farge, 'He was quite the most interesting person we knew.' The beginning of their long friendship is documented by this early portrait of William James in the act of painting; La Farge also painted a smaller profile of Henry James in 1862.

Apprehensive about William's 'attraction to painting' and hoping instead 'that his career would be a scientific one', the elder Henry James moved his family to Geneva in the autumn of 1859. However, William announced the following summer that he wished to return to Newport to paint in Hunt's studio and determine whether he could be an artist. As he told a friend, Charles Ritter, in July 1860, 'I shall know definitely whether I am suited to it or not. If not, it will be easy to withdraw. There is nothing on earth more deplorable than a bad artist.' He continued his studies with Hunt from October 1860 until the spring of 1861, then stopped. He later explained that, although he had skill as a draughtsman, he lacked the gift of visualisation, or thinking in images.

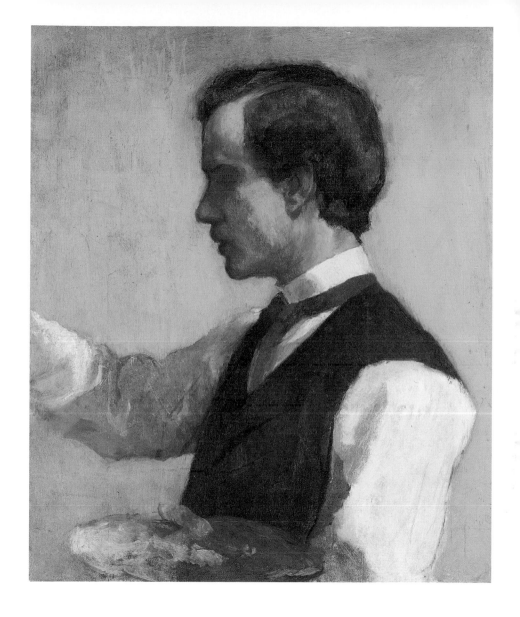

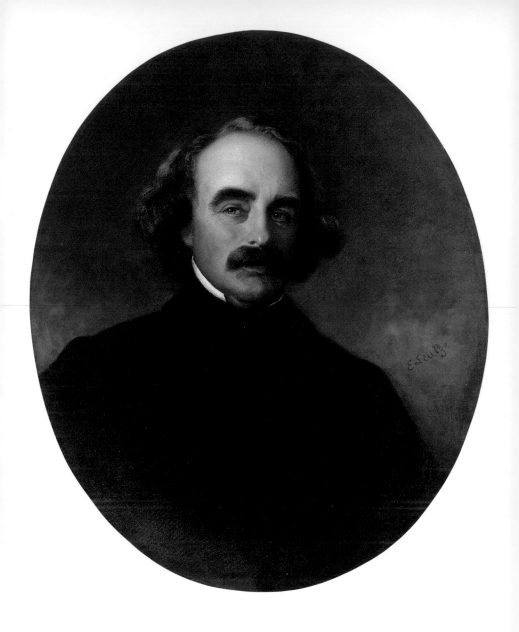

Nathaniel
Hawthorne
(1804–64)
Author

Emanuel Gottlieb
Leutze, 1862
Oil on canvas,
750 x 635mm
(29½ x 25") oval
Transfer from the
National Gallery of Art;
gift of Andrew W.
Mellon, 1942
NPG.65.55

Raised in Salem, Massachusetts, writer Nathaniel Hawthorne was steeped from youth in the Puritan traditions of his community. It was in this heritage, with its emphasis on original sin and piety, that he found the themes for much of his fiction. Among his most famous works are *The Scarlet Letter* (1850), a story of adultery set in the New England wilderness, and *The House of the Seven Gables* (1851), the plot of which centres on the curse of a falsely convicted witch from Salem's colonial past.

Emanuel Leutze (1816–68) painted this portrait in Washington, DC, in early April 1862, while he was at work on a mural for the United States Capitol called *Westward the Course of Empire Takes Its Way*. Hawthorne, in poor health, had come to Washington at the invitation of his Bowdoin College classmate Horatio Bridge. About the sitting he wrote to his wife:

I stay here only while Leutze finishes a portrait – which I think will be the best ever painted of the same unworthy subject...One charm it must needs have – an aspect of immortal jollity and well-to-do-ness; for Leutze, when the sitting begins, gives me

a first-rate cigar, and when he sees me getting tired, he brings out a bottle of splendid champagne...

He also described his visits to Leutze's studio in 'Chiefly About War Matters', an article he published in *Atlantic Monthly* in July. About the artist's now-famous mural, he wrote: 'The work will be emphatically original and American, embracing characteristics that neither art nor literature have yet dealt with, and producing new forms of artistic beauty from the natural features of the Rocky-Mountain region.' Seeing Leutze at work gave Hawthorne hope for the future of the country:

It was delightful to see him so calmly elaborating his design, while other men doubted and feared, or hoped treacherously, and whispered to one another that the nation would exist only a little longer...But the artist keeps right on, firm of heart and hand, drawing his outline with an unwavering pencil, beautifying and idealizing our rude, material life, and thus manifesting that we have an indefeasible claim to a more enduring existence.

Christian Schussele, 1862
Oil on canvas,
1305 x 1950mm
(51⅜ x 76")
Transfer from the National
Gallery of Art; gift of
Andrew W. Mellon, 1942
NPG.65.60

This painting by Christian Schussele (1824–79) was described in 1862 as showing 'the most distinguished inventors of this country, whose improvements…have changed the aspect of modern society, and caused the present age to be designated as an *age of progress*'. The subjects posed individually and were brought together in the artist's imagination. They are (*left to right*) Dr William Thomas Green Morton (1819–68), a dentist who developed anaesthesia; James Bogardus (1800–74), famed for his cast-iron buildings; Samuel Colt (1814–62), inventor of the revolving pistol; Cyrus Hall McCormick (1809–84), inventor of a mechanical reaper; Joseph Saxton (1799–1873), holder of patents for a hydrometer and an ever-pointed pencil; Charles Goodyear (1800–60), whose accidental discovery of 'vulcanisation' brought rubber into common use; Peter Cooper (1791–1883), designer and builder of the first successful locomotive in America; Jordan Lawrence Mott (1799–1866), developer of a coal-burning stove; Joseph Henry (1797–1878), first Secretary of the Smithsonian Institution, whose electromagnetic studies made the telegraph possible; Eliphalet Nott (1773–1866), who worked on the properties of heat for stoves and steam engines; John Ericsson (1803–89), designer and builder of the iron-clad battleship *Monitor*; Frederick Sickels (1819–95), whose inventions improved the steam engine; Samuel F. B. Morse (1791–1872), who invented the electric telegraph; Henry Burden (1791–1871), inventor of a machine making sixty horseshoes a minute; Richard March Hoe (1812–86), whose rotary press revolutionised the newspaper business; Erastus Bigelow (1814–79), who devised a power loom for patterned carpets; Isaiah Jennings (1792–1862), whose inventions included a threshing machine; Thomas Blanchard (1788–1864), the holder of a patent for a lathe to cut three-dimensional copies of a model; and Elias Howe (1819–67), recognised after much litigation as inventor of the sewing machine. In the background is a portrait of Benjamin Franklin, patron saint of US science and invention.

The first version was exhibited shortly after its completion and immediately engraved by Schussele's friend John Sartain. Schussele made this smaller version for Jordan Mott.

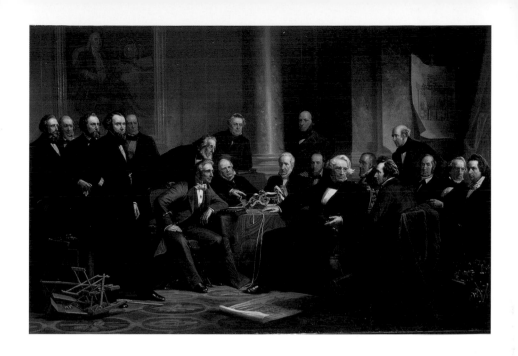

Orestes
Brownson
(1803–76)
Religious
philosopher

George Peter
Alexander Healy, 1863
Oil on canvas,
1461 x 1143mm
(57½ x 45")
NPG.79.207

Born and raised a Vermont Calvinist, Orestes Augustus Brownson spent his life on a religious pilgrimage that included Presbyterianism, Universalism, his own Society for Christian Union and Progress and, finally, Roman Catholicism. In his philosophical musings, he reflected the vitality and restlessness of pre-Civil War America. He wrote prodigiously about social reform, states' rights, nativism and emancipation, and demonstrated his versatility with the composition of mystical poetry. In 1844 he abandoned his intellectual life, concluding that anchorage lay with faith and authority, not reason. He converted to Catholicism and devoted his journal, *Brownson's Quarterly Review*, to the spread of Catholic doctrine. He recounted his inner experiences in *The Convert; or, Leaves from My Experience* (1857).

Brownson is seen looking out at the viewer with a directness that no doubt reflects the conversations about religion that he had with the artist during sittings. Healy (1813–94) painted the portrait in Chicago in winter 1863. According to his friend Eliza Allen Starr, 'Mr. Healy's portrait I consider little less than a miracle, which was replied to by Mr. Healy in this wise, "then it is a likeness, for Dr. Brownson is only less than a miracle." You know he is an enthusiastic admirer of Dr. Brownson.' A letter of 11 February 1863 from Healy to Brownson suggests he was working on two portraits, one for Brownson and one for himself, which he exhibited at the National Academy of Design in New York in 1863: 'After you left us I discovered I had the head too large for your body in my picture. I kept yours, & have repainted mine, which I now like & I hope you will also, when you see it in the N.Y. exhibition…'

The portrait here is the one the family owned. After Healy's death, his widow gave his copy to the Museum of Fine Arts, Boston. There are slight differences between the two, notably in the face of the sitter, which appears narrower in the former, and the position of the sitter's right hand, which in the latter is raised, resting on a walking stick.

William T. Sherman
(1820–91)
Union general

George Peter Alexander
Healy, 1866
Oil on canvas,
1588 x 972mm
(62½ x 38¼")
Transfer from the
Smithsonian American
Art Museum; gift of P.
Tecumseh Sherman, 1935
NPG.65.40

A pioneer of modern warfare, General William Tecumseh Sherman is a major figure in American military history. Named Tecumseh after the Shawnee chief, he graduated from the United States Military Academy at West Point in 1840. He began his Civil War career as a colonel, commanding a brigade in the first Battle of Bull Run in 1861. Promoted to brigadier general, he was assigned as General Robert Anderson's second-in-command in Kentucky and took over in October 1861 when Anderson broke under pressure. Appointed a divisional commander under Ulysses S. Grant, he distinguished himself in the Battle of Shiloh and was promoted to major general. As commander of the Military Division of the Mississippi, he captured Atlanta in September 1864. The fall of the city, a major industrial centre and rail hub, was a great blow to the Confederacy and was a significant factor in Abraham Lincoln's re-election in November. When Grant became president in 1869, Sherman succeeded him as commander-in-chief of the army.

Sherman's portrait was painted by George P. A. Healy (1813–94) in Chicago. The image of the victorious general is both heroic and contemplative. The Gallery's example, dated 1866, is one of three that are virtually identical. It belonged to Sherman, who commissioned a pendant portrait of his wife from Healy in 1868. When refusing Julian Alden Weir's request to sit for a new portrait in 1890, Sherman wrote to the artist, 'if there is any single thing on which I am resolved, it is never again to sit for a portrait or bust'. He described Healy's portrait, 'which is in my house here', as one of the two 'Standards', the other being a portrait by Daniel Huntington, and concluded, 'I have been caricatured by many, but have drawn the line.'

Healy painted Sherman again in 1868 for his *The Peacemakers on Board the River Queen*, depicting a historic meeting between Abraham Lincoln and his three military commanders – Sherman, Grant and Admiral David Dixon Porter – towards the end of the Civil War.

Edith Wharton
(1862–1937)
Author

Edward Harrison May,
1870
Oil on canvas,
730 x 597mm
(28¾ x 23½")
NPG.82.136

Chronicler of New York's élite and their 'power of debasing people and ideals', Edith Newbold Jones Wharton was perhaps the most celebrated American female author of her time. The youngest child of an affluent New York couple, she led an exciting life – winters in Paris, summers in Newport, Rhode Island, and the pick of New York's elegant gatherings. By the age of sixteen she had written her first novel, published several poems and developed a taste for, in her words, 'pretty clothes, pretty pictures, [and] pretty sights'. Preferring Europe to New York's 'intolerable ugliness', she spent much of her life in France. From there she surveyed her native country, the distance permitting poignant comments on American high society that manifested themselves in novels such as the Pulitzer Prize-winning *Age of Innocence* (1920). She shared a lifelong friendship with fellow expatriate novelist Henry James, who greatly admired her work.

British-born Edward Harrison May (1824–87) spent his childhood in New York, but eventually succumbed to the charms of Paris. In 1851 he entered the studio of Thomas Couture, painting portraits and submitting his works to the Paris Salon. Although he later devoted himself to history and genre paintings, his portraits remained highly valued and are an important part of his work.

Wharton was painted several times, starting when she was just three years old. May's portrait was probably completed in the latter half of the family's two-year stay in Paris (from 1866 to 1870 they divided their time between France, Germany, Italy and Spain). It conveys Wharton's privileged childhood and captures her during happy times in Europe, when she remembered being surrounded by things of 'immortal beauty and immemorial significance'. The image gives no hint of the problems that marked her adolescence, when her literary interests were deemed unsuitable by a mother with strict ideas about a young woman's role. In the early 1920s Wharton talked of having been a deeply anxious child because of her mother's coldness, and it was around the time of this portrait that she invented the intensely active form of 'making up' that provided her with a retreat.

Walter Greaves, 1870
Oil on canvas,
813 x 559mm
(32 x 22")
NPG.91.125

James Abbott McNeill Whistler had a peripatetic childhood. Born in Lowell, Massachusetts, from 1843 to 1848 he lived in Russia, where his father oversaw the construction of the Moscow to St Petersburg railway. The family returned to America when his father died and in 1851 Whistler entered the United States Military Academy at West Point. Attracted to art, he studied with painter Robert W. Weir there, but in 1854 Whistler was dismissed for failing chemistry. He worked briefly as a cartographer for the US Coast and Geodetic Survey, but, disenchanted with his lifestyle and wanting an artistic education, he left for France in 1855, never to return. At first he had formal training, but he soon decided to teach himself, absorbing influences from the richly textured world of contemporary French art. His 1862 painting *Symphony in White, No. 1: The White Girl* brought him to the art community's attention. Rejected from the annual exhibition at the Royal Academy in London and the official 1863 Paris Salon, it became a great attraction at the Salon des Refusés, the show held to exhibit work that did not meet academic standards. It was also his first major piece to focus on a purely artistic arrangement of forms,

'poetry of sight', rather than on specific descriptive or narrative details. Although art critic John Ruskin angrily accused him of flinging 'a pot of paint' in the face of the public, the artist had many champions in America and Europe, and influenced a number of artists.

Whistler first moved to London in 1859. When, in 1863, he settled in Chelsea, his neighbours included the Greaves family. Skilled boatmen, the sons, Walter (1846–1930) and Henry, had an interest in art. They escorted Whistler on his Thames painting trips and soon became his pupils. Devoted to their mentor, they adopted his painting style and manner of dress. Walter's numerous portraits reflect the esteem in which he held the charismatic artist. To the brothers' bitter disappointment, however, the relationship ended abruptly in about 1878, as Whistler's wife, Beatrice Godwin, did not approve of them.

Philip H. Sheridan
(1831–88)
Union general

Thomas Buchanan Read,
1871
Oil on canvas,
1372 x 987mm
(54 x 38⅞")
Transfer from the
National Museum
of American History;
gift of Ulysses
S. Grant III, 1939
NPG.68.51

General Ulysses S. Grant once said, 'as a soldier, as a commander of troops, as a man capable of doing all that is possible with any number', there was no one better than daring 'Little Phil' Sheridan. The head of Grant's cavalry from 1864, he demonstrated that prowess on 19 October the same year. Hearing that his troops were faring badly at the Battle of Cedar Creek in Virginia, he leapt on his favourite horse, Rienzi, and galloped thirty kilometres at breakneck speed to rally them. His arrival saved the day, turning almost certain defeat into victory.

Poet, painter and sculptor Thomas Buchanan Read (1822–72) spent much of the 1850s in Europe but returned from Rome to serve in the Union army. He wrote his famous poem, 'Sheridan's Ride', within two weeks of the event it celebrates. An expression of idealised heroism and support for the Union cause, it was a sensation in the North. After the war, the Union League of Philadelphia commissioned a life-size painting of Sheridan on his horse from Read, who made oil sketches of the general in New Orleans before returning in 1867 to Rome. There he executed several versions over four years. The Union League's was completed in 1869 and exhibited at the Pennsylvania Academy of the Fine Arts the next year. It reflects lines from Read's poem:

With foam and with dust the
 black charger was gray,
By the flash of his eye, and
 the red nostril's play,
He seemed to the whole great
 army to say:
'I have brought you Sheridan
 all the way
From Winchester down to
 save the day!'

According to the exhibition literature, it shows the 'resistless human WILL, before which all things material...give way. That, after all, is the moral and the lesson of Sheridan's Ride.' But the young Philadelphia artist Thomas Eakins, who saw a version in Paris, wrote to his father:

I never in my life saw such pretension united with bad work. You could not sell such a picture in an old rubbish store in Paris for 3 francs. Yet the man actually makes money out of his painting.

Mary Cassatt
(1844–1926)
Artist

Edgar Degas,
c.1880–84
Oil on canvas,
714 x 587mm
(28⅛ x 23⅛")
Gift of The Morris and
Gwendolyn Cafritz
Foundation and the
Regents' Major
Acquisitions Fund,
Smithsonian Institution
NPG.84.34

The child of a wealthy Pennsylvania banker, Mary Cassatt began her artistic training in Philadelphia at the Pennsylvania Academy of the Fine Arts. Eager to study abroad, she and her classmate Eliza Haldeman, accompanied by Cassatt's mother, left for Paris in December 1865. The following November she was admitted to the studio of Jean-Léon Gérôme, an academic painter known for his genre and history paintings. In 1870 the Franco-Prussian War forced her to return to America, but by 1872 she was back in Europe, first in Italy and later in Spain. She settled in Paris in 1874 and, apart from trips to America in 1898 and 1908, she lived abroad for the rest of her life.

Cassatt and Edgar Degas (1834–1917), one of the leading French Impressionists, became friends in the late 1870s. The exact circumstances of their meeting are unknown, but around 1877 Degas suggested that she participate in future Impressionist exhibitions, which she did in 1879, 1881 and 1886. Also in 1877 Cassatt recommended a painting by Degas to a close friend, American collector Louisine Elder (later Havemeyer). The two artists remained lifelong friends and, although their relationship had its tempestuous moments, in the late 1870s and early 1880s Degas was closely involved with Cassatt's work. Under his guidance, she adopted the fresh colours and effects of light so central to Impressionism and began to employ a more animated compositional structure in the domestic scenes for which she is so well known. Intrigued by Degas's etchings and by Japanese woodcuts, she also became a masterful printmaker. As a token of their friendship, Degas portrayed Cassatt several times.

Judging from her appearance, this painting was probably done in the early 1880s. Its free brushwork and muted colour also relate closely to Degas's other work from the period. While Cassatt admired its artistry, she was displeased with her pose and seriousness. She owned the painting until at least 1913, when she asked a Paris dealer to sell it, making sure it did not go to an American collection, where friends and family might see it.

Francis Bret Harte was born in New York State, but in 1854, after the death of his father, the family moved to northern California. In 1857 he settled in San Francisco, where he composed type for the magazine *Golden Era*. Clever sketches of frontier life, submitted anonymously at first, attracted the attention of the editor, who then hired him. In 1864 he was made secretary of the US Mint's branch in San Francisco, a political appointment that allowed him more time for his literary efforts. He headed east in 1871 and initially found himself lionised in both Boston and New York. Regrettably, he never felt any real kinship with the crude, rough-hewn world he portrayed, and his later stories were pale reflections of the originals. A restless soul, he became US commercial agent in Krefeld, Germany, in 1878 and in Glasgow in 1880. When his government appointment ended in January 1885, he moved to London, remaining there for the rest of his life.

Scottish artist John Pettie (1839–93) showed exceptional talent as a young man and enrolled in 1856 at the Trustees' Academy in Edinburgh to study with painter Robert Scott Lauder. He concentrated on historical genre painting, which took its subjects from British history, literature and legend. He first exhibited at the Royal Academy in London in 1860 and, encouraged by his reception, moved to the capital in 1862. Prolific, industrious and popular, he was made a full member of the Royal Academy in 1873. In his later years he turned to portraiture with great success, often painting his friends in historical costume. Harte and Pettie seem to have become friends shortly after the writer's arrival in London. Pettie, who was known for his ability to capture a likeness rapidly, spent many sessions with Harte because the two so enjoyed each other's company. The artist was proud of this portrait, which he gave to Harte, for he exhibited it at the Royal Academy in 1885 and the Jubilee exhibition in Berlin in 1886.

H. H. Richardson
(1838–86)
Architect

Sir Hubert von
Herkomer, 1886
Oil on canvas,
1092 x 1422mm
(43 x 56")
On extended loan
from Mrs Henry H.
Richardson III
L/NPG.1.99

Born in Priestley Plantation, Louisiana,
Henry Hobson Richardson decided to
become an architect while at Harvard
University. As there were then no
architecture schools in America, he
went to Paris, studying there between
1860 and 1862. He remained in France
for three more years, working for
French architect Théodore Labrouste.
He then returned to America and in
1867 formed a partnership with Charles
D. Gambrill in New York City. His career
spanned little more than two decades,
but in that time he became the most
admired American architect of his day,
and he remained a dominant influence
well after his death. One of his most
celebrated accomplishments is Boston's
Trinity Church (1872–7): a key building
using the Romanesque Revival style
for which he became famous, it won
numerous awards. The success of this
church brought many clients in the
region and in 1874 Richardson moved
his practice to the Boston suburb
of Brookline, where he established a
home and studio. He was responsible
for some of the finest examples
of nineteenth-century commercial
structures in America and numerous
railway stations in the Northeast.
Equally noteworthy were many of his

private homes, where he demonstrated
a genius for adapting his designs to the
requirements of the site.

The English painter Sir Hubert von
Herkomer (1849–1914) was on his second
painting expedition to America when he
produced this likeness in Richardson's
Brookline studio. A prize-winning artist
in England, he first attracted attention
in America when his work was shown
in the British section at the 1876
Philadelphia Centennial Exposition,
receiving favourable comment. While
painting the portrait, which was
completed in about nine hours over
two or three sittings, Herkomer noted
in his diary that Richardson was 'as
solid in his friendship as in his figure.
Big-bodied, big-hearted, large-minded,
full-brained, loving as he is pugnacious'.
In the background are objects from the
sitter's collection, including a blue vase
still in the possession of his heirs. In
payment for the picture, Richardson
drew up exterior designs for a house
for the artist that was built in the 1890s.

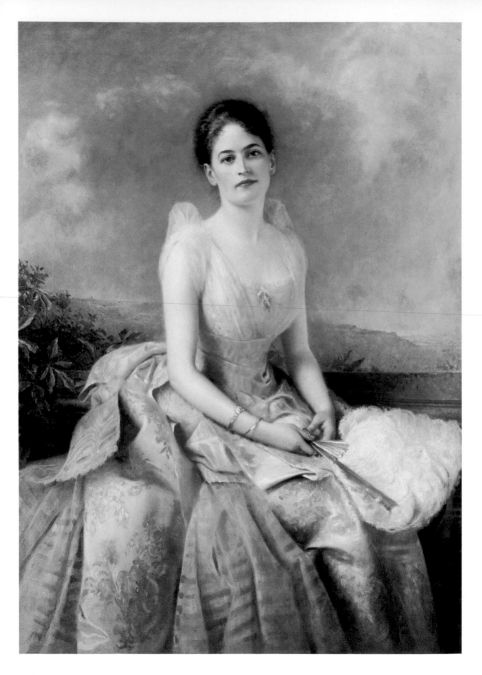

Juliette Gordon Low
(1860–1927)
Founder of the Girl
Scouts of America

Edward Hughes, 1887
Oil on canvas,
1323 x 971mm
(52⅛ x 38¾")
Gift of the Girl Scouts
of the United States
of America
NPG.73.5

Admired for her charm and vivacity, Juliette Gordon Low, or 'Daisy' as she was known to her southern family, was a model nineteenth-century débutante. Expensively educated and widely travelled, she sealed her aristocratic status in 1886 by marrying William Mackay Low, the wealthy son of a family well established on both sides of the Atlantic. She spent most of her nine-year marriage in Britain, mixing with the cream of society, but with the loss of her husband, her marriage and her pride – William Low died in 1905, before the couple's impending divorce, leaving his entire estate to his mistress – she sank into a deep depression. She began to reappraise her life and found a new purpose when she met General Sir Robert Baden-Powell, founder of the Boy Scouts. Inspired by his example, she organised her first group of scouts among poor girls living near her estate in Scotland in 1911. She formed two groups in London and one in her home town, Savannah, Georgia, the following year. Troops sprang up rapidly across the United States. Having been forced by circumstances to abandon one way of life, Low committed herself with unalloyed zeal to her troops and the Girl Scouts of America, an organisation in the vanguard of the suffrage movement.

London artist Edward Hughes (1832–1908) was awarded the silver medal of the Royal Society of Arts at only fourteen. He became an exceedingly popular portrait painter, with commissions including the Prince of Wales, his brother Prince Albert and his sister Princess Mary. William Low asked Hughes to paint his new bride's portrait just after the couple's move to England in 1887. She is the image of demure femininity. Her privileged status – she would be presented to Queen Victoria in two years' time – is made clear by her elaborate gown, her ostrich-feather fan and her simple yet elegant bracelets. Of the painter's work, Sir John Everett Millais said, 'Very many artists can paint the portrait of a man, but very few can paint the portrait of a lady, and Edward Hughes is one of those few.'

Talcott Williams
(1849–1928)
Journalist

Thomas Eakins, 1889
Oil on canvas,
622 x 508mm
(24½ x 20")
Gift of the Kate and Laurens
Seelye family and the
James Smithson Society,
and Gallery purchase.
Acquisition made
possible by a generous
contribution from the
James Smithson Society
NPG.85.50

Endowed with wide-ranging intellectual curiosity, Talcott Williams began his career in journalism in the early 1870s and in 1881 was named an editor of the *Philadelphia Press*. A notable political journalist, he also wrote penetrating reviews on art, literature and drama. In 1912 he became the first director of the Columbia School of Journalism, setting high standards and constantly reiterating his conviction that good journalism required not only writing ability but also a wide breadth of knowledge.

During the 1880s Williams made the acquaintance of the Philadelphia-born, French-trained painter Thomas Eakins (1844–1916) and in 1887 took him to nearby Camden, New Jersey, to meet the venerable poet Walt Whitman. Whitman recounted their meeting to a friend: '[Eakins] came over with Talcott Williams: seemed careless, negligent, indifferent, quiet: you would not say retiring, but amounting to that.' Eccentric and indifferent to social niceties, Eakins often asked his friends and acquaintances to pose but rarely sought or accepted commissions. His portraits were not necessarily conventional and Williams's wife, for one, stopped posing for Eakins when her portrait was far from complete because it did not conform to her idea of a proper, fashionable image. Nevertheless, when he painted persons of accomplishment and determination in the worlds of science, the arts, education and even sport, he often found kindred spirits who appreciated his work. Certainly Talcott Williams must have approved of this portrait, for, according to his wife, he gave the painter more than fifty sittings.

In his many bust portraits of friends, Eakins is noted for the variety of treatment and composition he was able to achieve in this limited format. In the painting here, for which Williams sat in the autumn of 1889, the artist has used a meticulous rendering of detail and dramatic lighting to animate his subject. By depicting Williams with an expression of intense concentration, his mouth open as though in conversation, he succeeds in suggesting the energy, quick wit and lively intelligence of his subject, who was known among friends as 'Talk-a-lot' Williams.

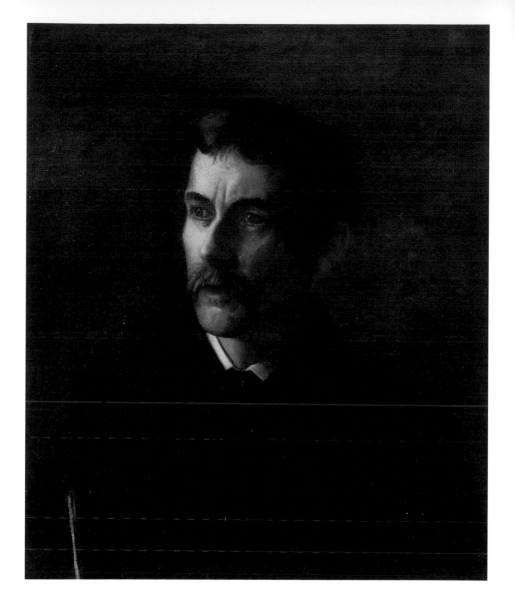

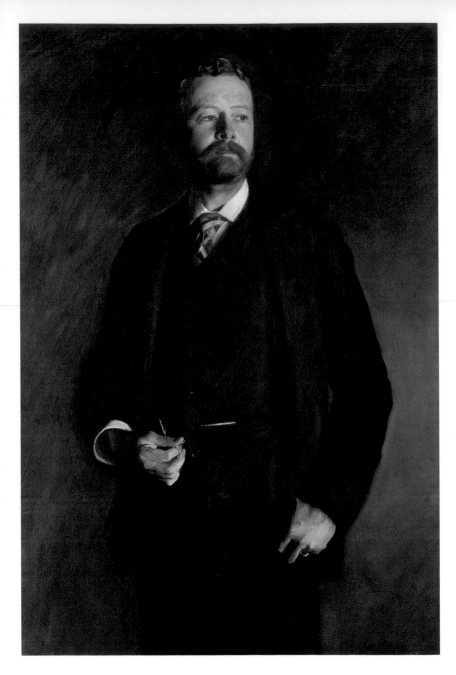

Henry Cabot Lodge
(1850–1924)
Statesman

John Singer Sargent,
1890
Oil on canvas,
1270 x 864mm
(50 x 34")
Gift of the Honorable
Henry Cabot Lodge
NPG.67.58

Henry Cabot Lodge exuded all the confidence that his distinguished New England ancestry, Harvard education and wide circle of wealthy, influential friends bestowed. In 1887, armed with these crucial assets, he began his career in Congress, where he quickly became a power in the Senate and one of the Republican Party's most respected leaders. In the early phase of his public life, Lodge, who saw himself as a statesman rather than a mere politician, joined with his close friend Theodore Roosevelt in espousing a larger role for America in world affairs and was central in the build-up of the country's navy. Ironically, however, he is best remembered for successfully spearheading Senate blockage of membership of the League of Nations after the First World War, on the grounds that it threatened American sovereignty. Thus the man who had prepared his country for international leadership was ultimately regarded as an isolationist.

John Singer Sargent (1856–1925) was born in Florence to parents who had left Philadelphia for a fashionable life in Europe. Having studied art briefly in Italy, he entered the Paris studio of Carolus-Duran in 1872 and was well established as a portraitist by the early 1880s. He was an ideal choice to paint Lodge, as they came from the same aristocratic world. The two met during Sargent's second trip to America, which began in 1889. Sargent, who had established a New York studio, was a frequent visitor to Boston, where he was working on the murals in the Public Library. In August 1890 he travelled to Nahant, the élite summer colony just north of Boston, and there he befriended Lodge, who then sat for him. The resulting portrait has an aloofness that often typifies Sargent's likenesses of wealthy individuals. In Lodge's case, this is a fairly accurate reflection of the 'unapologetic superiority' with which he carried himself, but it does not tell the whole tale, for Lodge was also a champion of the disenfranchised. Shortly before the 1890 congressional summer recess, for example, he had given a rousing if unsuccessful speech defending the right of blacks to vote.

Paul Wayland
Bartlett
(1865–1925)
Sculptor

Charles Sprague Pearce,
c.1890
Oil on canvas,
1086 x 762mm
(42¾ x 30")
Transfer from the
Smithsonian American
Art Museum; gift of
Caroline Peter (Mrs
Armistead Peter III), 1958
NPG.65.20

Born in New England, Paul Wayland Bartlett was sent to Paris at the age of nine because his father, the sculptor and art critic Truman H. Bartlett, considered it the only place to get the artistic education he wanted for his son. The young Bartlett, who studied with sculptors Emmanuel Frémiet and Auguste Rodin, had a bust of his grandmother exhibited at the prestigious Salon des Beaux-Arts when he was only fourteen and the following year entered the École des Beaux-Arts. He made a name for himself early on with his animal studies, especially *Bear Tamer*, a bronze of a man standing over two cubs, which received honourable mention at the 1887 Salon. When exhibited in Chicago at the 1893 World's Columbian Exposition, it brought him recognition in America for the first time. In the late 1890s his heroic bronze statues of Michelangelo and Christopher Columbus, executed for the rotunda of the Library of Congress, were well received. Around 1900 he began to experiment with architectural ensembles of sculpture. Among the best known are the six allegorical figures he created for the New York Public Library and the sculpture for the pediment of the House of Representatives' wing of the United States Capitol.

In 1873 the Boston-born artist Charles Sprague Pearce (1851–1914) came to Paris, where he spent three years in the studio of famed portrait painter Léon Bonnat. Pearce settled in Auvers-sur-Oise in 1885, just after his first real success at the Salons. He was known for his landscape and figure subjects, particularly pensive women alone in rustic landscapes. The meticulously painted figures were often placed against a more loosely brushed background with muted colours. This portrait of his friend Bartlett grew from their mutual affection; Bartlett is said to have made a bust of Pearce at about the same time. Pearce depicts Bartlett in a dramatic profile pose, cigarette in hand, and affecting a loose tie, a detail of dress often associated with artists in the late nineteenth century. The portrait captures both the Gallic insouciance of Bartlett's bearing and the pensive, almost melancholy side of his nature, but nothing about the profession in which he gained his reputation.

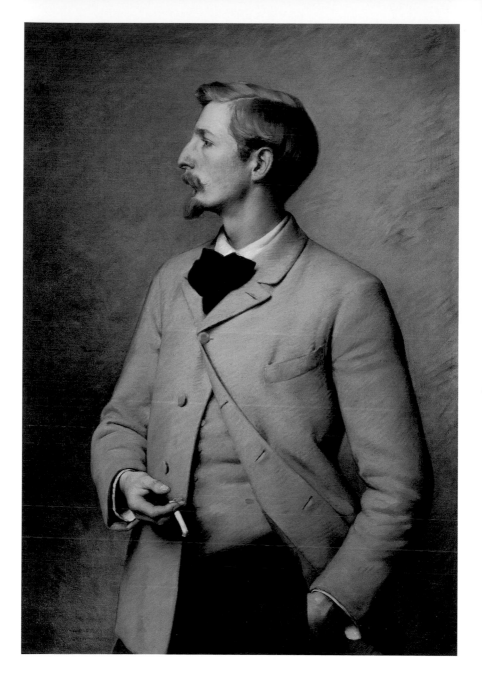

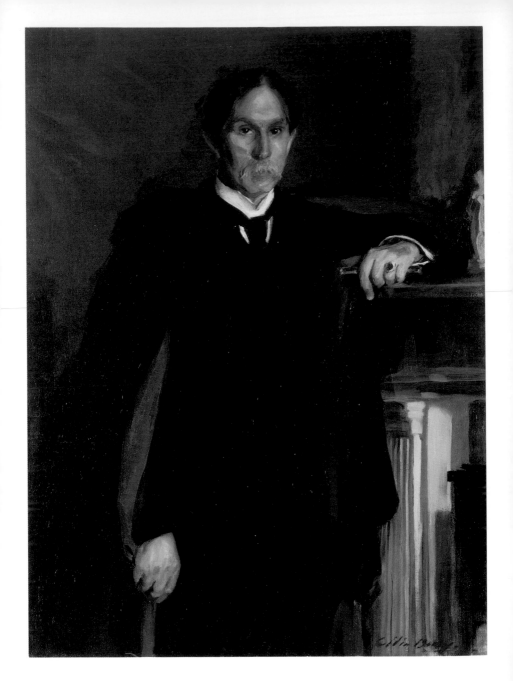

Richard Watson
Gilder
(1844–1909)
Editor, poet

Cecilia Beaux, 1902–3
Oil on canvas,
1165 x 876mm
(45⅞ x 34½")
Gift of Rodman and
Mary Ellen Gilder
NPG.98.77

For nearly three decades Richard Watson Gilder held one of the most prestigious and influential positions in American publishing: editor-in-chief of the *Century Monthly Magazine*. Having begun his career in journalism at the age of twenty, in 1869 he became editor of Charles Scribner and Company's *Hours at Home* and in 1870 was promoted to assistant editor of its more ambitious replacement, *Scribner's Monthly Magazine*. For more than ten years he contributed to the journal's growth, championing the early efforts of realism and acknowledging the genius of Walt Whitman when most of literary New York rejected him. Promoted to editor-in-chief of the newly renamed *Century Monthly Magazine* in 1881, he remained committed to elevating the status of American literature. He printed excerpts from Mark Twain's *Huckleberry Finn* before the book was published and kept petitioning Henry James for contributions, until the unsuccessful serialisation of *The Bostonians* in 1885–6. He and his wife, the artist Helena de Kay, hosted Friday-evening gatherings for artists, writers and musicians at their Manhattan residence, exerting considerable influence on New York's cultural scene.

Recognised with numerous awards during her lifetime, Cecilia Beaux (1855–1942) was one of America's most sought-after portraitists. She trained at the Pennsylvania Academy of the Fine Arts and at the Académies Julian and Colorossi in Paris. Her portraits are noted for their calculated but seemingly spontaneous craftsmanship and their strong, self-assured quality. The Gilders were close friends and she stayed with them in New York for a brief period during the 1890s, benefiting greatly from the contacts she made there. Gilder also published several of her portrait sketches in the *Century*. Beaux began this portrait in her Washington Square studio in 1902. To contemporary viewers, the sympathetic rendering of the editor conveyed the close rapport that existed between sitter and artist. In 1910 a critic in *The Craftsman* praised the 'affection and understanding' with which Beaux rendered her friend. Certainly the artist must have been satisfied with her work, because she painted a replica thirty years later, when her painting activities had virtually ceased.

Samuel L. Clemens
(Mark Twain)
(1835–1910)
Author

John White Alexander,
c.1902
Oil on canvas,
1917 x 914mm
(75½ x 36")
NPG.81.116

Better known by his pen name, Mark Twain, satirist Samuel Langhorne Clemens spent much of his youth in Hannibal, Missouri, the Mississippi River town that inspired much of his writing. After earning his living as a gold prospector, a river pilot and a newspaper reporter, he published his first major work of fiction, *The Celebrated Jumping Frog of Calaveras County and Other Sketches*, in 1867. With *The Innocents Abroad* (1869), a mocking account of his trip to the Mediterranean and the Holy Land, his reputation as a humorist was secure. He continued to draw on his experiences for material and his three next works – *Roughing It* (1872), *The Gilded Age* (1873) and *The Adventures of Tom Sawyer* (1876) – were all set in the West of his youth. His greatest critical success came with *The Adventures of Huckleberry Finn* (1884), which, like *Tom Sawyer*, recalled his boyhood in Hannibal.

Originally from western Pennsylvania, John White Alexander (1856–1915) moved to New York City in 1875 to work as an illustrator for *Harper's Weekly*. In about 1877 he joined a group of Americans studying at the Royal Academy in Munich and in 1879 went with some of them to Venice and Florence. There he met the painter James McNeill Whistler, whose softly focused and tonally restricted work would prove important in the development of his own style. He went back to New York in 1881, where he taught and worked as an illustrator and portraitist. In 1891 he moved his family to Paris, where he spent a productive decade creating decorative, carefully composed images of women. Returning to America in 1901, he continued with fashionable portraiture and his more poetic compositions. The precise circumstances of Clemens's sittings are not known. Alexander did, however, paint Clemens's daughter Clara in Paris between 1898 and 1900 and was in touch with the author as late as 1905, since he was invited to his seventieth birthday party. Alexander chose an animated pose for the ageing raconteur, opting for a decorative use of darks and lights, together with long, sweeping brushstrokes, to characterise his inherent energy.

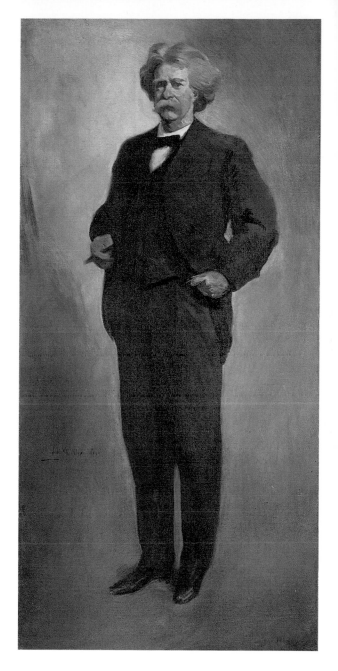

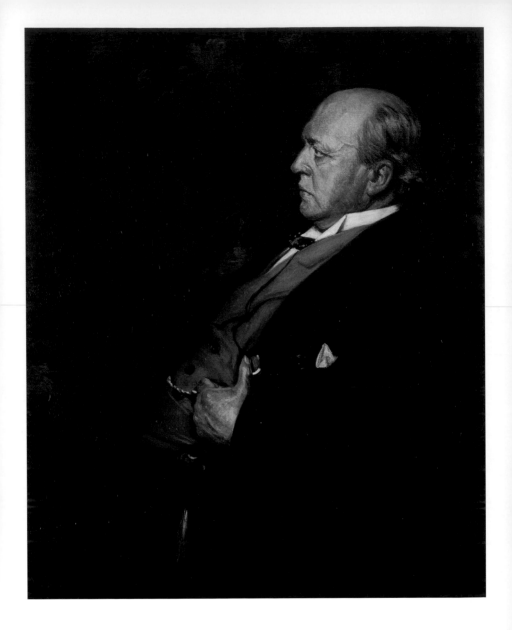

Henry James
(1843–1916)
Author

Jacques-Émile
Blanche, 1908
Oil on canvas,
996 x 813mm
(39¼ x 32")
Bequest of Mrs
Katherine Dexter
McCormick
NPG.68.13

The son of a wealthy New Yorker who was determined to give his children a cosmopolitan education, Henry James spent much of his childhood in Europe. As a student at Harvard from 1861 to 1865, he met author and editor William Dean Howells, who encouraged his literary talents and convinced him to make writing his career. In 1876 James settled in England, where he began a series of novels dealing with relationships between Europeans and Americans and the moral questions such encounters created, including *Roderick Hudson* (1876), *The American* (1877), *Daisy Miller* (1879) and *Portrait of a Lady* (1881). He reached the height of his literary craftsmanship with the publication of three of his most elaborately structured works, *The Wings of the Dove* (1902), *The Ambassadors* (1903) and *The Golden Bowl* (1904).

Like James, Jacques-Émile Blanche (1861–1942) moved in affluent, fashionable circles. Although he claimed to have had very little formal artistic education, he counted James McNeill Whistler, Walter Sickert and Edgar Degas among his acquaintances. This portrait was painted at a time when James was busy preparing a collected edition of his fiction, an arduous task that, he said, 'paralyzed' him. In April 1908, however, he travelled to France to visit his old friend Edith Wharton, at whose suggestion he agreed to pose for Blanche. The artist's initial, full-face portrait did not please either him or his sitter; James worried that it made him look 'very big and fat and uncanny and "brainy" and awful'. Blanche then painted this second, profile, likeness, completing it in time for a London exhibition that autumn. Blanche described it thus:

a Poet-Laureate, with a faraway, meditative look, against a William Morris wallpaper of gilded vine leaves and grape clusters – the sort you'd find in the study of an Oxford or Cambridge don.

Edith Wharton thought it the 'only one that renders him as he really was', and even James felt it had 'a certain dignity of intention and indication – of who and what, poor creature, he "is"!'

Lee Simonson
(1888–1967)
Scenic designer

Self-portrait,
c.1912
Oil on canvas,
1019 x 816mm
(40⅛ x 32⅛")
Gift of Karl and Jody
Simonson
NPG.77.239

From an early age it was clear to Lee Simonson, a major force in American set design, that painters and designers had a vital role to play in bringing theatre to life. Raised in a family that valued the arts, he attended Harvard, where he was able to pursue his twin interests in painting and drama. After graduating in 1909, he went to Paris, hoping to become a mural painter. There he studied painting and formed friendships with such expatriate Americans as writer and collector Gertrude Stein and painter Stanton MacDonald-Wright. He also attended some of the most experimental European theatrical productions. He returned to New York in 1912, determined to launch his career as a set designer.

After the First World War was over, he co-founded New York's Theatre Guild in 1919 and, with his friend Lawrence Langner and others, began twenty-one years of design production for them, working on more than seventy-five stage productions. After resigning his directorship in 1940, he went on to create sets for the opera and museum exhibitions and also to publish his memoirs, various essays and several volumes on theatre design. The business of a stage designer, he believed, was 'not to create a work of art that can be judged as having a life of its own as a more or less beautiful picture but to bring to life the world as pictured by the play'.

Simonson may still have been in Paris when he painted this self-portrait. With its areas of pure, vibrant colour, it is similar to a now-lost portrait of Stanton MacDonald-Wright and Simonson that the former painted at this time. Both men were acquainted with avant-garde European trends in painting, writing and drama. They admired Post-Impressionist painters such as Cézanne and Gauguin, as well as many of their French contemporaries, and saw that the arts were in a period of transition. Ultimately, MacDonald-Wright chose to explore colour abstraction, while Simonson left easel painting behind altogether and concentrated on bringing the vision of a modern painter to the American stage.

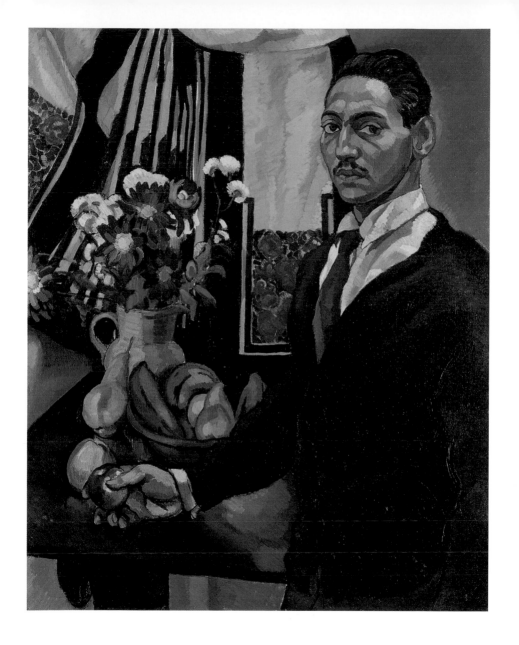

121

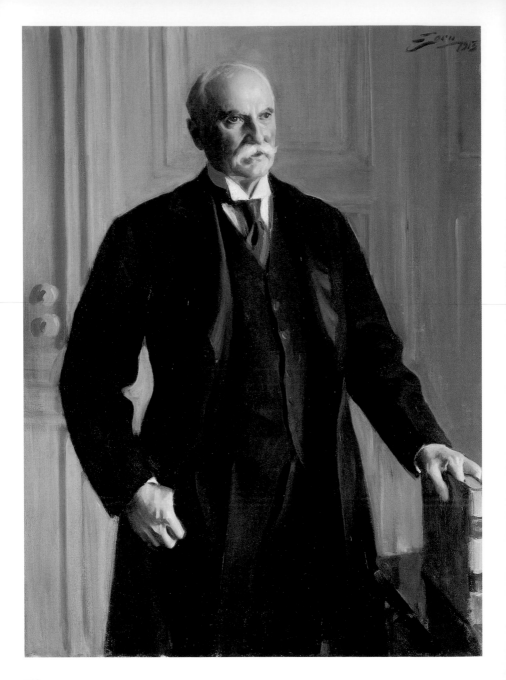

Nelson Aldrich
(1841–1915)
Statesman

Anders Leonard Zorn,
1913
Oil on canvas,
1308 x 978mm
(51½ x 38½")
Gift of Stephanie
Edgell in memory of
Elsie Aldrich Campbell
NPG.69.85

Essentially a self-made man, Nelson Wilmarth Aldrich rose from service in the Civil War and partnership in a wholesale grocery business to become one of Rhode Island's foremost financiers and the leading spokesman of Old Guard politics during the McKinley, Roosevelt and Taft administrations. He championed the industrial and financial interests of the Northeast, holding firm to the notion that what was good for big business was good for the nation. A consummate strategist, he was known for his undaunted courage, indifference to public opinion and enjoyment of a fight. He served in the Senate for thirty years, thwarting Democratic progressivism, lobbying for banking reform and paving the way for the creation of the Federal Reserve System, which regulates America's monetary system to this day.

The Swedish painter, etcher and sculptor Anders Zorn (1860–1920) first appeared on the American scene in 1893, when he was appointed Swedish commissioner to the *World's Columbian Exposition*. Well travelled and personable, he soon entered the inner circles of America's rich and famous. Presidents Taft, Roosevelt and Cleveland were among the important statesmen he painted during his seven visits to the United States. In these and other works, critics usually praised his impressionistic style and his ability to capture the momentary expressions of his sitters. 'Of all the sitters I ever had,' Zorn confessed, 'Senator Aldrich is the most difficult because of the expression of his eyes – it is so hard to get.' His failure to capture what has been called the 'tense alertness of a thoroughbred race horse' may have been why Zorn's first attempt at creating the senator's likeness, in 1911, was rejected by the family. Painted just after Aldrich's return to Washington following a brief recuperative stay on Jekyll Island, it may have reflected some sense of the senator's faltering health. Zorn's second portrait, begun in Paris the following year while Aldrich was on a book-buying trip to Europe, was more successful. Depicted at the age of seventy-two, two years after his retirement from the Senate, Aldrich here seems to embody all the intrepidity his peers remarked upon.

Willard Huntington
Wright
(S. S. Van Dine)
(1887–1939)
Author

Stanton MacDonald-Wright,
1913–14
Oil on canvas,
914 x 762mm
(36 x 30")
Acquisition made
possible by a generous
contribution from the
James Smithson Society
NPG.86.7

Having begun his career writing book reviews for the *Los Angeles Times*, in 1911 Willard Huntington Wright moved to New York and was soon editing *The Smart Set.* He sought contributions from writers such as D. H. Lawrence, W. B. Yeats and Theodore Dreiser in an effort to transform this monthly magazine from a fashionable repository for light satire, poetry and short stories into a more serious literary journal. An art critic, he championed modernist trends in *Modern Painting* (1915) and *The Future of Painting* (1923) and also published several volumes on philosophy. Confined to his bed for two years after a nervous breakdown, he discovered an interest in writing detective fiction. His first effort, *The Benson Murder Case* (1926), sold out in a week and over the years similar successes followed, so that today he is best remembered for these stories, written under the name S. S. Van Dine.

A label on the back of the canvas, 'Paris 1913/14', suggests this portrait may have been started while Wright was visiting the artist, his brother, in Paris during the summer and autumn of 1913, and finished when they returned in April 1914, after a short stay in New York. They remained in Europe until the outbreak of war in August 1914.

Stanton MacDonald-Wright (1890–1973) had moved to Paris in 1907, attending classes taught by the Canadian E. P. Tudor-Hart. There he learned much about modern painting and colour theory, and met artist Morgan Russell, with whom he developed a type of abstraction, based solely on colour and shape, called Synchromism. This portrait of his brother is unlike any of his Synchromist works, but it does reveal his interest in Cézanne's style, with its colours laid on in broad, flat planes. The careful, rhythmic balancing of primary and secondary colours also suggests that he was aware of the work of the Fauves. Although the portrait's style is very contemporary, the likeness is traditional in its depiction of a writer lost in contemplation, seated at his desk and surrounded by books.

Francis P. Garvan
(1875–1937)
Collector

Philip Alexius de
László, 1921
Oil on canvas,
762 x 635mm
(30 x 25")
Gift of Mrs. Anthony
Nicholas Brady Garvan
NPG.96.131

A prominent collector of early American paintings, prints and decorative arts, Francis Patrick Garvan had faith in the moral value of art patronage. After attending Yale University and New York University Law School, he was appointed assistant to the district attorney of New York County in 1901 and headed up the Homicide Bureau. In 1910 he entered private practice and in 1914 became chief of the US Bureau of Investigation in New York. As Alien Property Custodian in Washington, DC, he discovered that most chemical patents in the country were held by foreigners, especially Germans, so in 1919 he founded the Chemical Foundation to encourage research and strengthen America's chemical industry. On his marriage in 1910 to Mabel Brady, the daughter of a wealthy entrepreneur, he turned to art collecting. The couple began buying antique English furniture while on honeymoon but, after discovering several fakes, began to collect American objects exclusively. 'I had eight years' experience in the District Attorney's office here in New York,' Garvan said, 'and I try every piece as I would a murderer. It must be proved innocent of every charge that can be brought against it before I accept it.' By his

death, he had given Yale University some 10,000 objects of American painting, prints, silver, pewter, furniture and other decorative arts, and to this day the Mabel B. Garvan collection at Yale is one of the most comprehensive collections of early American arts and crafts.

The Hungarian artist Philip Alexius de László (1869–1937) trained in Budapest, Munich and Paris. He exhibited widely in Europe, winning gold medals at the 1899 and 1900 Paris Salons. In 1907 he settled in England, quickly establishing a reputation for his portraits of kings, emperors and society dignitaries. In spring 1921 he paid a three-month visit to the United States, where the Garvans were among his clients. He painted an enormous family portrait of Mrs Garvan and her four children as well as this portrait of the family patriarch. The loose handling of paint and the bright palette provide a sense of active, unsullied optimism that is evocative of Garvan's personality.

Thomas Hart
Benton
(1889–1975)
with his wife, Rita
Artist

Self-portrait, 1922
Oil on canvas,
1257 x 1016mm
(49½ x 40")
Gift of Mr and Mrs
Jack H. Mooney
NPG.75.30

This double portrait depicts the artist and his wife, Rita Piacenza Benton, on South Beach, Martha's Vineyard, Massachusetts, where they spent many summers. Although the subjects are casually attired, their monumentality and the intensity of their expressions suggest that this was intended as a commemorative work, perhaps a marriage portrait, since it was painted in the year they were married. In the quiet atmosphere of his summer house there, Benton was able to break away from the modernist abstraction that had interested him earlier in his career and forge his own representational, sculpturally conceived style.

Born in the Midwest, he received his formal training at the Art Institute of Chicago and, after 1909, in Paris, where he absorbed current avant-garde theories of painting. On his return to New York, he joined the American Synchromists, a group of artists concerned with the explication of form through colour. His own distinctive style emerged only after he became a draughtsman in the navy in 1919. His accurate drawings of naval yard activities and a growing interest in American history and culture led him to advocate and make naturalistic paintings of American subjects. Travelling around the country, he absorbed and sketched his impressions of everyday life in small towns, farm country and elsewhere. The resulting memories and sketches formed the basis for his numerous paintings and public murals. In 1933 he won a gold medal from the Architectural League of New York for his work in mural painting, an art form that underwent a powerful revival in the Depression thanks to government subsidies.

In order to develop a style of representational solidity and articulation, Benton combined his contemporary sense of abstract composition with a study of sixteenth-century Italian Renaissance technique, including the practice of making small, three-dimensional clay models of his compositions. These studies honed the skills that he needed to paint pictures such as this double portrait, an early example of his mature style, and to paint the landscapes and genre scenes that made him America's foremost regionalist painter during the 1930s.

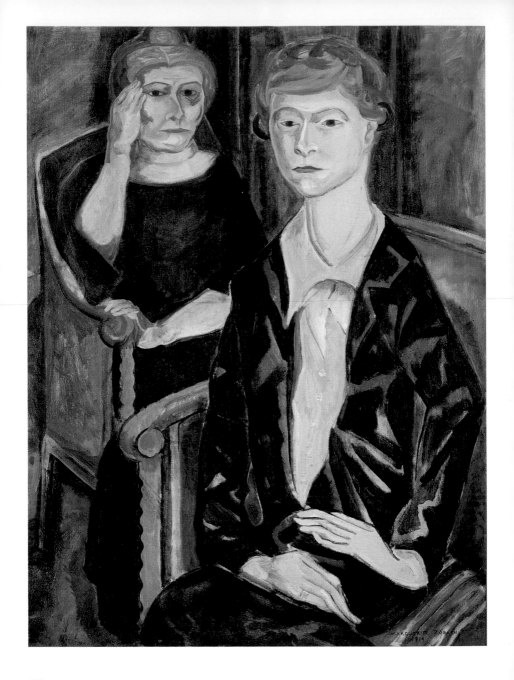

Marguerite Zorach,
1925
Oil on canvas,
1022 x 762mm
(40¼ x 30")
NPG.87.217

The recipient of virtually every major literary award the United States had to offer, including the Pulitzer Prize and the National Book Award, Marianne Moore was acclaimed by such contemporaries as T. S. Eliot for the 'original sensibility and alert intelligence' of her poetry. Her innovative, witty and often ironic verse, using unconventional metrical schemes and concerned with such no-nonsense virtues as courage, loyalty and patience, secured her a leading position among modernist writers. Indeed, her status among the artists and authors living in Greenwich Village, New York, during the 1920s prompted poet William Carlos Williams to proclaim her their 'saint'.

Marguerite Zorach (1887–1968), who fell under the spell of the Cubists and Fauves during four profoundly influential years in Paris from 1908, was one of the first members of the New York avant-garde to achieve popular success. She exhibited her boldly coloured works at the Armory Show in 1913, and was in the vanguard in the applied arts with her needlework and textile designs. Moore was introduced to the artist as early as 1915, when she saw a joint exhibition of William and Marguerite Zorach's work at the Daniel Gallery in New York. Born two months apart, Moore and Zorach had a certain kinship, and the artist made at least three portraits of Moore during the 1920s: two pencil sketches and this double portrait of the poet and her mother. The painting records Moore at an important moment in her rise to fame, but its distinction also rests in the artist's perceptive rendering of the complex mother–daughter relationship. The committed team of poet and editor/censor shared an apartment in New York until Mary Moore's death in 1947, and the influence of the 'pious, possessive schoolteacher' is everywhere apparent in her daughter's poetry. Zorach's portrait conveys Moore's resolute confidence, her rigid posture and fire-red hair, a striking contrast to the muted tones and relaxed posture of her mother behind. The boldly coloured idiom can also be seen as particularly suited to the bright optimism of Moore's poems and the intensity with which they touched her public.

Edward Weston
(1886–1958)
Photographer

Peter Krasnow, 1925
Oil on canvas,
1270 x 965mm
(50 x 38")
Gift of the artist
NPG.77.35

Edward Weston began his career working in the soft-focus, sentimental photographic style popular around 1900. By 1920 his work was internationally known, but his mature style did not emerge until a three-year stay in Mexico beginning in 1923, during which time he came under the artistic influence of Diego Rivera. The brilliant light of Mexico seemed to demand a more sharply focused image, and this, together with the impact of modernist painting and the revolutionary photographs of Paul Strand and Charles Sheeler, led Weston to create images – whether portraits, still lifes, nudes or landscapes – that were precise and without artifice, combining his consummate craftsmanship with his clear aesthetic ideals. As he later wrote, 'The camera should be used for a recording of life, for rendering the very substance and quintessence of the thing itself, whether it be polished steel or palpitating flesh.' Long recognised on the West Coast as a leading modernist, he achieved national prominence in 1937 as the first photographer to receive a Guggenheim Fellowship. His career reached its climax in 1946 with a retrospective exhibition at New York's Museum of Modern Art. Two years later,

crippled by Parkinson's disease, he retired.

The Russian-born painter and sculptor Peter Krasnow (1890–1979) studied at the Art Institute of Chicago until 1915 and later spent two years in New York City, where he learned about European modernism and met avant-garde artists. He moved to the Los Angeles area in 1922 and immediately became close friends with Weston, a neighbour and fellow artist, with whom he held joint exhibitions. Weston returned briefly to Los Angeles from his seminal stay in Mexico during the early months of 1925, noting in his diary that Krasnow was the first of his friends to see his new work, and the portrait must have painted at this time. It is striking and sombre, with its startling contrast between Weston's black cape and the pale aquamarine sea in the far background. The division of the pictorial space into separate entities and the rounded, carefully delineated and subtly coloured forms are typical of Krasnow's work during the early 1920s.

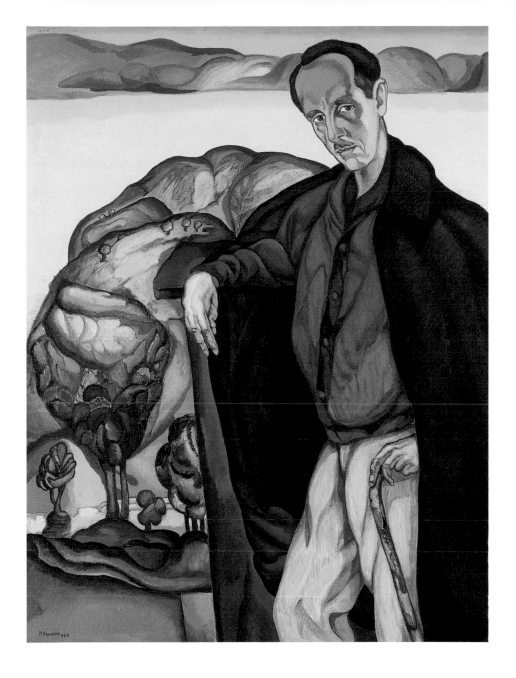

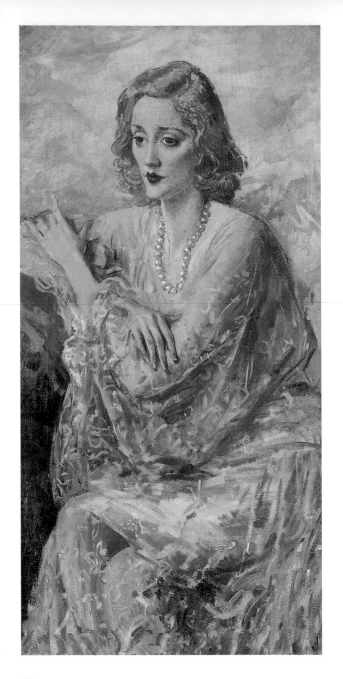

Tallulah Bankhead
(1902–68)
Actress

Augustus John, 1930
Oil on canvas,
1219 x 622mm
(48 x 24½")
Gift of the Honorable
and Mrs John Hay
Whitney
NPG.69.46

During a popular 1946 revival of Noël Coward's *Private Lives*, one New York theatre critic noted that what the crowds wanted to see was not the play but the star, 'a remarkable personality with a remarkable name: Tallulah Bankhead'. Bankhead, famous for her sultry voice, began her stage career in London during the 1920s. Known as much for her languorous sophistication as for her acting, she had a magnetic quality that made her a great popular success. In America she won the coveted New York Drama Critics Award in 1939 for her powerful performance as Regina in Lillian Hellman's *The Little Foxes*. Three years later she took the same prize for her role as Sabina in Thornton Wilder's *The Skin of Our Teeth*. In 1952 she published a witty, best-selling autobiography, *Tallulah*. Her talents were further employed during the 1950s in both radio and television.

While performing in London, Bankhead decided to 'consent to immortality' and sit for the flamboyant artist Augustus John (1878–1961), a recently elected member of the Royal Academy who was as famous for his unconventional lifestyle as for his painting skills. Trained at the Slade School of Fine Art, he had asked Bankhead to pose several years before, but she had refused. Now, when she accepted his offer, she made John promise to sell her the finished portrait for £1,000. Executed in the loosely brushed, delicate style he then used for many of his likenesses, it caused a stir when exhibited at the Royal Academy. The soulful attitude of the sitter and the evanescent pink of the negligee (which Bankhead had worn in the comedy *He's Mine*) caused one critic to compare the figure to those in works by El Greco: 'wispy, a little gaunt and eerie'. Another reviewer talked of it as 'the greatest portraiture since Gainsborough's *Perdita*'. Bankhead kept the portrait on display in her bedroom. She considered it her most valuable possession and once remarked that even if she were reduced 'to living in a hall bedroom and cooking on a Sterno, [I'd] never part with that picture'.

George Gershwin
(1898–1937)
Composer

Arthur Kaufmann, 1936
Oil on canvas,
914 x 616mm
(36 x 24¼")
NPG.73.8

George Gershwin bridged the gap between popular song and serious concert music, bringing inventiveness, energy and vitality to both. The child of immigrant parents of Russian Jewish descent, he so assimilated contemporary American tastes and national traditions that he was able to create folk and popular music, as well as symphonic works that captured the American imagination. 'True music,' he once wrote, 'must repeat the thoughts and aspirations of the people and the time. My people are American. My time is today.' His short career was launched at fifteen, when he worked for a music publisher. By the time he was twenty, the young jazz composer had written a score for a Broadway show and composed 'Swanee', a song made famous by Al Jolson. Between 1924 and 1935 he collaborated with his lyricist brother Ira on more than a dozen musicals, producing such memorable songs as 'Fascinating Rhythm', 'Embraceable You' and 'I Got Rhythm'. As one contemporary put it, his work marked 'the beginning of the age of sophisticated jazz', and his concert pieces – among them *Rhapsody in Blue* (1924), *Concerto in F* (1925) and *An American in Paris* (1928) – transformed jazz into a serious art form. Perhaps Gershwin's greatest triumph was his opera *Porgy and Bess*. Although it was a failure when it opened in 1935, in time many came to see its richly complex score as the culmination of all the composer's earlier work.

Following a few years at the Düsseldorf Academy, the German-born artist Arthur Kaufmann (1888–1971) spent time in France, Italy and England. After the First World War, during which he was a map-maker, he helped organise several artists' associations and large exhibitions in Germany before accepting a professorship at the School of Applied Art in Düsseldorf in 1929. In 1933 he was discharged for being 'non-Aryan' and emigrated to the Netherlands. He visited America in 1935 and moved there in 1936 – the same year he painted Gershwin, with whom he had become friends. The portrait is typical of the expressionistic style he applied most frequently to portraiture. Gershwin's dark hair and strongly modelled features stand out against a pale background, while his expressive hands, casual pose and sartorial disarray give an immediacy that suggests Kaufmann's clarity of observation.

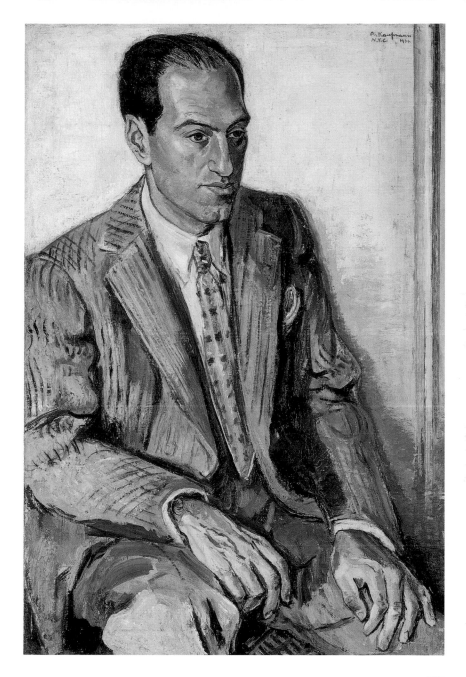

137

Martha Graham
(1894–1991)
Dancer,
choreographer

Paul Meltsner,
c.1940
Oil on canvas,
1066 x 813mm
(42 x 32")
NPG.73.41

Martha Graham's career as a pioneer in modern American dance spanned more than six decades. Her introduction to dance came in 1916, when she enrolled in the Denishawn School in Los Angeles. After studying for several years with Ruth St Denis and Ted Shawn, and touring with his company, she began independently to explore new methods in dance while teaching at the Eastman School of Music. The revolutionary elements of her style, which first emerged in such works as *Immigrant*, *Revolt* and *Heretic*, generated much controversy in the 1920s and 1930s. During the 1930s productions such as *American Provincials*, *Frontier* and *American Document* were derived from American Indian material and from other elements of American heritage and culture. In the years following, as Graham and her company turned to more ambitious works such as *Letter to the World*, *Appalachian Spring* and *Clytemnestra*, her originality began winning broad acceptance. In 1984 dance critic Anna Kisselgoff adjudged her 'raw, powerful and dynamic' technique the 'first lasting alternative' to classical ballet ever to be developed.

Native New Yorker Paul Meltsner (1905–66) had achieved prominence in the art world by the mid-1930s. He was known for his lithographs and watercolours but even more for his carefully composed, dramatic, even ponderous oils, many of which portrayed scenes of industry and workers. Around 1939 he began to exhibit portraits of actors and other performers, including Martha Graham. In fact, contemporary reviews of his paintings often noted that she was his favourite subject. Although Meltsner's work was sometimes considered overly posed and mannered, it was also praised for its well-balanced composition and rich colours. This portrait of Graham is perhaps the strongest and simplest of his celebrity likenesses. He has omitted all extraneous details or references, concentrating on the striking criss-cross arrangement of the dancer's controlled figure and the dramatic effect of the picture's rich, resonant blues and dark reds, contrasting with Graham's pale skin and stark profile. Meltsner is said to have portrayed her here as she appeared in 'Tragic Holiday', from her work *Chronicle*, which was first performed in December 1936.

George Washington
Carver
(1864–1943)
Scientist

Betsy Graves Reyneau,
1942
Oil on canvas,
1124 x 889mm
(44¼ x 35")
Transfer from the
Smithsonian American Art
Museum; gift of the George
Washington Carver Memorial
Committee, 1944
NPG.65.77

George Washington Carver was born a slave in war-torn Missouri and died an honoured scientist. Overcoming numerous obstacles, he received his master's degree from Iowa State University in 1896. Shortly afterwards he accepted an offer from the famous black educator Booker T. Washington of a post at Tuskegee Institute in Alabama, which Washington had founded in 1881. Carver spent nearly forty years there, conducting research and teaching scientific agricultural methods. His main contribution to science was the extraction of new products from previously untapped sources: for example, the peanut and sweet potato yielded more than 400 synthetic products, ranging from margarine to library paste. His work gave the South agricultural alternatives to soil-exhausting cotton and brought him international recognition. He was still at work in his late seventies, during the Second World War, when he developed hundreds of different dye shades to replace those formerly supplied by Europe.

Betsy Graves Reyneau (1888–1964) studied at the Boston Museum of Fine Arts School and then worked in Italy and England for more than ten years.

When she returned to the United States in 1939, she found social conditions and racial prejudice intolerable, so, through contacts with the Harmon Foundation, she began a series of portraits of prominent black Americans that would be exhibited throughout the country to help counter negative racial stereotypes. The first to be painted was this portrait. Carver had previously refused all requests for portrait sittings, but when he saw examples of Reyneau's work he was persuaded, saying that she had the ability to capture 'the souls of people'. As Reyneau recalled in 1946, he 'gave me no regular sittings…He'd just come and sit in the sun when he felt like it.' He is depicted in an outdoor setting, wearing a laboratory apron and examining a red and white amaryllis, a hybrid that he developed as part of a lifelong hobby. Reyneau used clear, seemingly uncomplicated colours and a simple composition, with a diagonal emphasis that recalls a snapshot, to capture Carver's sympathetic character and gentle but formidable intelligence.

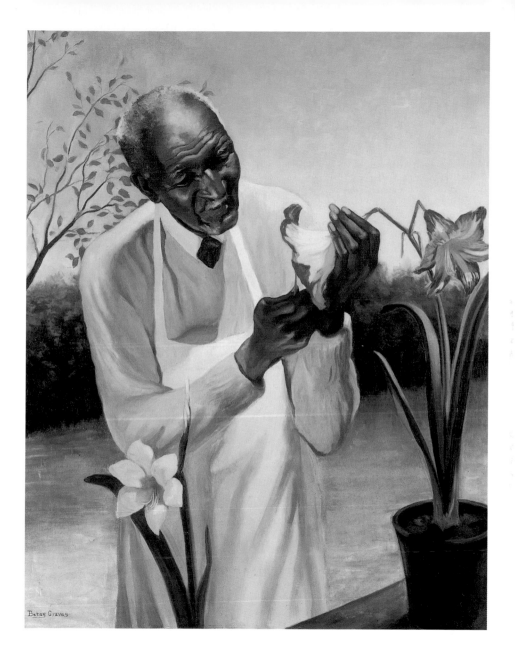

Betsy Graves

Elaine de Kooning
(1918–89)
Artist

Self-portrait, 1946
Oil on Masonite,
768 x 581mm
(30¼ x 22⅞")
Courtesy Elaine
de Kooning Trust
NPG.94.81

When art student Elaine Marie Fried moved into the New York loft of artist Willem de Kooning in 1939, she explained the amount of time she spent away from her Brooklyn home by telling her parents that she was taking private drawing lessons from the Dutchman. While hardly the whole story, she subsequently attributed her assurance as a portrait painter to those intense lessons, during which Willem insisted on linear precision and careful, articulate modelling. Convinced from the time she first met de Kooning, whom she married in 1943, that he was the most important person she would ever know, Elaine diverted most of her energies in the 1940s and 1950s to championing his career. She used her considerable personal talents both to enlarge the circle of artists who admired his work and to introduce him to critics such as Harold Rosenberg and Tom Hess, whose writings enhanced his reputation. While she exhibited sporadically at this time, her own career did not flourish until she and Willem separated in 1957.

Her interest in figure painting was jump-started in the mid-1940s after seeing a portrait her friend Fairfield Porter was making of his wife. Until then she had focused primarily on still lifes, largely under the influence of her husband. During a period when money was tight, she and a painter friend, Joop Sanders, saved money on models by posing for each other. Around 1946 she began a series of self-portraits. In this one, the mug and ashtray casually left on the floor by her feet indicate her ownership of the carefully decorated space. She stares fiercely at the viewer, a woman assured of her artistic and intellectual capabilities. It is an image devoid of any feminine winsomeness or fragility – qualities so long applied by male artists to their female sitters.

Portraiture became a key part of her later oeuvre, with major sitters including dealer Leo Castelli, choreographer and dancer Merce Cunningham and, in 1962, President John F. Kennedy. 'Portraiture is the kind of thing that liberates her talent,' Fairfield Porter wrote in 1961. It is 'what she uniquely can do'.

Edward Biberman, 1947
Oil on canvas,
1295 x 788mm
(51 x 31")
NPG.85.2

From the age of sixteen, Lena Horne has captivated audiences in one artistic medium or another. She began her stage career as a chorus girl in Harlem's Cotton Club but was soon appearing in nightclubs and on Broadway. In 1942 she became the first black woman in almost thirty years to sign a long-term contract with a major Hollywood film studio, MGM. Her beauty, natural grace and apparently limitless talents opened doors that were otherwise closed to many gifted African American performers and she became a role model for many. Her encounters with racism – first as the only black member in Charlie Barnett's band and then in Hollywood – led her to play an active part in the civil rights movement in the 1960s. Throughout her career she has maintained a strong sense of justice and personal integrity. Among her many honours are two Grammy Awards, a Tony Award and the Kennedy Center Honors Award for Lifetime Contribution to the Arts.

Painter and graphic artist Edward Biberman (1904–86) studied in Paris and at the Pennsylvania Academy of the Fine Arts. He spent time in Europe and New York in the 1920s and 1930s, travelling and exhibiting his work, then moved permanently to Los Angeles in 1936. He was introduced to Horne in southern California in 1947. She had just returned from her first singing tour of Europe, where she had secretly married white musician Lennie Hayton. (Their marriage, which lasted until Hayton's death in 1971, incurred much criticism from both black and white American communities.) Biberman greatly admired Horne's beauty and asked her to pose. She stands in the crook of a grand piano, beating time with her left hand. The artist intended this action to signify her vitality as a performer, while letting her calm, cool comportment convey the quiet, intellectual side of her personality. The image celebrates the sophistication for which Horne was known, while also acknowledging the persona she adopted in her effort to move beyond stereotypical constructions of black performers: 'The image that I chose to give them was of a woman who they could not reach.'

The most vocal proponent of the Abstract Expressionist movement and the originator of the term 'action painting', Harold Rosenberg was renowned for his fiercely intellectual criticism on art, politics and society. Even before he turned his attention, in the late 1940s, to the work of artist friends and neighbours in New York, he was an established writer, with essays, reviews and also poems published in a variety of American magazines. He became the *New Yorker*'s art critic in 1967 and during his lifetime published several collections of his essays – *Artworks and Packages* (1969), *Act and the Actor* (1970), *The De-Definition of Art* (1972), *Discovering the Present* (1973), *Art on the Edge* (1975) – and three monographs on artists – Arshile Gorky, Willem de Kooning and Saul Steinberg. Above all else, though, Rosenberg is remembered for his eloquently stated expositions on Abstract Expressionism, what he called 'the most vigorous and original movement in art in the history of this nation'. Locating the work of art's supreme value in the act of creation – the circumstances of the artist's life leading to a specific expression in paint – Rosenberg positioned himself squarely against the formalist critic Clement Greenberg and gained instant notoriety in art circles. His 1952 *ARTnews* article, 'The American Action Painters', was adopted as Abstract Expressionism's manifesto and had a profound effect on the artistic landscape of 1950s New York.

First introduced to the theories of abstract painting through Willem de Kooning in the 1930s, Rosenberg was a lifelong friend of the artist and his wife, Elaine de Kooning (1918–89). If Willem was 'the king of art' for Rosenberg, the singular genius against whom all others were measured, then Elaine was his educator, the person who taught him how to develop his eye. 'He knew almost everything,' she once said of the critic, 'except how to look at a painting.' In this portrait, Elaine de Kooning portrays Rosenberg's bulky frame and piercing gaze amid a frenzy of broad gestural brushwork, evoking both a summary of his intense personality and the energy she put forth constructing his image. As evidenced in this work, her great contribution to the art of portraiture was to marry its need for likeness with Abstract Expressionism's demand for self-expression by the artist.

René Bouché, 1959
Oil on canvas,
1220 x 560mm
(48 x 22")
NPG.91.80

'Are your parties dull affairs? Why not have someone enter the room suddenly while the dinner, dancing, or bridge is in progress, and address the hostess in a clear, cold voice: "Pardon, Mrs Smith, but a dreadful thing has happened. Somebody has been murdered in the front bedroom upstairs."' So suggested Elsa Maxwell, who virtually invented the murder mystery party and codified the scavenger hunt, delighting her selected guests with 'come as your opposite' and 'come as the person you least like' parties. Launched into the entertainment world in her early twenties as a member of a touring Shakespeare company, she went on to play piano in nickelodeon theatres and at private parties, meeting wealthy benefactors along the way. In 1919 she discovered her true calling when she hosted a dinner at the Ritz Hotel in Paris for British foreign secretary Arthur Balfour. Later, she appeared in a string of 1930s films loosely based on her adventures in high society, had her own radio programme and published four books filled with amusing anecdotes. As she declared, 'not bad, for a short, fat, homely piano player from Keokuk, Iowa, with no money or background, [who] decided to become a legend and did just that'.

Born in Prague, René Bouché (1905–63) emigrated to the United States during the Second World War. Having achieved success as an illustrator for *Vogue* in Paris, he continued to work for the magazine in New York. His painting was predominantly figurative until the late 1940s, when he joined a group of Abstract Expressionist painters in the Eighth Street Club. Losing interest in the movement within a few years, he then turned to portraiture, painting innumerable celebrities of the time. In this portrait, he presents a more sombre Maxwell than was usually seen. She is stuffed into the narrow vertical canvas, her serious demeanour offset by the suggestion of disarray given by her fallen shoulder strap. 'A court jester' is how the artist described the professional party-giver, 'but also a desperately serious woman who considers herself a serious critic of society'.

149

Carl Sandburg
(1878–1967)
Poet

William A. Smith, 1961
Oil on canvas,
1016 x 914mm
(40 x 36")
Gift of the Kent-Lucas
Foundation
NPG.80.39

John F. Kennedy said of Carl Sandburg, 'His has been the role of the poet in the best of ages, the interpreter of the nation's traditions and the shaper of its great myths.' Sandburg found beauty in the ordinary language of the people, the 'American lingo', as he called it, using that language to interpret the frontier past and set it in the context of an industrial present. Born in Galesburg, Illinois, of Swedish immigrant parents, he served in the Spanish-American War, attended Lombard College and worked as a labourer and a journalist before gaining recognition as a poet. The publication in 1914 of 'Chicago', which won the Levinson Prize, and the appearance two years later of *Chicago Poems* marked his emergence as an important literary figure. He became associated with a group of Chicago writers in a movement called the Chicago Renaissance. Three more volumes of poetry continued the theme of Chicago: *Corn Huskers* (1918), *Smoke and Steel* (1920) and *Slabs of the Sunburnt West* (1922). He reaffirmed his faith in the collective wisdom of the people with *The People, Yes* (1936), which has been called one of the great American books. In 1940 he was awarded the Pulitzer Prize for his monumental biography *Abraham Lincoln: The War Years* (1939).

Sandburg was a close friend of William Smith (1918–89) and sat for many portrait sketches, as well as this painting, while visiting the artist's home in Pineville, Bucks County, Pennsylvania. Smith, who had studied at the Art Students League in New York and maintained a studio there until 1956, when he left for rural Pennsylvania, was well known for his illustrations and watercolours in addition to his portrait work. He had been friends with the poet for a decade when this likeness was painted, so was able to portray his subject's characteristic attitude, arresting scowl and trademark – a coloured scarf wound loosely around his neck – with great precision and sympathy. The sketchlike appearance of most of the canvas appealed to Sandburg, who stated, 'I like it, Bill. It has some of the chaos that is in everything you do!'

T. S. Eliot
(1888–1965)
Poet

Sir Gerald Kelly, 1962
Oil on canvas,
1146 x 94mm
(45⅛ x 37")
Gift of the National
Portrait Gallery
Commission and senior
staff in memory of
Donald P. Klopfer
and Gallery purchase
NPG.86.88

After reading Thomas Stearns Eliot's 'The Love Song of J. Alfred Prufrock' (1915), which the St Louis-born poet had composed shortly before settling in England, Ezra Pound pronounced it the best poem by an American he had ever read. In 1922 this high regard for Eliot's talent became widespread with the publication of *The Waste Land*. Hailed as a watershed in twentieth-century literature, the work established Eliot as a poet of the first rank on both sides of the Atlantic, and he later also achieved eminence as a literary critic and playwright. In 1927 he became a British citizen and was confirmed in the Anglican Church, which had become a spiritual haven for him and an inspiration for his work. He was awarded the Nobel Prize for Literature in 1948.

Known from the 1920s as a fashionable portraitist, Sir Gerald Kelly (1879–1972) painted artists and entertainers, socialites and aristocrats. A formidable champion of the arts and friend to fellow painters, he served as president of the Royal Academy of Arts from 1949 until his retirement in 1954. He was renowned for his highly detailed, crafted paintings. Many of these have a quality of flatness and lack of spatial depth, possibly because he often made use of photographs. Eliot had known Kelly for some years before he began posing for this portrait in 1960. The artist was over eighty at the time and ill-health caused postponement of the remaining sittings until well into the next year. Eliot purchased one version of the portrait for his wife, calling it a 'masterpiece' and telling Kelly, 'I shall never have a better portrait, even from yourself.' The likeness seen here is more elaborate. Eliot has been posed in front of a collection of his books, carefully selected and delineated to reveal something of his taste for art and literature. Kelly had used this convention of portraying men of letters with their books in other portraits, but it is further personalised here with the inclusion of a card table and an interrupted game of patience, directing attention to Eliot's attitude of contemplation and reverie.

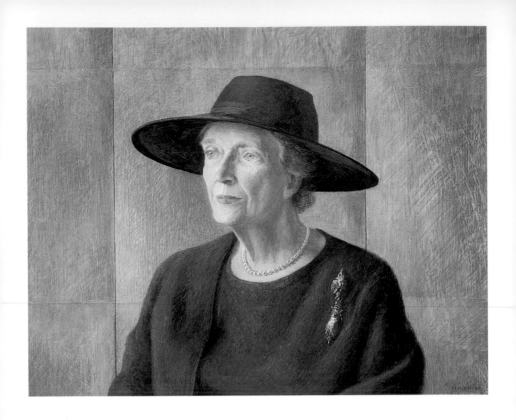

In 1965 Alice Roosevelt Longworth, the daughter of President Theodore Roosevelt and the widow of influential Ohio congressman Nicholas Longworth, sat for her portrait in Washington, DC. Long after the death of her husband in 1931, her acerbic yet brilliant conversation and her irreverent sense of humour made her one of the city's most colourful and frequently quoted figures. Her epigrammatic barbs at presidents and other public figures were legendary. Of her gift for amusing commentary, she once said, 'I'm not witty. I'm funny…I give a good show – just one of the Roosevelt show-offs.' The spirit of the exuberant young girl whose love for a particular shade of grey-blue sparked the turn-of-the-century hit tune 'Alice Blue Gown' shines quietly in Peter Hurd's serene portrait of the aged but sprightly Mrs Longworth. Her face, its calm gaze betrayed by a hint of a smile, is accentuated by the cool, bright light that remained one the artist's major preoccupations throughout his career.

Peter Hurd (1904–84) was born in New Mexico but received his education in Pennsylvania, where he later apprenticed himself to artist-illustrator N. C. Wyeth. A few years after he and Wyeth's daughter Henriette married in 1929, they returned to New Mexico to a life of ranching and painting. Hurd was well known for his landscapes of the Southwest, as well as for his portraits, and his name was particularly associated with the revival and refinement of the traditional Renaissance medium of egg tempera. As he wrote in its praise, 'I have been able to get a *colour quality* and *flatness* hitherto unknown to me…remarkable brilliance and complete flatness – with absolutely no shine in any light!' He also favoured Italian Renaissance compositional motifs for portraits, isolating his sitters in front of a very simple backdrop, as in this picture, or in front of a distant landscape background, painting meticulously with hundreds and hundreds of tiny brushstrokes. In this way he was able to capture the delicacy, the reserve and the vibrant elegance of Mrs Longworth, Washington's professional wit and 'whip-cracker'.

Lincoln Kirstein
(1907–96)
Impresario

Jamie Wyeth, 1965
Oil on canvas,
971 x 762mm
(38¼ x 30")
Bequest of
Lincoln Kirstein
© Jamie Wyeth
NPG.96.97

Lincoln Kirstein was the quintessential Renaissance man. While at Harvard in the late 1920s, with two fellow undergraduates he founded the Harvard Society for Contemporary Art, which exhibited the work of cutting-edge artists at a time when other museums and galleries were often dismissive. His commitment to modern art was lifelong, but he also had wide-ranging literary interests. The magazine he started at Harvard, *Hound & Horn*, published the work of James Joyce and Gertrude Stein, while he himself wrote some thirty books and hundreds of articles on art, architecture, literature and dance. He is perhaps best known for his pioneering efforts in the development of ballet in America. While travelling abroad, he met George Balanchine, then choreographer for Diaghilev's ballet company, and in 1933 persuaded Balanchine to join him in founding the School of American Ballet and become its director. He also formed the Ballet Caravan in 1936 and the Ballet Society in 1946, from which the New York City Ballet Company evolved, with Kirstein as its general director. He created a truly American tradition of ballet with his storylines for such works as *Billy the Kid* and *Yankee Clipper*, which merged European classical style with spirited American subject matter.

Jamie Wyeth (b.1946) was born into a celebrated artistic dynasty: N. C. Wyeth, his grandfather, delighted children with fanciful book illustrations and Andrew Wyeth, his father, was noted for his realistic figure studies and landscapes. Trained largely by Henriette Wyeth Hurd, his aunt, he demonstrated such precocious artistic talent that he left school at eleven. Kirstein was an old friend of Andrew Wyeth, whose suggestion it was that the impresario commission Jamie to paint his portrait. Achieving what Kirstein called 'a mix of Eakins and Sargent', the work was exhibited at Wyeth's first one-man show in 1966 and thereafter hung above the sitter's fireplace. Wyeth first made two sketches of Kirstein, one frontal and the other this unconventional pose with his hands clasped behind his back. The pose, like that of a ballet master, gives the portrait its regal air, as befitted Kirstein's aristocratic persona.

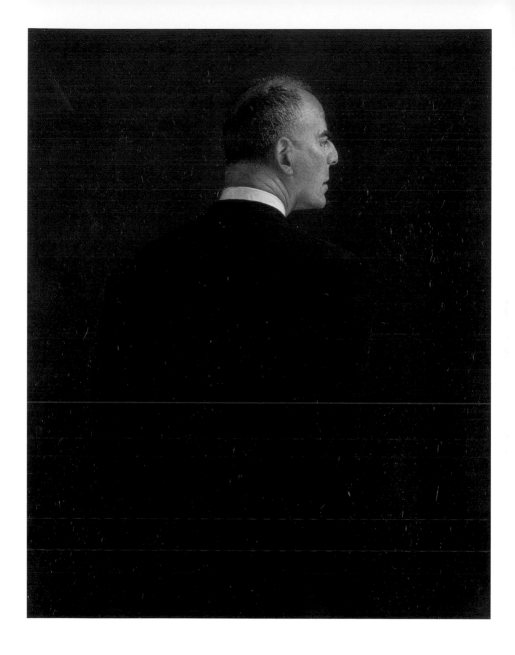

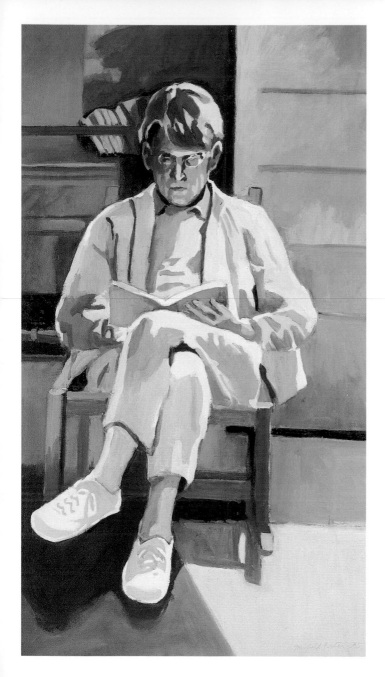

Eliot Porter
(1901–90)
Photographer

Fairfield Porter, 1975
Oil on canvas,
1473 x 813mm
(58 x 32")
NPG.93.25

The brothers Eliot and Fairfield Porter shared a fascination with nature, the ability to reveal extraordinariness in everyday life, and a reputation as stubborn independents who refused to conform to the practices of their contemporaries. Their father's influence as an amateur photographer and science enthusiast led to Eliot's interest in nature photography, but before devoting himself to it fully he studied chemical engineering and medicine. From 1929 to 1939 he taught at Harvard University, doing research in bacteriology and biophysics. His commitment to photography grew steadily, however, and when in 1939 Alfred Stieglitz gave him a one-man exhibition at his New York City gallery, Eliot left teaching. He is best known for his ornithological photographs and his pioneering use of colour at a time when black and white was the norm for artistic photography. Awarded successive Guggenheim Fellowships for his work developing new ways of creating the rich, saturated colours of his photographs, he fused his interests in science and photography, establishing colour nature photography as a valid artistic genre. His work also contributed to the environmentalist cause, heightening public awareness about the need for wilderness preservation.

Fairfield Porter (1907–75), who adhered to representational subjects during the heyday of Abstract Expressionism, claimed he painted in a figurative style throughout his life because he once overheard critic Clement Greenberg tell Willem de Kooning it was passé. He studied fine art at Harvard and then spent two years at the Art Students League in New York. Influenced by the work of Vuillard and Bonnard, he focused on colour relations and the effect of light in his eternally sunlit domestic scenes and figure studies. A gifted writer and critic, he was editorial associate at *ARTnews* from 1951 to 1959, contributed widely to other art periodicals and was art critic for *The Nation* in the early 1960s. This portrait was painted just months before the artist's death. It captures the celebrated photographer in a quiet moment on Great Spruce Head Island in Maine's Penobscot Bay, where the two had grown up, and documents the sympathetic relationship they forged in later life.

Alice Neel
(1900–84)
Artist

Self-portrait, 1980
Oil on canvas,
1371 x 1016mm
(54 x 40")
© Estate of Alice Neel
NPG.85.19

At the age of seventy, Alice Neel said that the closest she ever came to a self-portrait was the image of an empty chair by an apartment window. Five years later she began this shocking, endearing and unconventional portrait, a project that took another five years to complete. Presenting a striking challenge to the centuries-old convention of idealised femininity, Neel's only painted self-portrait is wonderfully suggestive of the artist's bohemian, bawdy character. She was raised in what she described as the 'puritanical' town of Colwyn, Pennsylvania, and studied art at the Philadelphia School of Design for Women from 1921 to 1925. She moved to New York in 1931 after suffering a nervous breakdown and attempted suicide when her first husband, a Cuban artist, left with their child. There she painted, along with genre and street scenes, the picturesque characters of Greenwich Village and the poverty-stricken inhabitants of Spanish Harlem. A string of lovers left her with two sons, a situation that made life even more challenging when her support from the Works Progress Administration ceased in 1943. Beginning in the 1950s, she increasingly painted many of her colleagues in the art world.

Never one to conform to established norms, Neel adhered to a representational idiom in the midst of the Abstract Expressionist movement and was consequently ignored by the art world for many years. Her 1970 exhibition at the Pennsylvania Academy of the Fine Arts and her 1974 retrospective at New York's Whitney Museum of American Art signalled her long-overdue arrival on the art scene. She aimed in her figure studies (she disliked the term portraiture because of its connotations of flattery and idealisation) to capture the very essence and immediacy of each person she portrayed. An expressionistic brushstroke, manipulation of scale and almost intuitive reading of body language allowed her to create psychologically penetrating yet benevolent renderings of her sitters. This self-portrait is the crowning achievement of more than fifty years of unabashedly honest painting. She clearly considered it as much a landmark in her personal growth as it was in her artistic development. 'I had to do this,' she said. 'I couldn't have lived otherwise.'

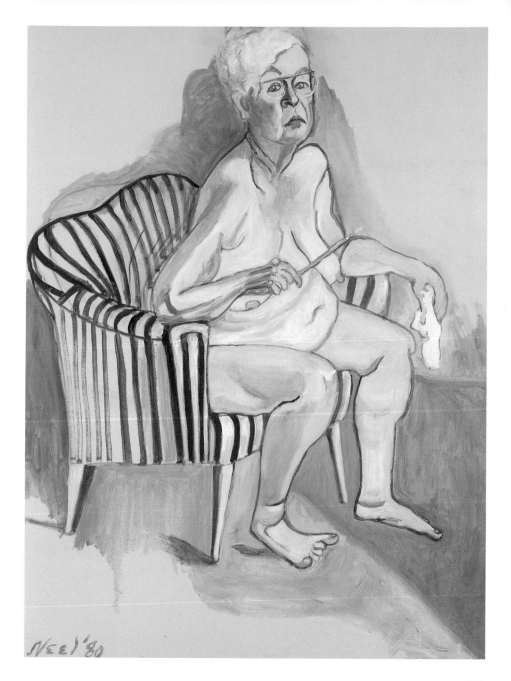

Neel '80

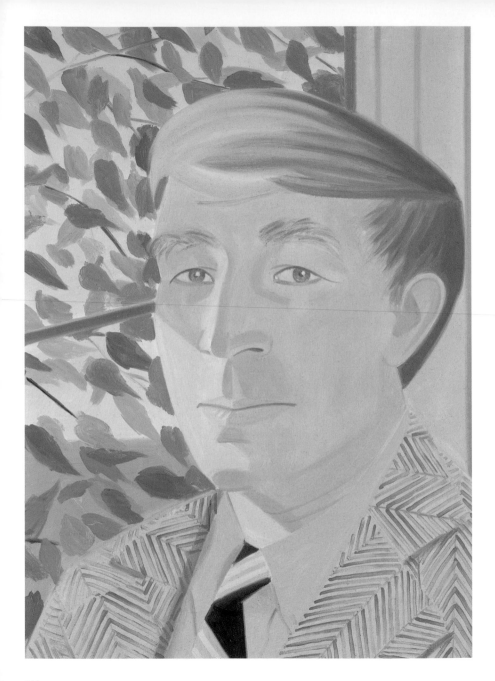

John Updike
(b.1932)
Author

Alex Katz, 1982
Oil on canvas,
1225 x 867mm
(48½ x 34⅛")
Time cover,
18 October 1982
Gift of *Time* magazine
© Alex Katz/Licensed
by VAGA, New York, NY
NPG.84.TC156

John Updike has established himself as one of America's foremost chroniclers of modern life and the anxieties of suburban existence. His many novels and short stories are written in a style characterised by wit, detachment and a penchant for detailing every aspect of his characters' lives. A prolific writer, he has also published much non-fiction and criticism. He grew up in Shillington, Pennsylvania, and graduated in English from Harvard in 1954. He then studied briefly at Oxford, but while in England he received an offer to join the *New Yorker*. Updike and his wife lived in New York until 1957, when they moved to Ipswich, a small Massachusetts town near Boston. After publishing a collection of poetry and a highly praised novel, Updike wrote *Rabbit, Run* (1960), which chronicles the life of a former well-known athlete, Harry ('Rabbit') Angstrom, who, unable to recapture success when encumbered by marriage and small-town life, flees these responsibilities. Several 'Rabbit' books follow the same character throughout his later life, two of them, *Rabbit Is Rich* (1981) and *Rabbit at Rest* (1990) winning Pulitzer Prizes.

Alex Katz (b.1927), a New York-based artist who first came to prominence in the early 1960s with the advent of Pop Art, is known for his larger-than-life portraits of family and friends. Like Updike, he creates technically brilliant and provocative works of art from seemingly mundane sources. In devising his images, he plays with the tensions between consumer imagery and the traditions of fine art, between abstraction and perceptual information, although the quality of the portrait still resides in likeness: 'If you don't have a good likeness, you don't have a good picture.' Katz was approached by *Time* to paint Updike for the magazine's cover. With its immediacy, flattened forms that fill the canvas and complex colour and tonal relationships, the result typifies the artist's work. Although there is a likeness, Katz has avoided meticulous detail to emphasise his interest in pictorial problems. As he noted in 1984, 'People think realism is details. But realism has to do with an over-all light, and having every surface appear distinctive.'

Michael Jackson
(b.1958)
Singer

Andy Warhol, 1984
Oil on silkscreen
on canvas,
761 x 661mm
(29⅞ x 26")
Time cover,
19 March 1984
Gift of Time magazine
©Andy Warhol Foundation
for the Visual Arts/ARS,
New York
NPG.86.TC14

Michael Jackson's career as a recording star began at the age of eleven, with the popularity of the first single he and four of his brothers, the Jackson 5, released. A string of hits followed and in 1979 he released his first solo album. By 1984 he was being hailed as the biggest star since the Beatles or Elvis Presley, and Time called him 'the most popular black singer ever' in the issue where this image appeared. In 1984, at the peak of his celebrity, he won an unprecedented eight Grammy Awards for his internationally acclaimed album Thriller. In his meteoric rise to prominence, Jackson exploited his aura of innocent eroticism and his androgynous appearance.

Andy Warhol (1928–87) is synonymous with Pop Art, a style he developed in the early 1960s as a counterpoint to the Abstract Expressionism of artists such as Jackson Pollock and Willem de Kooning. Rather than strive for their spontaneous, expressive abstraction, he chose to use objects appropriated from popular culture as imagery for fine art. In particular, he favoured photographs of celebrities and mundane objects such as soup cans, reproducing them on canvas through a silkscreen process. Using a detached, semi-mechanical approach, he let photographic labs and assistants create much of the image before retouching it. As he said, 'I sort of half paint them just to give it a style.' By the mid-1970s he had perfected the technique used here. The silkscreened photographic image is augmented with flat areas of bright colour. More expressive lines, meant to signify the artist's own pencil, are screened over the image in various contrasting hues to capture Jackson's boyishness and electrifying energy. The choice of Warhol as Jackson's portraitist was particularly appropriate, bringing together two leading exponents of popular culture. It was Warhol who suggested that in the modern world anyone might achieve fifteen minutes' fame, and the media explosion of the past three decades, plus the public's endless fascination with celebrity and notoriety, Jackson's included, have borne this out.

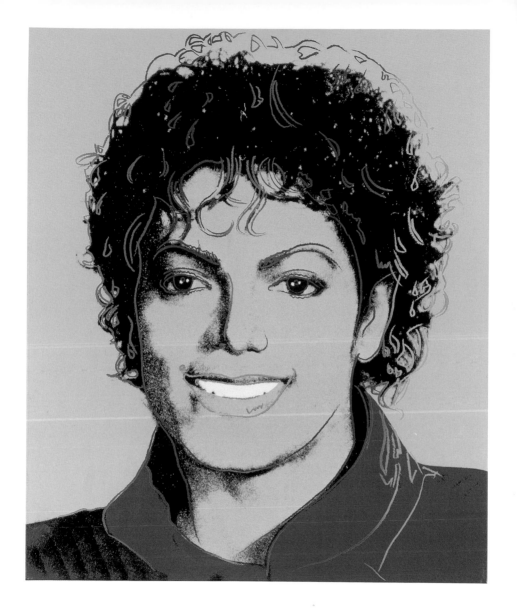

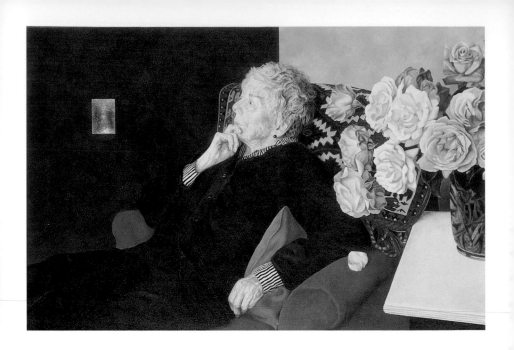

M. F. K. Fisher
(1908–92)
Writer

Ginny Stanford, 1991
Acrylic and silver
leaf on canvas,
660 x 990mm
(26 x 39")
© Ginny Stanford
NPG.92.173

Through her artful essays on food and life, Mary Frances Kennedy Fisher transformed the mundane activity of eating into a passion. A unique blend of thoughtful instruction, sense-awakening recipes and reflections on life's values, her writing is everywhere informed by the conviction that our basic human needs for love, shelter and food are inextricably linked. She spent three years in Dijon, France, in her early twenties, and it was there that she learned about food. After teaching French for five years and researching gastronomy in her spare time, in 1937 she published her first collection of essays, *Serve It Forth*. This was favourably reviewed by the leading American food writer, Lucius Beebe, and marked the start of a long and successful writing career. *How to Cook a Wolf* (1942), *The Gastronomical Me* (1943) and *Here Let Us Feast: A Book of Banquets* (1946) were published to great acclaim, but it was with books such as *A Cordiall Water: A Garland of Odd & Old Receipts to Assuage the Ills of Man & Beast* (1961) and *Map of Another Town: A Memoir of Provence* (1964) that she transcended the narrow bounds of food writing to become an important writer in her own right. Her prose style continues to be praised for its elegance, wit and richness of sensuous detail.

Ginny Stanford (b.1950), a self-taught artist best known for the dreamlike quality of her figure studies, portraits and pastoral paintings, was introduced to Fisher in 1991, just a year before the writer's death. Seeking to paint the image of a courageous older woman 'who could look unflinchingly at herself', she produced three portraits, each exploring a different aspect of Fisher's character. This one, the first in the series, is a testament to Fisher's strength in the face of a string of illnesses, including Parkinson's disease, which eventually stole her voice. She posed for Stanford in her home in California, seated next to a large bouquet of roses sent by one of her many admirers. The dignity of Fisher's image belies any notion that illness had weakened her resolve.

Photographs

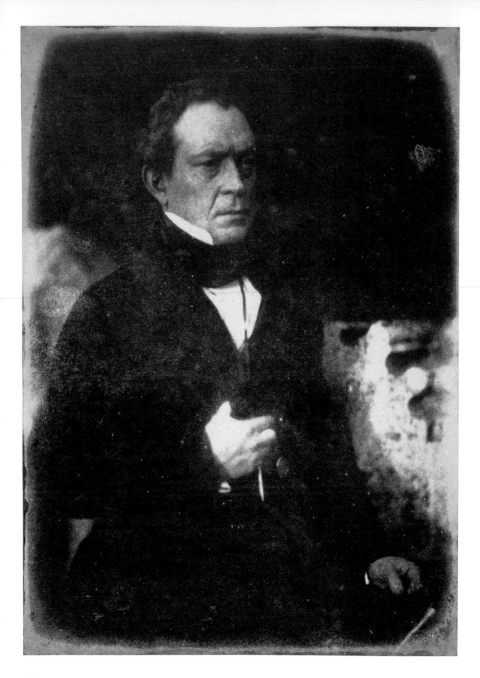

Edward Everett
(1794–1865)
Statesman

Robert Adamson and
David Octavius Hill,
1844
Calotype,
200 x 144mm
(7⅛ x 5⅝")
NPG.85.13

A distinguished scholar, respected politician and statesman, and brilliant orator, Edward Everett enjoyed a long and influential career in public life. In 1814 he became minister of the Brattle Street (Unitarian) Church, the largest and most fashionable congregation in Boston. He then accepted the recently established chair of Greek literature at Harvard and, to prepare, he sailed to Europe in 1815 to start several years of study. He was awarded a PhD from Göttingen University, Germany, two years later and after travelling for another two years began his work at Harvard. An address he gave at the school in 1824 began his political career, bringing him the nomination to represent the Middlesex district of Massachusetts in Congress. During five terms (1825–35) he represented the state's conservatism, showing deference to southern feeling on the question of slavery. Four terms as governor followed (1836–9), before his appointment as minister to the Court of St James in London (1841–5), where his standing in the world of scholarship and letters, his social grace and his charm as an orator made him very popular. He was secretary of state for a brief period from 1852, before entering the Senate. His political

career was now at its height, but his fear that the abolition of slavery would threaten the stability of the Union proved his downfall. He finally realised his search for a compromise was doomed with the formation of the southern Confederacy upon Abraham Lincoln's election as president. At that point, he gave the government his whole-hearted support, travelling widely to deliver a succession of stirring wartime addresses in support of the Union.

Robert Adamson (1821–48) trained as an engineer but turned to photography because of his poor health. David Octavius Hill (1802–70) was a respected painter and a member of the Royal Scottish Academy. Their collaboration, which began shortly after the introduction of photography and lasted only four years (1843–7), remains one of the most creative and significant in the history of the medium. The vast majority of their photographs were taken in Scotland, but in 1844 they attended a meeting of the British Association for the Promotion of Science in York, where they photographed several distinguished participants, including Edward Everett.

John Brown
(1800–59)
Abolitionist

Augustus Washington,
c.1846–7
Daguerreotype,
100 x 82mm
(3⅞ x 3¾")
Purchased with major
acquisition funds and with
funds donated by Betty
Adler Schermer in honour
of her great-grandfather,
August M. Bondi
NPG.96.123

The radical abolitionist John Brown was born in Torrington, Connecticut, and his early adult life was marked by business failure. After spending time in Pennsylvania, Massachusetts and Ohio, by the mid-1850s he was settled in North Elba, New York, a community of free blacks. This earliest known portrait depicts him during his brief tenure as a wool broker in Springfield, Massachusetts. He was already an abolitionist when he arrived in Massachusetts in 1846, but once in Springfield his activism increased. In the portrait he stands with one hand raised, as if repeating the pledge he had made to dedicate his life to the overthrow of slavery. With his other hand he grasps what is thought to be the standard of his 'Subterranean Pass Way', envisaged as an alternative to the non-violent Underground Railroad. This called for the establishment of clandestine bases in the Allegheny Mountains from which armed parties could attack slave-holding properties and provide cover for fugitive slaves making their way north; the scheme was never realised. He followed five of his sons to Kansas in 1855 and in 1856 organised the murder of five pro-slavery settlers near Pottawatomie Creek. He is best remembered for the 16 October

1859 attack and capture of the arsenal at Harpers Ferry, Virginia, which was retaken two days later by Colonel Robert E. Lee. Brown was found guilty by a Virginia court of insurrection, treason and murder, and was hanged.

Augustus Washington (1820/21–75), another committed abolitionist, is one of the few African American daguerreotypists whose career can be documented. The son of a former slave, Washington obtained a solid education, but only after much struggle. From 1844 he taught at a school for black students in Hartford, Connecticut, and in 1846 he opened one of the town's first daguerrean studios. Although personally successful, he grew increasingly pessimistic about the future for blacks in the United States, so in 1853 he emigrated with his family to Liberia. Once in West Africa, he opened another successful daguerrean studio and also played a prominent part in Liberian politics.

George Bancroft
(1800–91)
Historian

John Jabez Edwin
Mayall, c.1847
Tinted daguerreotype,
139 x 109mm
(5½ x 4¼") image
Gift of Dr and Mrs Lester
Tuchman and Gallery
purchase
NPG.79.214

George Bancroft, the 'Father of American history', was also a distinguished statesman and diplomat. He studied at Harvard and in Germany, travelling widely in Europe before returning to teach Greek at Harvard. In 1822 he left the university to establish a boys' school based on European models. His efforts were unsuccessful, but after leaving the school in 1831 he started work on his monumental ten-volume *History of the United States*, which was published between 1834 and 1867. This was an open celebration of American institutions, written to reflect his conviction that the historian must promote a moral outlook. The first three volumes (1834, 1837 and 1840) received immediate critical acclaim. Their pro-Democratic bias was commented upon and Bancroft suddenly found himself rising rapidly in Democratic political circles. As a delegate to the National Democratic Convention in 1844, he played an important role in James Polk's presidential nomination and was rewarded, after Polk's election, with the cabinet position of secretary of the navy. In 1846 he was appointed minister to the Court of St James in London. Returning to the United States in 1849, he devoted himself to writing six further volumes of his *History* (published between 1852 and 1866). President Andrew Johnson appointed him US ambassador to Berlin in 1867, where he remained until 1874.

This daguerreotype would have been taken soon after Bancroft arrived in London. It was made by John Mayall (1813–1901), who was born in Manchester but learned and practised the daguerreotype process in Philadelphia, where he owned one of the city's major galleries. In 1846 he moved to London and opened his American Daguerreotype Institution, making daguerreotypes that were distinctly British in their poses and delicate use of transparent tinting, but utilised American techniques to achieve a superlative finish to the plates. Appointed official photographer to Queen Victoria, Mayall went on to become one of the most prominent photographers of nineteenth-century England.

P. T. Barnum
(1810–91) and
Charles Sherwood
Stratton ('Tom
Thumb') (1838–83)
Showman and
performer

Samuel Root or Marcus
Aurelius Root, c.1850
Daguerreotype,
140 x 108mm
(5½ x 4¼")
NPG.93.154

Together Phineas T. Barnum, the showman, and his most famous performer, Charles S. Stratton, better known as 'General Tom Thumb', established a new kind of flamboyant entertainment, combining real talent and spectacular hoaxes, or 'humbug'. As Barnum, who even called himself the 'Prince of Humbug', knew, audiences would be happy to pay for the chance to detect a clever fraud alongside genuine acts. In his own words, 'Every sham shows that there is a reality.'

Barnum had begun his career with a touring exhibition featuring Joice Heth, a former slave who claimed to be 160 years old. In the 1840s and 1850s, he put on enormously popular shows with such acts as Tom Thumb and the soprano Jenny Lind, 'the Swedish nightingale'. He opened Barnum's American Museum in 1841, showing 'Curiosities', or 'freaks of nature', in New York, to which many flocked. It was in the early 1870s that, with his partner James A. Bailey, he invented the three-ring travelling circus, the 'Greatest Show on Earth', displaying such attractions as Jumbo the elephant, sent over from London, and the 'White Elephant of Siam'. According to one of his biographers, Barnum can be credited with 'the creation of mass amusements' in America. Originally from a poor Connecticut family, when he died he was worth some $5,000,000.

Tom Thumb was a dwarf who sang, danced and played numerous roles in costume, including Cupid, Robinson Crusoe and Napoleon. When he began working for Barnum, he was five years old, 63.5 centimetres tall and weighed only 6.8 kilos. Their lucrative partnership continued for more than twenty years.

Having studied the daguerreotype process with Robert Cornelius in Philadelphia around 1843, working there for some years and purchasing the studio of John Mayall when he left for England, Marcus Aurelius Root (1808–88) opened a New York City gallery in 1849 and put his brother Samuel (c.1819–89) in charge. In 1850 one of them, probably Samuel, produced a daguerreotype of Jenny Lind. By 1851 Marcus had sold his interest in the gallery, but both brothers continued working independently as daguerreans.

Mathew Brady
(1823–96) with his
wife, Juliette Brady,
and Mrs Haggerty
Photographer

Unidentified artist,
Mathew Brady Studio,
c.1851
Daguerreotype,
107 x 83mm
(4¼ x 3¼")
NPG.85.78

One of the most important figures in American photographic history, Mathew Brady was the son of Irish immigrants. He studied with portrait artist William Page in Saratoga, then went to New York in 1839, where he attended Samuel Morse's classes on the work of Louis Daguerre. Within a year of the daguerreotype's introduction to America it was so popular that studios were opening across the country. Brady quickly moved beyond what Morse taught him and became a leading innovator in the field of photographic portraiture. He opened his own Daguerrean Miniature Gallery in New York in 1844, which was an immediate success. For the next twenty years he was the most prominent daguerreotypist in the city, responsible for the portraits of any number of distinguished dignitaries and personalities. Some of these he published in the form of lithographs in 1850 in a book entitled *Gallery of Illustrious Americans*. In 1853 he opened an even more lavish gallery in New York, where he was joined by Alexander Gardner, a Scottish photographer expert in the new 'wet-plate process' that would take over from daguerreotypes. Throughout the 1850s Brady's career flourished and

in 1858 he opened the National Photographic Art Gallery in Washington, DC. In 1861 he was granted permission to make a photographic record of the Civil War and hired teams of photographers to work for him. He had envisaged an enormous market for this form of early photojournalism, but although the images appeared in magazines and received critical acclaim, they were never a commercial success. The war marked a turning point in Brady's fortunes. When it was over he found that his activities diminished, his eyesight failed and his income vanished. Congress bought his Civil War collection in 1875 for $25,000, which cleared his debts but left no money for further ventures. He died in a New York charity ward.

This daguerreotype, taken at about the time of Brady's marriage to Juliette Handy, depicts him with his wife and a Mrs Haggerty, believed to be his sister. At one time owned by his descendants, it is the only unquestionably authentic daguerreotype of Mathew Brady known to exist.

Jonas Chickering
(1798–1853)
Piano
manufacturer

Albert Sands
Southworth and Josiah
Johnson Hawes, c.1853
Daguerreotype,
215 x 161mm
(8½ x 6⅜")
NPG.95.177

The father of the modern piano, Jonas Chickering was born in Mason, New Hampshire. While apprenticed to a local cabinet-maker, he helped repair a piano that had been shipped over from England, suffering badly in the process. This marked the start of a new career and, at the age of twenty, he moved to Boston to work with John Osborne, the only person making pianos in America at the time. Within five years he had mastered his craft. In 1830 he went into partnership with Captain John Mackay and completed his first upright piano, which was based on existing English instruments of the 'bookcase' type. This proved very popular, but he was already turning his attention to the grand piano. At the time, it was difficult to keep a grand piano in tune, but to remedy this Chickering invented a one-piece cast-iron plate. Abandoning earlier cast-iron frames was the foundation of modern piano construction. To enhance sound quality, he also developed the overstringing method – setting the strings in two banks rather than side by side – used in pianos to this day. Chickering worked with his three sons, all masters in the field, and pianos were made under the name Chickering and Sons for more than a century. Past owners include Franz Liszt, Abraham Lincoln, Henry Wadsworth Longfellow and George Gershwin.

Albert Sands Southworth (1811–94) and Josiah Johnson Hawes (1808–1901) worked together in Boston from 1843 to 1862 and are widely held to be among the first great masters of photography in America. Like Chickering, they were technical and creative innovators who saw themselves as artists. Their use of daguerreotypes, where each image is made on a polished metal plate without a negative, ensured mirror-like results. According to an article from the August 1855 issue of the *Photographic and Fine Art Journal*, they produced 'the finest in every respect, artistic, mechanical, and chemical; graceful, pleasing in posture and arrangement, and exact in portraiture…presenting beautiful effects of light and shade, and giving depth and roundness together with a wonderful softness or mellowness'.

George Armstrong
Custer
(1839–76)
Union general

Unidentified artist, 1859
Ambrotype,
108 x 83mm
(4¼ x 3¼") image;
415 x 415 x 57mm
(16⅜ x 16⅜ x 2¼")
mount
NPG.81.138

Although General George Armstrong Custer graduated from the US Military Academy at West Point in 1861 at the bottom of his class, during the Civil War he served with great distinction, winning a reputation as a brilliant, if egotistical, cavalry officer in the first Battle of Bull Run and the Virginia and Gettysburg campaigns. Although his units suffered enormously high casualty rates, his fearless aggression in battle earned him the respect of his commanding generals and increasingly put him in the public eye. His cavalry units played a critical role in securing the retreat of Confederate General Robert E. Lee's forces. After the war he was stationed in the West and in 1874 he led an expedition into the Black Hills of the Dakota Territory, where his party found evidence of gold. The Black Hills were, however, sacred to the Cheyenne and Lakota (or Sioux) Indians, whose possession of the land the government had guaranteed just six years before. When the discovery of gold resulted in an influx of prospectors, hostilities escalated and armed conflict became inevitable. In June 1876 Custer set out with troops of the Seventh Cavalry to help subdue a large Lakota encampment at the Little Big Horn River in Montana. He was supposed to wait for two other units, under Generals Crook and Gibbon, but on 25 June he rushed headlong into battle. The move was a disaster, and Custer, along with hundreds of his men, fell almost immediately. Known forever after as 'Custer's Last Stand', the event generated a controversy that has not yet died. While some saw Custer as a martyred hero, others regarded his action as an irresponsible attempt to cover himself with glory.

Custer was a cadet at West Point when he posed for this ambrotype. Although the circumstances of the sitting are unknown, it most likely took place in the summer of 1859, when he returned home to Michigan on the leave customarily granted to cadets after they had completed their second year.

John Heenan
(1835–73)
Boxer

Charles DeForest
Fredricks, 1860
Coated salt print,
203 x 154mm
(8 x 6⅛")
NPG.97.102

The American heavyweight champion John Heenan electrified boxing fans on both sides of the Atlantic when he fought the English champion, Tom Sayers, to decide the world championship on 17 April 1860 at Farnborough in Surrey. The 'Benicia Boy', a tough fighter from a California town of the same name, challenged Sayers to a bare-knuckle battle of the nations. Nicknamed the 'Immense Invader' by the British, Heenan was 1.88 metres tall and weighed 88.5 kilos, while Sayers was only 1.73 metres tall and weighed just 70.5 kilos, which in theory meant he was a middleweight. Following the London Prize Ring rules of the day, theirs was a gruelling match, a mixture of boxing and wrestling only a few steps removed from a street fight, with rounds not ending until one of the men went down. Heenan's power was matched by Sayers's agility, and after more than two hours there was no clear winner. Ended by a brawl when the ringside crowd surged through the ropes, the fight was declared a draw and both men were awarded silver belts. Heenan and Sayers remained the champions of their respective nations, but Sayers never fought again and Heenan retired three years later.

Charles DeForest Fredricks (1823–94), who was born in New York, may have learned the daguerrean process there as early as 1840 from Jeremiah Gurney. He then travelled widely in South America and Europe, perfecting his art and making a good living, before returning to New York and Gurney's studio in 1853. In 1854 he pioneered work in paper photography and began making enlarged photographs. He was no longer working with Gurney when he opened his Photographic Temple of Art on Broadway around 1857. Such was his success that by 1860 he had eleven camera operators working for him. He was especially well known in the 1860s for his cartes-de-visite and continued to work until a few years before his death.

INCIDENTS OF THE WAR.

No. 212.

MRS. GREENHOW AND DAUGHTER,

Imprisoned in the Old Capitol, Washington.

Rose O'Neal
Greenhow
(1817–64) and
her daughter
'Little Rose'
Confederate spy

Alexander Gardner,
Mathew Brady
Studio, 1862
Albumen silver print,
197 x 160mm
(7¾ x 6¼")
NPG.96.78

Rose Greenhow was a leading member of Washington society, a passionate secessionist and one of the most renowned spies in the Civil War. She passed information to Confederate officials about Washington's defences and Union troop movements. After a period of house arrest and then imprisonment, she was exiled to the Confederate states, where she was warmly welcomed by President Jefferson Davis. She toured Britain and France as a propagandist for the Confederate cause, publishing her memoirs, *My Imprisonment and the First Year of Abolition Rule at Washington*, shortly after arriving in London. The book was an immediate success, and she was well received by members of royalty and the nobility sympathetic to the South's cause. In 1864, after a year abroad, she started for home, but her ship, the *Condor*, a British blockade-runner, ran aground at the mouth of the Cape Fear River near Wilmington, North Carolina. To avoid the Union gunboat pursuing her, she fled in a rowing boat, but it capsized and she was drowned. In October 1864 she was buried with full military honours at Wilmington. Her coffin was wrapped in the Confederate flag and carried by Confederate troops.

Her epitaph reads: 'Mrs. Rose O'N. Greenhow, a bearer of dispatchs to the Confederate Government'.

Alexander Gardner (1821–82), an idealistic Glasgow newspaper editor who studied science in his spare time, was later credited with the photographic advances brought about by the wet-plate process. He left Scotland in 1856 for New York, where he worked for Mathew Brady. He then managed Brady's gallery in Washington, DC, from 1858 until the start of the Civil War. Early in the war, Brady obtained permission for his photographers to work on the battlefield and document the conflict's progress. Gardner joined the staff of General George B. McClellan in 1861 and continued to work sporadically for Brady until 1862. He made this image of Rose Greenhow and her daughter between January and May 1862, while they were in the Old Capitol Prison. More than 100 of his wartime photographs were published in *Gardner's Photographic Sketch Book of the War* in 1866.

Clarence King
(1842–1901) and the
Field Party of 1864
Geologist

Silas Selleck, 1864
Albumen silver print,
206 x 155mm
(8⅛ x 6⅛")
NPG.92.61

One of America's great nineteenth-century scientists, Clarence King was born at Newport, Rhode Island, into a family of sea captains, merchants and makers of navigational tools. From an early age he showed much interest in geology. In 1862 he was in the first graduating class of the Sheffield Scientific School at Yale, where he was inspired by two professors in particular, James Dwight Dana, the geologist attached to the first expedition to the Shasta region of California in 1841, and George Brush. It was through Brush that he heard about William Brewer, the botanist chosen to lead the northern part of the Geological Survey of California, where the centre of interest was Mount Shasta. King decided to go to California, inviting his friend James Gardiner to accompany him. While on a boat heading for San Francisco, they actually met Brewer, and King immediately volunteered to join the survey. He was with Brewer on the 1863 trip to Mount Shasta, and Gardiner joined them the following year, when this photograph was taken. Brewer is seated, with King to his left, while Gardiner kneels and a fourth member of the party, Richard Cotter, stands to Brewer's right. When the survey concluded in 1866, King proposed, and then went

on to lead, a survey of the 40th parallel (1870–78), the success of which led to his appointment as director of the new United States Geographical Survey in 1879. He resigned in 1881, withdrawing from the scientific world and becoming more involved with commercial mining ventures. Although these proved unsuccessful and he suffered from poor mental and physical health for the rest of his life, his contributions to the early study of geology in America, based on scientific accuracy, sound organisational skills and integrity, remain immeasurable.

In 1851 Silas Selleck (*fl.c.*1851–76) was a founding member of the New York State Daguerrean Association and is thought to have worked in Mathew Brady's New York gallery. He arrived in San Francisco in 1852, working there in partnership with George Johnson at the latter's photographic gallery. He has been credited with teaching Eadweard Muybridge, among others.

189

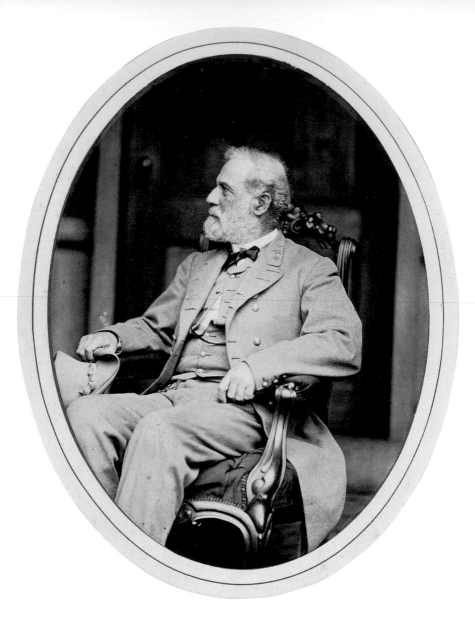

Robert E. Lee
(1807–70)
Confederate
general

Mathew Brady, 1865
Albumen silver print,
208 x 153mm
(8⅛ x 6")
NPG.78.243

The son of 'Light-Horse Harry' Lee, a cavalry hero of the American Revolution, Robert E. Lee attended the US Military Academy at West Point, graduating in 1829, and received a commission in the Engineer Corps. He served with distinction under Winfield Scott in the Mexican War and from 1852 to 1855 was superintendent of West Point. He commanded the US troops that captured John Brown at Harpers Ferry in 1859. When the southern states seceded, he resigned from the US Army so as to be free to serve his native state of Virginia. Even though he revered the Union and was said not to be in favour of slavery, he felt that Virginia was where his first loyalty lay. In 1862 he accepted the position of commander of the Confederate Army of Northern Virginia. In the early part of the war his forces won several notable victories – at the second Battle of Bull Run, at Fredericksburg and Chancellorsville – but their efforts to push northwards proved unsuccessful, ending finally in defeat at Gettysburg in 1863. Again, in the Wilderness campaign of 1864 they fared badly against Union troops. In February 1865 Lee became commander-in-chief of all the southern armies, but by then the Confederate cause was hopeless, and on 9 April he surrendered to General Ulysses S. Grant at Appomattox Court House, Virginia. From 1865 until his death he served as president of Washington College in Lexington, Virginia.

With the outbreak of the Civil War Mathew Brady (1823–96), who already had successful photographic studios in New York and Washington, DC, set about compiling a visual record of American history in the making, employing teams of photographers who operated from different bases across the battlefields. At the end of the war, he went to Richmond, Virginia, to photograph Lee at his home on Franklin Street. Some people, he recalled, thought it 'preposterous' to ask Lee to sit for him after his defeat, but Brady himself felt that this was the perfect time for such a 'historical picture'. The result is Lee transformed into a civilian, sitting sedately on the front porch at his home.

Mathew Brady Studio,
1865
Albumen silver print,
367 x 455mm
(14½ x 17⅞")
NPG.94.97

William Tecumseh Sherman, a graduate of the US Military Academy at West Point and a veteran of the Mexican War, rejoined the Union army on the outbreak of the Civil War. He emerged as an important military leader at the Battle of Shiloh in April 1862, after which he was involved, with Ulysses S. Grant, in further notable victories against the Confederacy at Vicksburg and Chattanooga. In March 1864 he was appointed by Grant to the command of the Military Division of the Mississippi and in May he began his lengthy campaign against Atlanta, which was evacuated on 1 September before his troops fired the city. His success there effectively ensured Abraham Lincoln's re-election as president, and also introduced the concept of 'total war' – in other words, war on civilians and economic targets as well as military opponents. After Atlanta, Sherman commenced his 'March to the Sea', in which his army of more than 60,000 men destroyed everything in their path en route to Savannah, which they reached in December 1864. They then moved north through the Carolinas, causing even further devastation and winning more victories. The war finally came to an end on 26 April in Durham,

North Carolina, when General Joseph E. Johnston surrendered to Sherman (Robert E. Lee had already surrendered to Grant on 9 April). After the war Sherman served as commander-in-chief of the US Army until his retirement in 1883. In 1884 he famously refused to be nominated for president by the Republican Party, saying, 'I will not accept if nominated and will not serve if elected.'

Sherman and his generals sat for a group portrait in Mathew Brady's Washington studio in the spring of 1865 as part of Brady's project of recording the events of the Civil War in photographic form. Along with Sherman are, from the left, Oliver Otis Howard (1830–1909), John Alexander Logan (1826–86), William Babcock Hazen (1830–87), Jefferson Columbus Davis (1812–94), Henry Warner Slocum (1827–94) and Joseph Anthony Mower (1827–70). Another general, F. B. Blair, should have been present but could not be found at the time; in some later reproductions of the image, his figure has been added.

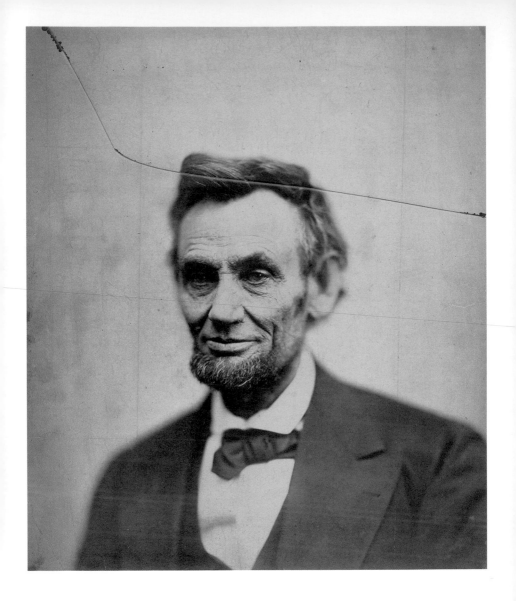

Abraham Lincoln
(1809–65)
Sixteenth
President of the
United States

Alexander Gardner,
1865
Albumen silver print,
450 x 386mm
(17⅝ x 15¼") image
NPG.81.M1

Although he was born in a Kentucky log cabin and grew up on the frontier with practically no schooling, by 1836 Abraham Lincoln was practising law in Springfield, Illinois. He served a term in Congress in 1846 and in 1858, as a senatorial candidate for the new Republican Party, attracted attention as a skilled orator in debates about the extension of slavery, to which he was fiercely opposed. In May 1860 he won the Republican nomination for president and, helped by a split in the Democratic Party, was duly elected. In his inaugural address on 4 March 1861, against the background of secession by the southern states, he declared the Union perpetual and reiterated his determination to uphold the law in all states. However, on 12 April 1861 the Confederates attacked Fort Sumter in Charleston and the Civil War began. Lincoln was profoundly hostile to slavery, but for the first seventeen months of the war he emphasised other issues, particularly the importance of enforcing the Constitution and democracy. But in September 1862 he issued the preliminary proclamation of emancipation, seeing that the destruction of slavery was essential to Union victory; the final proclamation, freeing all slaves in the area of rebellion, was signed on 1 January 1863. Thanks in part to Sherman's capture of Atlanta, he was re-elected in 1864. In March 1865, in his second inaugural address, he spoke of reuniting the country 'with malice toward none', but a month later, on 14 April, he was assassinated in his presidential box at Ford's Theater by John Wilkes Booth.

On 5 February 1865 Lincoln visited the photographic studio of Alexander Gardner (1821–82), where he posed for a series of portraits, including this one. Gardner used a very large glass negative, which unfortunately broke after it was developed, and only a single print was made before the negative was discarded. After Lincoln's death, this portrait acquired special significance. The slicing crack in the plate was seen as foretelling his impending death and, although Robert E. Lee's surrender at the Appomattox Court House was still months away, viewers read Lincoln's contemplative smile as a weary response to the war's end.

James T. Fields
(1817–81)
Publisher

Julia Margaret
Cameron, 1869
Albumen silver print,
325 x 261mm
(12¾ x 10¼")
NPG.83.194

James Thomas Fields exerted considerable influence over the American literary scene throughout the middle years of the nineteenth century. Born in Portsmouth, New Hampshire, in 1838 he joined the Boston publishing firm that eventually became Ticknor & Fields. He and W. D. Ticknor printed books on the first floor of their premises and then sold them downstairs in their Old Corner Bookstore, which became a meeting place for many of the most important writers and thinkers of the day. They also introduced the royalty system, enabling authors to continue receiving money for their work after publication. In 1861 Fields became editor of the influential *Atlantic Monthly,* and, during his ten years there, he published a number of important New England writers, including Henry Wadsworth Longfellow and Harriet Beecher Stowe. He lectured and wrote several volumes of poetry and essays, including *A Few Verses for a Few Friends* (1858) and the reminiscences collected in *Yesterdays with Authors* (1872). His wife, Annie Adams Fields, was well known for her literary salons at their Boston home. Frequent trips to Europe and friendships with a wide range of people made Fields America's unofficial literary ambassador, while his ability to find good books that also sold made him a wealthy man.

Julia Margaret Cameron (1815–79) met Fields through Alfred, Lord Tennyson, the Poet Laureate, who was a mutual friend, and took this photograph of him in 1869, on his final trip to Europe. Her interest in photography had started when, at the age of forty-eight, she was given a camera by her children. She became an indefatigable amateur photographer, much influenced in style by the work of the Pre-Raphaelites, and produced a steady stream of portraits and fancy-dress tableaux using the wet collodion process. Many of these depict prominent figures from the worlds of arts, letters and science, since this was the milieu in which she moved. Her photographs are notable for their sense of extreme intimacy and psychological intensity, effects she achieved by her use of close-up and dramatic lighting and her suppression of detail (sometimes accompanied by peripheral blurring).

Frank Cushing
(1857–1900) with
Laiyuahtsailunkya,
Naiyutchi,
Palowahtiwa,
Kiasiwa, Nanake
Ethnologist

James Wallace Black,
1882
Albumen silver print,
160 x 223mm
(6¼ x 8¾")
NPG.95.23

Although Frank Cushing's education as a child could at best be described as informal and sporadic, this did not mean that it lacked depth or focus. Almost from the moment one of his father's farmhands showed him an Indian arrowhead found in a field, he was determined to learn all he could about the remains of Indian culture in the area around his family's home in Medina, New York. By the age of eighteen his field research and wide reading about Indian culture had made him such a capable ethnologist that the Smithsonian Institution appointed him its Curator of Ethnology. A few years later, under the auspices of the Bureau of American Ethnology, he embarked on his most ambitious project to date: a five-year study of Zuni Pueblo culture. Through this detailed examination of an American Indian culture he demonstrated how it was wrong to assume that cultures at similar stages of development automatically shared patterns of social organisation and customs. He pioneered the participant method of field observation by living among the Zuni, taking an active part in the secular and sacred lives of their people. He was rewarded in 1881 with the singular honour of membership in the Bow Priesthood.

The following year he escorted six Zuni Priests of the Bow on a journey to the east coast. After stopping in Washington, where they were received by President Chester Arthur, Cushing and his party travelled north to Boston. While there they visited the studio of James Wallace Black (1825–96) and posed for this photograph, which features Cushing, dressed in Zuni attire, surrounded by five members of the Bow Priesthood delegation.

Black had initially wanted to be a painter, but after failing to make a mark in this sphere he turned to photography, starting as a daguerreotype plate polisher. His career was marked by experimentation and innovation. Working with the balloon navigator Samuel A. King, he made the first successful aerial photographs in the United States, and later he was best known for his interest in the magic lantern, a candlelight-powered projector that was the forerunner of today's slide projector.

John Swartz, 1900
Gelatin silver print,
166 x 316mm
(6⅝ x 12½") image
NPG.82.66

The Wild Bunch, the last and most colourful of the outlaw gangs of the Old West, were at their most audacious between 1896 and 1901. Led by Robert Leroy Parker ('Butch Cassidy', 1866–1908) and his sidekick Harry Longabaugh ('The Sundance Kid', 1867–1908), they were responsible for a series of daring bank, train and payroll robberies in Utah, Colorado and Wyoming. On 2 June 1899, for example, they flagged down a Union Pacific train in Wyoming and blew open the safe, collecting more than $30,000. A number of similar robberies prompted the railway company to form its own gang to bring in the outlaws. In 1900, pursued by lawmen, Pinkerton detectives, and bank and railway detectives, the Wild Bunch decided to split up. Butch Cassidy and the Sundance Kid made plans to move to South America. On 21 November 1900 the gang met at Fort Worth, Texas, and had their photograph taken by John Swartz. The image shows, from left to right, standing: William R. Carver ('Will Casey') and Harvey Logan ('Kid Curry'); seated: the Sundance Kid, Ben Kilpatrick ('The Tall Texan') and Butch Cassidy. Five months after being robbed on 19 September 1900, the First National Bank in Winnemucca, Nevada, received a copy of this photograph and for years the men shown were assumed to have carried out the robbery. However, it is now known that neither Butch Cassidy nor the Sundance Kid was in Winnemucca then and that Pinkerton agents had in fact sent the photograph. A detective in Fort Worth had found it at Swartz's studio and, recognising the gang, sent a copy to Pinkerton's, who were investigating the robbery for the American Bankers Association.

By March 1901 Butch Cassidy and the Sundance Kid, together with the latter's wife, Etta Place, had settled on a ranch in Argentina. The outlaws soon reverted to robbery, though, operating throughout South America. A Pinkerton agent was still on their trail, and finally, in 1908, after holding up a payroll in the mountains of Bolivia, they were surrounded by Bolivian cavalry. Refusing to surrender, they supposedly died in the ensuing gunfight.

Jack London
(1876–1916)
Author

Arnold Genthe,
c.1900
Gelatin silver print,
238 x 180mm
(9⅜ x 7¹/₁₆")
NPG.98.57

The best-selling and highest-paid American author of his time, Jack London was the illegimate son of a spiritualist. Growing up in poverty in San Francisco, he had little formal schooling but was an avid reader, educating himself at public libraries. He eventually went to university, but stayed only six months, finding it 'not alive enough'. Instead he determined to make his mark as a writer. Tales of adventure, his works focused on man's endless struggles with nature, and his own experiences provided the inspiration. He had been a labourer, a sailor and a gold prospector in the Klondike (1897–8). As a journalist he covered the Russo-Japanese War in 1904 and the Mexican Revolution in 1914. During his travels he espoused socialism, for which he remained a passionate advocate. His output was prolific: many books and articles were published in his lifetime and more appeared posthumously. His most famous books include *The Call of the Wild* (1903), *The Sea-Wolf* (1904), *White Fang* (1906), *The Iron Heel* (1908) and *South Sea Tales* (1911). The semi-autobiographical *Martin Eden* (1909) describes the hero's struggles to become a writer, but ends with his disillusionment. *John Barleycorn* (1913)

is a record of London's own fight with alcohol. He died of kidney failure at the age of forty, a broken man.

Originally trained as a classical scholar, Arnold Genthe (1869–1942) taught himself photography after emigrating from Germany in 1895. The success of his photographs of San Francisco's Chinatown led him to open a portrait studio there. In his memoirs, *As I Remember*, he describes being introduced to London by John O'Hara Cosgrave, editor of *The Wave*:

> Cosgrave had given him a note to me which read, 'Please make a picture of bearer. He has written a rattling good story for *The Wave* and I feel sure he will be heard from in the future.' I made many pictures of London during the following years, and as a token of his appreciation he gave me copies of every one of his books, inscribing some lines on the flyleaf of each.

Stanford White
(1853–1906)
Architect

Gertrude Käsebier,
c.1903
Gum bichromate print,
205 x 152mm
(8⅛ x 6")
NPG.94.262

A partner in the prestigious New York firm of architects McKim, Mead and White, Stanford White was largely responsible for their reputation as masters of decorative detail. With a remarkable eye for colour and texture, he was considered one of the best architects of his day. Eventually best known for his work in the classical style, he was responsible for Madison Square Garden and the Tiffany Building in New York, while his Madison Square Presbyterian Church, which no longer survives, was considered to be his masterpiece. In the late 1880s he was the darling of the nouveaux riches, who had discovered Long Island as a fox-hunting, polo-playing and yachting haven. He designed several hotels and homes there, including the Garden City Hotel, which became the centre of Island society, frequented by the Vanderbilts, Morgans and Astors, and a huge stone French château built on 600 acres in Roslyn Harbor for silver-mining heir Clarence Mackay. But perhaps White is best remembered as the man-about-town who was shot to death, seated at his table on the rooftop restaurant at Madison Square Garden, by millionaire playboy Harry Thaw, with whose wife White had had an affair.

Gertrude Käsebier (1852–1934) originally wanted to be a portrait painter and in her thirties returned to college to study painting and drawing. She had always been interested in photography, however, and when, in 1894, she won two photography competitions she decided to reconsider her choice of career. In 1895 she opened a photographic studio in New York, and this soon became very successful. She was much admired for her ability to express emotion and character without relying on props and fussy backgrounds. She also experimented with new processes, adding brushstrokes, removing detail and enhancing the surface of her photographs with ink, chalk or pencil. She was the first woman to be elected to the prestigious Linked Ring and was also a founding member of Stieglitz's Photo-Secession, groups whose members sought to elevate photography to the highest form of art. The soft, dark, textured portrait shown here conveys both Käsebier's ambitions as an artist and White's aesthetic prowess.

Edward Steichen
(1879–1973)
Photographer

Heinrich Kühn, c.1907
Waxed bromoil print,
289 x 229mm
(11⅜ x 9")
NPG.84.269

One of America's most influential figures in twentieth-century photography, Edward Steichen worked in a range of different styles throughout his long career and was curator of a number of important photographic exhibitions. He was born in Luxembourg but moved to America in 1881. Having studied art and painting, he began to work with photography in 1895, becoming well known for photographs whose soft focus and painterly effects showed the influence of Impressionist painting. His work was included in the exhibition *The New School of American Photography* in London and Paris (1901), and he was elected to the Linked Ring – a group of photographers based in London who wanted to enhance photography as a fine art. In 1902 he became a founding member of the Photo-Secession, which sought to raise the profile of photography in America. He also helped Alfred Stieglitz establish the Little Galleries (later 291). In 1906 he moved to Paris, where he became involved with the avant-garde movement, sending Stieglitz works by artists such as Picasso, Cézanne, Rodin and Matisse, which would be shown in America for the first time at 291. In the 1920s and 1930s he concentrated on commercial photography,

working for *Vogue* and *Vanity Fair*. After the Second World War he organised exhibitions, most importantly *The Family of Man* (1955) at the Museum of Modern Art, New York, the first major post-war museum-sponsored photographic exhibition in America. As he wrote in 1967, 'Today I am no longer concerned with photography as an art form. I believe it is potentially the best medium for explaining man to himself and his fellow man.'

In 1901 he met Heinrich Kühn (1866–1944), who was already a member of the Linked Ring and involved in the European art photography scene. On Stieglitz's invitation, Kühn became the first foreign member of the Photo-Secession in 1904. He met Steichen, Stieglitz and fellow photographer Frank Eugene in Europe at least twice in 1907 and 1909, and they experimented with some of the latest processes in colour photography. At one of these collaborations he is believed to have taken this portrait of Steichen, which shares the same dark, painterly, romantic style that Steichen often used in his own early portrait work.

Katharine Nash
Rhoades
(1885–1965)
Artist

Alfred Stieglitz, 1915
Waxed platinum print,
247 x 195mm
(9¾ x 7⅝")
Gift of Elizabeth
Rhoades Reynolds
NPG.85.51

Katharine Nash Rhoades left a sheltered New York home to pursue a career as an artist and advocate of modern art. In 1908 she joined sculptor Malvina Hoffman on an extended trip to Europe, and when she returned she joined New York's Dada group. Alfred Stieglitz published her poetry in *Camera Work* and exhibited her paintings at his gallery, 291, where critics observed that she had 'not been studying with any one, but in Paris, and that has been enough'. In 1915 Agnes Meyer, a friend and fellow Stieglitz supporter, introduced her to Charles Lang Freer, the collector of Asian art. For many years Rhoades worked as Freer's secretary and research associate, helping him establish the Freer Gallery of Art, which opened to the public as part of the Smithsonian Institution in 1923.

Alfred Stieglitz (1864–1946) was born in America to German parents and went to Berlin to complete his education, studying photochemistry. He returned to New York in 1890 and became a partner in the Photochrome Engraving Company but was soon more interested in campaigns to promote photography as a means of artistic expression. He edited the *American Amateur Photographer*, then worked for the Camera Club of New York and its periodical, *Camera Notes*, before establishing the Photo-Secession and *Camera Work*, which he published and edited from 1903 to 1917. He organised national exhibitions of pictorialist photography and ran 291, which introduced Americans to modern European art movements. In 1915 he was briefly involved with the New York Dada group, and it was on 6 June that he photographed Rhoades, at the time of her exhibition at 291. The portrait shows his work in a transitional phase, between pictorialism and modern art. Although he used soft platinum paper and emphasised dramatic design, in every other way he transformed the old pictorialist conventions with energy and light, from the electric feathers of Rhoades's hat to the strong physical presence of her head and hands. It was a style he was to develop later, notably in his portraits of Georgia O'Keeffe.

Georgia O'Keeffe
(1887–1986)
Artist

Paul Strand, 1918
Platinum print,
199 x 189mm
(7¾ x 7½") image
NPG.84.159

One of America's greatest artists, Georgia O'Keeffe studied at the Art Institute of Chicago (1905–6) and the Art Students League, New York (1907–8) but found the emphasis placed on imitative realism too restrictive. It was not until 1912, when she studied with Arthur Wesley Dow, that her interest in art was rekindled. Dow believed that art should express the artist's personal feelings and was best realised through harmonious arrangements of line and colour. O'Keeffe experimented with his ideas for two years, during which time she taught art in Texas. In 1916 her abstract charcoal drawings were seen by Alfred Stieglitz, and the two began to correspond. Stieglitz exhibited ten of her drawings at his avant-garde gallery, 291, and in 1917 she had a one-woman show of her work there. In 1918 he offered her financial support to paint for a year in New York and, shortly after her arrival, they started living and working together, marrying in 1924. In 1929 O'Keeffe spent the first of many summers painting in New Mexico, where the stunning vistas and stark landscapes provided sources of great inspiration. From 1923 until his death in 1946, Stieglitz organised annual exhibitions of her work and as early as the mid-1920s, when she began painting large-scale, close-up flowers, her importance was recognised. In 1949 she moved permanently to New Mexico, where she continued to paint and work in clay until ill-health put an end to her artistic activities in 1984.

Paul Strand (1890–1976) became interested in photography as a student of Lewis Hine, who introduced him to Stieglitz in 1907. Over the next few years he saw both the new abstract art and sculpture and also photographs by the nineteenth-century masters exhibited at 291. Inspired by its expressive possibilities, he advocated a form of realism known as 'straight' photography. Examples appeared in Camera Work, and he had a one-man show at 291. He was introduced to O'Keeffe by Stieglitz, and they became close friends. This picture was taken in 1918, when Strand went to Texas at Stieglitz's request to encourage O'Keeffe to come to New York to paint.

Irene Castle
(1893–1969)
Dancer

Baron Adolph de Meyer,
1919
Photogravure,
448 x 350mm
(17⅝ x 13¾")
NPG.94.10

Born into a prosperous family in New Rochelle, New York, Irene Foote was determined from a young age to be a star. In May 1911 she married Vernon Castle, an English actor working in America, and later that year, in Paris and in need of money, the couple took a job as exhibition dancers at the Café de Paris. Their act was a great success, and they suddenly found themselves in demand throughout Europe. In 1913 they returned to New York, where they were engaged by the Café de l'Opera. At a time when conservatives felt threatened by the craze for ragtime and the sensuous nature of so-called 'animal dances' – the turkey trot, the chicken scratch, the grizzly bear – the Castles were seen as providing a wholesome alternative: a young married couple who could dance with grace and decorum to modern music. They were taken up by New York society and Broadway shows followed. They ran an enormously successful dancing school and Irene became a role model for young women: when she bobbed her hair and abandoned corsets for loose-fitting dresses, others followed. Then, in 1916, Vernon returned to England and joined the Royal Flying Corps. After many wartime missions, he came back to America to train pilots but was killed in 1918 in a flying accident. Irene tried to rebuild her dancing career with new partners, and also continued to appear on stage and in silent films, but times had changed; her greatest successes were behind her. In 1939 Fred Astaire and Ginger Rogers starred in a film version of the Castles' life story.

Baron Adolph de Meyer (1868–1946) was part of London society before the First World War and started taking elegant portrait photographs of his stylish friends. In 1914 he and his wife left for New York, where he was hired by Condé Nast as the first full-time photographer at *Vogue*. The magazine realised that his glamorous portrait style could be used to help sell modern fashions, and this portrait appeared on 1 April 1919, illustrating the Lewis Company's ostrich-feather hat.

Michel Fokine
(1880–1942)
Choreographer

Clara Sipprell, 1923
Gelatin silver print,
237 x 189mm
(9⅜ x 7½")
Bequest of
Phyllis Fenner
NPG.82.157

As ballet master for Sergei Diaghilev's Ballets Russes in Paris from 1909 to 1914, Russian-born choreographer Michel Fokine brought ballet into the modern era with such innovative and influential works as *Les Sylphides* (1909), *The Firebird* (1910), *Petrushka* (1911) and *Daphnis et Chloé* (1912). He studied at the Imperial Ballet in St Petersburg and started teaching there in 1902. He emphasised the need to move beyond mere ornamentation and appeal to audiences' souls, making use of the whole body to express emotion, and put his theory into practice in 1907 when he choreographed a memorable 'Dying Swan' for Anna Pavlova. His training enabled him to preserve the principles of classic choreography while at the same time discarding its more stylised, artificial conventions and introducing a new vitality. He collaborated with leading composers and designers of the day, such as Stravinsky and Ravel, and Bakst and Benois, to realise his vision of ballet as an art form in which dance movements, music and stage settings were of equal importance in creating a dynamic whole. After breaking with Diaghilev, he worked throughout Europe, teaching and choreographing for theatre and ballet.

In 1918 he and his wife left Russia for good, staying in Denmark briefly before going to the United States in August 1919. When they first arrived there was little interest in ballet outside New York and they toured major US cities, dancing at galas and charity events to raise awareness. They opened a ballet school at their New York home and Fokine worked on and off Broadway, his performances and choreography doing much to lay the foundations for the interest in ballet that exists in America today.

Clara Sipprell (1885–1975) was one of America's most prolific and successful pictorial photographers. Her use of a soft-focus lens and her reliance on natural lighting gave her work an atmospheric, moody romanticism, ideally suited to the subject here. She did not confine herself to portraits, however, and throughout the 1920s and 1930s her landscapes, cityscapes and still lifes were exhibited widely in the US and abroad.

Peggy Guggenheim
(1898–1979)
Art collector, patron

Man Ray, 1924
Gelatin silver print,
485 x 331mm
(19⅛ x 13⅛") image
NPG.84.120

Peggy Guggenheim, one of the principal patrons and collectors of modern art, came from an influential and affluent New York family. Benjamin Guggenheim, her father, controlled the family's mining interests, and Solomon R. Guggenheim, her uncle, founded the Guggenheim Museum. Her father died on the *Titanic* in 1912, having spent almost all his fortune, but the family saw to it that Peggy was provided for. In 1919 she was taken by friends to meet Alfred Stieglitz at his 291 gallery. There he showed her a painting by Georgia O'Keeffe, introducing her to the abstract and modern art that would become her passion. In 1920 she moved to Paris, where she was soon involved in the avant-garde art movement. She stayed there for many years, supporting writers and artists – often expatriate Americans – and buying works of art. In 1938 she opened the short-lived London Jeune gallery. She left Europe in 1941 and returned to New York, where she opened a new gallery, Art of This Century, and was an important patron to such artists as Jackson Pollock, Robert Motherwell and Mark Rothko. In 1947 she moved to Venice, staying there for the rest of her life.

Painter and photographer Man Ray (1890–1976) was the only American to play a prominent role in the Dada and Surrealist movements. When Guggenheim met him in the 1920s, he was an established fashion photographer who had worked for the designer Paul Poiret, as well as *Vogue* and *Harper's Bazaar*. He was interested in combining art and fashion in a new kind of avant-garde aesthetic. In 1924 she asked him to photograph her in a Paul Poiret gown with a beaded pink and blue bodice and a long gold-lamé skirt. With it she wore a gold Russian-style turban designed by Vera Stravinsky, the composer's wife, to make her look more exotic. The portrait is reminiscent of Man Ray's fashion photography for Poiret, but the full-length pose and large size make it different from many of his other portraits at this time.

'Babe' Ruth
(1895–1948)
Baseball player

Nickolas Muray, 1927
(printed 1978)
Gelatin silver print,
245 x 195mm
(9⅝ x 7⅝") image
NPG.78.150

George Herman 'Babe' Ruth was the ultimate baseball hero – a larger-than-life character with breathtaking talent who set the standard by which others were judged. Born into a poverty-stricken family in Baltimore, he was playing in a minor league until, aged nineteen, he was spotted by the Boston Red Sox. He became their star pitcher, setting the record for pitching scoreless innings, and also excelled as a hitter. In 1920 the New York Yankees purchased him for $125,000 plus a huge loan. At the time this seemed an enormous sum, but Ruth silenced the critics with an astonishing fifty-four homers in his first season and fifty-nine the next. He set record after record over his fifteen years with the Yankees: fifty home runs in four separate seasons, sixty home runs in 1927, 714 home runs overall (a figure not surpassed until 1974) and fifteen home runs in World Series games. Attendance records were broken and profits soared. In 1930 and 1931, in the middle of the Depression, his annual salary was a massive $80,000. When the Yankees moved into a splendid new stadium in 1923, the nation knew it as 'the house that Ruth built'. In the words of sports writer Red Smith, 'It wasn't just that [Ruth] hit more home runs than anyone else, he hit them better, higher, farther, with more theatrical timing and a more flamboyant flourish.'

As a student in Hungary Nickolas Muray (1892–1965) studied all aspects of photography. He then moved to New York, where he was employed by Condé Nast as a photo-engraver, making colour separations and half-tone negatives. Determined to work for himself and interested primarily in portraiture, in 1920 he opened a studio in Greenwich Village, and here he photographed many celebrities of the day. *Harper's Bazaar* began to publish his work regularly. Reflecting on his career in later life, he wrote, 'Photography…to me has not only been a profession but also a contact between people – to understand human nature and record, if possible, the best in each individual.'

Alexander Calder
(1898–1976)
Artist

André Kertész, 1929
(printed later)
Gelatin silver print,
167 x 226mm
(6½ x 8⅞")
NPG.83.212

Best known as the inventor of the mobile, Alexander Calder was a pioneer of kinetic art. His grandfather and father were sculptors and his mother was a painter, but he did not show an interest in art until he finished training as a mechanical engineer. He then studied at the Art Students League in New York (1923–6), where his ability to convey a sense of movement with a single unbroken line was remarked upon. From this it was a short step to his wire sculptures, the first of which was done in 1925. He also made animated toys in a similar fashion. He exhibited these works in New York in 1928. From then he divided his time between America and France. He knew many of the leading European avant-garde artists, notably Miró, who became a lifelong friend. In 1931 he joined the Abstraction-Creation association and in the same year produced the first of his non-figurative moving constructions. Operated by hand or by motor power, they were named 'mobiles' in 1932 by Duchamp; Arp suggested 'stabiles' for the non-moving constructions in the same year. In 1934 Calder began to make the unpowered mobiles for which he is best known. Constructed from pieces of shaped and painted tin suspended on thin wires or cords which responded by their own weight to the faintest air currents, they were designed to take advantage of the changing light effects that resulted. Calder described them as 'four-dimensional drawings' and, in a letter to Duchamp in 1932, wrote of his wish to make 'moving Mondrians'.

Hungarian-born photographer André Kertész (1894–1985) settled in Paris in the late 1920s. A pioneer in the use of the small-format camera for serious photography, he exerted great influence on his contemporaries and on succeeding generations of photographers. In the words of Cartier-Bresson, 'Whatever we have done, Kertész did first.' This photograph, taken in Paris in 1929, shows Calder assembling his first major work, *The Circus*, a whimsical construction of string, wire and wood inspired by a visit to the Ringling Brothers–Barnum and Bailey Circus in 1925.

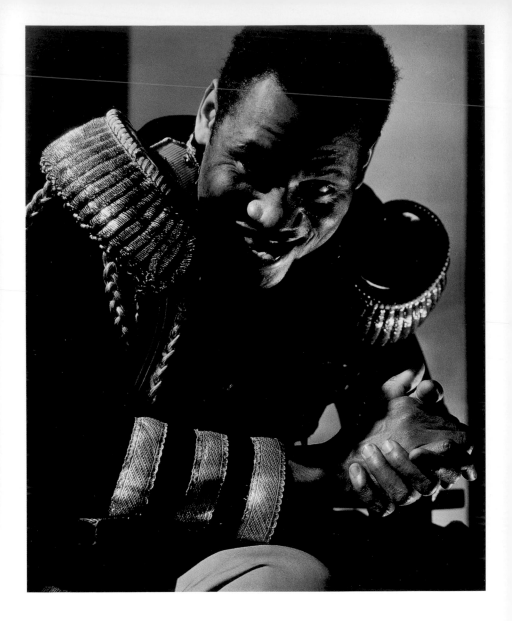

An actor with extraordinary presence and a rich, powerful singing voice, Paul Robeson became an international star in the 1930s. Born in Princeton, New Jersey, he was an outstanding college athlete and received a law degree from Columbia University but decided on a stage career. He first appeared on Broadway in 1922 and in 1924 played the lead in Eugene O'Neill's *The Emperor Jones*, a performance that won him great critical acclaim. His success as an actor was matched by his popularity as a singer and he gave concerts of spirituals and Broadway musical songs worldwide. He also appeared in musicals, his rendition of 'Ol' Man River' in the 1932 revival of *Show Boat* being particularly memorable. His greatest stage role was Othello, in England in 1930 and New York in 1943. Meanwhile, he appeared in a number of films, including *Sanders of the River* (1935) and *King Solomon's Mines* (1937), both made in Britain. Because of the racist attitudes he encountered in America, he spent much of the 1930s abroad, especially in London. He became a socialist and during the Spanish Civil War went to entertain Republican troops and members of the International Brigade.

He became an increasingly committed communist and this, along with his increasing support for civil rights activities in America through the 1940s, brought him to the attention of Senator Joseph McCarthy and congressional investigators. His loyalty was called into question and he was denounced for his political views. His passport was revoked in 1950, he was blacklisted and his career was effectively destroyed. In 1958, when he published *Here I Stand*, a statement of his beliefs, the major papers refused to review it, and he spent his remaining years in seclusion.

Edward Steichen (1879–1973) became chief photographer for Condé Nast in 1923, publishing regularly in *Vogue* and *Vanity Fair* for the next fifteen years. Unlike Stieglitz, with whom he had formerly worked closely, he believed that fashion and other forms of commercial photography could be raised to the level of art. He took this photograph of Robeson as the Emperor Jones for *Vogue* in 1933.

Andrew Furuseth
(1854–1938)
Labour leader

Dorothea Lange, 1934
Gelatin silver print,
205 x 196mm
(8⅛ x 7⅝")
NPG.95.91

Born in Romedal, Norway, Andrew Furuseth came to America in 1880 as a seaman and in 1888 helped to organise the Sailor's Union of the Pacific, becoming its secretary. He led the International Seamen's Union from 1908 until 1938, acting as the spokesman for America's seamen and promoting legislation abroad to benefit them. Most noteworthy among his achievements was the drafting of the Seamen's Act, passed in 1915, which provided for minimum safety and living conditions and otherwise defined the legal rights of seamen. Although he headed a powerful union, throughout his time in office he took only the wages of an ordinary seaman.

Having been given her first camera by Arnold Genthe, Dorothea Lange (1895–1965) studied under Clarence White at Columbia University, New York, and started her career as a portrait photographer in San Francisco. Here she was shocked by the number of homeless people in search of work and decided to take pictures of them to draw attention to their plight. She was introduced to Furuseth in 1934 by Paul Schuster Taylor, a professor of economics at the University of California at Berkeley. While a graduate student at the University of Wisconsin, investigating the relationship between history, economics, politics and labour, Taylor had made Furuseth and his work with the Sailor's Union of the Pacific the subject of his dissertation and first book. Lange photographed Furuseth the year Taylor hired her to provide documentation for his research into conditions in the migrant labour camps in the Sacramento Valley. Her work for Taylor, and for the Farm Security Administration photographic unit under Roy Stryker, made her a leader in the use of documentary photography as a force for social change. She photographed migrant workers, sharecroppers, tenant farmers and other victims of the Depression in twenty-two states between 1935 and 1942, her pictures 'Migrant Mother' and 'White Angel Breadline' becoming some of the best-known images of the time. This portrait of Furuseth combines her political commitment, her aesthetic vision and her compassion for her subjects. It also unites her work with that of Taylor, who became her husband in 1935.

Aaron Copland
(1900–90)
Composer

George Platt Lynes,
c.1935
Gelatin silver print,
329 x 261mm
(12⅞ x 10¼")
NPG.84.264

In the course of his long musical career, Aaron Copland distinguished himself as a conductor, teacher and critic, but his greatest achievements by far were as a composer. Born in Brooklyn to Russian Jewish parents, he was the first American composer whose work was recognised as being distinctively national. In 1921 he went to Paris to study composition with Nadia Boulanger, staying three years. On his return he composed the Symphony for Organ and Orchestra, which was performed at Carnegie Hall with the New York Symphony Orchestra. After this successful debut, he spent several months composing in New Hampshire. His early compositions were influenced by jazz rhythms in a style he described as 'symphonic jazz'. For a time his work became more austere and abstract, but he abandoned this approach in the mid-1930s for greater simplicity and melody, in an effort to be more accessible to the general public. The next ten years were his most productive. Incorporating elements of American folk music, including cowboy ballads and New England hymns, he produced a wide range of work, including operas, ballets, choral pieces, film scores and symphonies, including the ballets *Billy the Kid* (1938), *Rodeo* (1942) and *Appalachian Spring* (1944), his Lincoln Portrait (1942) for orchestra and speaker, and his Third Symphony (1946), called 'the greatest American symphony' by his friend and fellow musician Serge Koussevitsky. In the 1970s he virtually stopped composing, although he continued to conduct. He also wrote several books, was influential in promoting contemporary composers and taught at the Berkshire Music Center (1940–65).

Influenced by the work of Man Ray, the self-taught photographer George Platt Lynes (1907–55) was interested in unconventional methods of lighting and posing his subjects and cropping the resulting images. He opened his own studio in New York in 1933, enjoying considerable success as a commercial fashion and portrait photographer throughout the 1930s and 1940s and his celebrity portraits appeared in *Vogue* and *Harper's Bazaar*. Although the reasons for this sitting are not known, the Copland portrait was found in Lynes's personal archives.

Paul Strand
(1890–1976)
Photographer

Ralph Steiner, 1935
Gelatin silver print,
60 x 65mm
(2⅜ x 2½")
NPG.84.270

Paul Strand, a major figure in American twentieth-century photography, was taught by Lewis Hine at the Ethical Culture School in New York. A visit Hine organised to Alfred Stieglitz's 291 gallery inspired Strand's early interest in photography further, and he began to think of it as a valid form of artistic expression rather than just a hobby. After graduating, he worked as a self-employed commercial photographer and continued to move in Stieglitz's circle. The last two issues of *Camera Work* (1916 and 1917) were devoted to Strand's most recent work, which comprised sharp-focused, almost abstract compositions that signalled the demise of the romantic aesthetic that had dominated art photography since before the turn of the century. Strand's pictures represented a new form of realism that became known as 'straight photography' and set the standard in America for the following decades. His words, images and meticulously crafted prints all articulated this new pure, direct approach, which required, he said, 'a real respect for the thing in front of [one] expressed in terms of chiaroscuro… through a range of almost infinite tonal values which lie beyond the skill of the human hand. The fullest realisation of this is accomplished without tricks of process or manipulation.' Throughout his long career, Strand's images – a subtle reflection of his political beliefs – concentrated primarily on working people and the landscape they inhabited, and conveyed great emotional intensity. Unfortunately for Strand, he became caught up in the McCarthy witch-hunts of the early 1950s. He left America to escape persecution and settled in France, where he lived for the rest of his life.

Strand was a film-maker as well as a photographer, working on both art films (*Manhatta*, 1920, with Charles Sheeler) and documentaries. In 1935 he collaborated with photographer Ralph Steiner (1899–1986) on the classic social documentary *The Plow That Broke the Plains*, Pare Lorentz's film about the dust bowl storms. This portrait emerged from their collaboration. Steiner took it while Strand was sleeping on a train ride to Sheridan, Wyoming, where the film was being shot.

Paul Strand on train
(sleeping) to Sheridan, Wyo.
Site of Custer's Last Stand
to film The Plow That Broke
the Plains 1935
 Ralph Steiner

Bessie Smith
(1895–1937)
Singer

Carl Van Vechten, 1936
Gelatin silver print,
252 x 186mm
(9⅞ x 7⅜")
NPG.91.108

One of the all-time greats of jazz, Bessie Smith was known as the 'Empress of the Blues'. Born into a poor family in Chattanooga, Tennessee, she was orphaned by the age of nine and started singing in the street to earn money. She began her musical career as one of Ma Rainey's Rabbit Foot Minstrels, her extraordinarily powerful voice and dynamic stage presence winning her an enthusiastic following. In the 1920s she was the highest-paid black performer in America. Her first record, 'Down Hearted Blues', sold 800,000 copies when it was issued in 1923, and over the next fifteen years she recorded some 150 songs, many featuring the accompaniment of such outstanding jazz instrumentalists as Louis Armstrong and Benny Goodman. She was renowned for her volatile temper, her tempestuous love affairs and her hard drinking, and eventually managements became wary of booking her. This meant that during her later years she performed very little, but she provided inspiration for many other singers, including Billie Holiday, Mahalia Jackson and Janis Joplin. The circumstances surrounding her death in a car crash inspired Edward Albee's play *The Death of Bessie Smith* (1960). Although badly injured, she was refused entry to the nearby whites-only hospital and had to be taken much further away to an African American hospital, by which time doctors were unable to save her.

The journalist Carl Van Vechten (1880–1964) wrote about music and the theatre for a number of newspapers. In the 1920s he became particularly interested in black artists, writers and performers, and in the 1930s he started photographing them. He was one of Bessie Smith's greatest fans and delighted in playing her recordings for friends. While appearing at a New York nightclub in February 1936, Smith took a break between shows to pose for him in his West 57th Street apartment. Writing of this encounter in his 'Memories of Bessie Smith' for *Jazz Record*, Van Vechten recalled getting 'nearer her real personality than I ever had before and the photographs, perhaps, are the only adequate record of her true appearance and manner that exist'.

Carmelita Maracci
(1911–87)
Dancer, teacher

Edward Weston, 1937
Gelatin silver print,
118 x 92mm
(4⅝ x 3⅝")
NPG.96.18

Carmelita Maracci was one of America's most innovative dancers and choreographers. She also went on to teach many of the new generation of American dancers. Rumoured to have been born in various exotic locations in South America, she was in fact from Nevada, the child of a German mother and an Italian father. She began to learn modern dance at thirteen and also studied ballet and Spanish dance. Small and compact, her build was considered perfect for a dancer, and her grace and energy gave her remarkable stage presence. She starred in her own dance creations in the 1930s in Los Angeles and made her New York debut in 1937. She then toured America with her own troupe, performing her unique choreography to great critical acclaim. Technically based in an amalgamation of ballet and classical Spanish dance, she defied classification. Her themes were highly political, often dealing with social injustice. She stopped performing around 1951 because she was unwilling to work with most dance companies and believed that the pieces she performed should contain a strong message. However, she was immediately sought out by other dancers as a teacher and found that she excelled at that too.

Edward Weston (1886–1958) took this portrait in southern California in 1937, when he had just become the first recipient of a Guggenheim Fellowship for photography. It embodies many of the purist principles he followed in his efforts to capture 'the very substance and quintessence of the thing itself, whether it be polished steel or palpitating flesh'. He used sunlight, preferring the sun's range of intensity to the harsh uniformity of artificial light, and his favourite background, posing Maracci against an intense cloudless sky. This, he felt, gave the sense of isolation and space necessary to convey her strength and vitality as a dancer. The result is a hard-edged, sensuously precise portrait. The reason for the commission is not known, although it could have been connected with her New York debut. Weston took more than thirty photographs of her, as was his custom when trying to capture a sitter's essence; only three were published.

Jean Harlow
(1911–37) and
Clark Gable
(1901–60)
Actors

Clarence Sinclair Bull,
1937
Gelatin silver print,
399 x 263mm
(15⅝ x 10⅜")
NPG.81.13

With her platinum-blonde hair and her beautiful figure, Jean Harlow, the 'Blonde Bombshell', was the quintessential Hollywood sex symbol, playing fast-talking, wisecracking women who gave as good as they got and brazenly flaunted their sexuality. Under contract to Metro-Goldwyn-Mayer from 1932, she turned out to be a memorable sparring partner for the studio's top male stars and developed into a fine comedian. Her big break came in 1933 with the film *Bombshell*, in which she effectively parodied her own career as a Hollywood siren. Clark Gable, known for his roles embodying both rugged male virtues and a wry sense of humour, was one of those top MGM stars. He won an Academy Award in 1934 for his performance in *It Happened One Night,* and by the time he and Harlow worked together on *Saratoga* (1937) they were both at the height of their box-office appeal. They had first appeared together in *The Secret Six* in 1931 and had struck up an immediate rapport. Over the next few years they co-starred in several movies, but *Saratoga* was their last. While filming, Harlow died of kidney failure, largely because her mother, a Christian Scientist, refused to allow her to receive medical treatment.

As Gable once said poignantly of Harlow, 'She didn't want to be famous. She wanted to be happy.' Gable's career continued to go from strength to strength. In 1937 he was voted King of Hollywood and two years later he was adjudged the perfect Rhett Butler in the Civil War epic *Gone With the Wind*, playing opposite Vivien Leigh. After military service during the Second World War he returned to Hollywood and went on starring in films until *The Misfits*, with Marilyn Monroe, in 1960.

Clarence Sinclair Bull (1895–1979), who became head of MGM's stills department in 1924 and stayed in the job for more than forty years, was one of the movie industry's leading glamour photographers during the golden age of Hollywood. This romantic portrait of Harlow and Gable was taken as part of the publicity campaign for *Saratoga*.

Ernest Hemingway
(1899–1961)
Author

Robert Capa, 1940
Gelatin silver print,
342 x 231mm
(13½ x 9⅛")
NPG.85.88

When Ernest Hemingway won the
Nobel Prize for Literature in 1954, the
awarding committee referred to his
'mastery of the art of modern narration'.
More than any other writer, he was the
voice of the so-called 'lost generation',
the group of American writers and
artists who, unhappy with American life
and culture after the First World War,
settled in Europe in the 1920s. Written
in the terse, clipped style that became
his hallmark, his first successful novel,
The Sun Also Rises (1926; published in
Britain as *Fiesta*, 1927), captured that
post-war mood of disillusion. *A Farewell
to Arms,* one of the great novels of
the First World War, based on his
experiences as a volunteer civilian
ambulance driver on the Italian front,
followed in 1929 to great critical acclaim.
An active supporter of the Republicans,
he was in Spain from 1937. He reworked
his experiences there into the classic
novel of the Spanish Civil War, *For
Whom the Bell Tolls* (1940), which was
made into a Hollywood film three years
later. His novella *The Old Man and the
Sea* (1952), about an old Cuban
fisherman's struggle to catch a giant
fish, only to have it devoured by sharks,
won him the Pulitzer Prize in 1953 and
the Nobel Prize in 1954. His last years,

punctuated by chronic bouts of ill-
health, were less productive and
he eventually suffered a mental
breakdown. In July 1961 he took his
own life.

The Hungarian-born photojournalist
Robert Capa (1913–54) studied in
Berlin but left in 1933 to avoid Nazi
persecution, settling in Paris. There he
was involved in setting up the agency
Alliance Photo and as a result met
many writers and artists, including
Hemingway. They met again in Spain,
during the Civil War, where Capa was
on assignment. His powerful images
were reproduced in a number of
magazines worldwide, earning him
a reputation as 'the greatest war
photographer in the world' (*Picture
Post*). This picture was taken for
Life magazine while Hemingway, a
passionate sportsman, was hunting
pheasant on holiday in Sun Valley,
Idaho, but was not published.

Ingrid Bergman
(1915–82)
Actress

George Platt Lynes,
c.1940
Gelatin silver print,
239 x 190mm
(9½ x 7½")
NPG.91.52

Ingrid Bergman is best known for her appearances in Hollywood films in the 1940s – most famously *Casablanca* (1942), in which she starred with Humphrey Bogart – although she was also an accomplished stage actress. Born in Stockholm, she studied at the Royal Theatre Dramatic School there (1933–4). Her film career began with a small part in *Munkbrogreven* (*The Count from the Monk's Bridge*, 1934), and she quickly became a star in her own country. After playing the lead in *Intermezzo* (1937), she was signed by David O. Selznick for a Hollywood version of the same film, which appeared in 1939. In addition to *Casablanca*, she starred in such Hollywood classics as *Gaslight* (1944), for which she received an Academy Award, *Spellbound* (1945) and *Notorious* (1946). In 1949, while working in Italy on *Stromboli*, she fell in love with the film's director, Roberto Rossellini. They had a child, Isabella Rossellini, and the following year she divorced her husband. Ostracised by the Hollywood film industry, she continued her career in Europe, appearing in such films as her husband's classic *Viaggio in Italia* (*Journey to Italy*, 1953). Her marriage to Rossellini was eventually annulled and

in 1957 she resumed her career with *Anastasia*, for which she won a second Academy Award and a New York Film Critics Award. A string of successful films followed, including *Inn of the Sixth Happiness* (1957), *Goodbye Again* (1961) and *Murder on the Orient Express* (1974). Her last film was Ingmar Bergman's *Autumn Sonata* (1978). She died of cancer on her sixty-seventh birthday.

George Platt Lynes (1907–55) took this photograph, which is probably a fashion shot, while Bergman was appearing in the play *Liliom* at the 44th Street Theatre, New York, shortly after her arrival in America. Lynes's fashion and portrait work appeared regularly in such magazines as *Vogue*, *Harper's Bazaar* and *Town and Country* during the 1930s and 1940s. Prior to this he had worked in Paris, where he pursued his interest in Surrealism and was part of Gertrude Stein's circle. From 1937 to 1945 he had a large studio at 604 Madison Avenue, the address that appears stamped on the back of this portrait.

Spencer Tracy
(1900–67)
Actor

Louise Dahl-Wolfe, 1942
Gelatin silver print,
343 x 270mm
(13½ x 10⅝")
NPG.93.351

One of the most popular screen actors of his day, Spencer Tracy continues to feature in lists of top all-time movie stars. Born in Milwaukee, he enlisted in the navy at the start of the First World War but never served. After the war, he decided on an acting career and enrolled at the American Academy of Dramatic Arts in New York, supporting himself with jobs as a bellhop, janitor and salesman. He made his Broadway debut in 1923, but his break into films did not come until some years later, when he was seen in a play by director John Ford, who signed him to do *Up the River* (1930) for Fox Pictures. He moved to Hollywood shortly afterwards. Initially typecast as a tough guy and a gangster, his simple technique and reliability soon earned him more demanding roles and the quality of his acting was recognised. He won Academy Awards for *Captains Courageous* (1937) and *Boys Town* (1938) and was nominated on seven other occasions, for *San Francisco* (1936), *Father of the Bride* (1950), *Bad Day at Black Rock* (1955), *The Old Man and the Sea* (1958), *Inherit the Wind* (1960), *Judgment at Nuremberg* (1961) and *Guess Who's Coming to Dinner* (1967). However, he is probably best remembered for his films with

Katharine Hepburn, their offscreen love affair – which lasted until Tracy's death – no doubt contributing to their obvious onscreen rapport. In 1942 they were paired for the first time in the comedy *Woman of the Year*; their other films together include *Adam's Rib* (1949), *Pat and Mike* (1952) and *Desk Set* (1957), as well as Tracy's final film, *Guess Who's Coming to Dinner*.

Louise Dahl-Wolfe (1895–1989) was acknowledged as one of the leading fashion photographers of her generation, with much of her work appearing in *Harper's Bazaar*. She was also an accomplished portraitist who, during the late 1930s and early 1940s, worked in Hollywood. Transferring the methods she had pioneered in her fashion shots, she was among the first to photograph film stars out of doors and away from the transfiguring lights of the studio.

Lucille Ball
(1911–89)
Actress

Harry Warnecke, 1944
Colour carbro print,
409 x 332mm
(16⅛ x 13⅛")
Gift of Elsie M.
Warnecke
NPG.94.40

Best known for her starring role in the television comedy *I Love Lucy* and its subsequent spin-offs, Lucille Ball first came to the American public's attention in 1933 as the Chesterfield Cigarette Girl. This got her to Hollywood as part of the chorus in *Roman Scandals* (1933). She had small parts in more than thirty films during the 1930s and 1940s, but, in her own words, 'I never cared about the movies because they cast me all wrong.' She began to concentrate on radio work and from 1947 to 1951 played the harebrained wife of a banker, a precursor to her 'Lucy' role, in the comedy *My Favorite Husband*. In 1950 she and her husband, Desi Arnaz, tried to persuade CBS to put on *I Love Lucy* and, after initial objections, it was aired on 15 October 1951. Within months, millions of Americans tuned in every Monday evening. It was one of the first shows to be filmed before an audience, rather than performed live, making it possible to keep high-quality prints for rebroadcast. The storylines allowed Ball to display the full range of her zany, slapstick talents. *I Love Lucy* continued until 1957, winning five Emmys. Ball and Arnaz divorced in 1960, but two years later Ball revived the character in *The Lucy Show* (1962–8) and *Here's*

Lucy (1968–74). She also starred in the Broadway hit *Wildcat* (1960) and the film version of *Mame* (1974). An astute businesswoman, from 1962 to 1967, she presided over Desilu Productions, one of the biggest and most successful TV production companies. Together with her second husband, Gary Morton, she founded Lucille Ball Productions in 1968.

Harry Warnecke (1900–84) worked for the *New York Daily News* from 1921 until 1970. Having taken prize-winning black-and-white photographs for more than a decade, he convinced the newspaper that he could also produce colour photographs for the Sunday section, and soon his studio was responsible for their dramatic covers, long before colour reproduction was common. This photograph was published in the *Daily News*'s Coloroto section on Sunday 2 April 1944.

Gypsy Rose Lee
(1914–70) and
her entourage
Entertainer

Ralph Steiner, 1944
Gelatin silver print,
260 x 334mm
(10¼ x 13⅛")
NPG.84.267

Known at one time as 'the most-publicized women in the world', Gypsy Rose Lee is perhaps America's best-known stripper. Born Rose Louise Hovick in Seattle, Washington, she made her stage debut there with her sister, 'Baby' June Havoc, and her mother at the age of four. The sisters toured as child actresses until the late 1920s, making as much as $1,250 a week at the height of their popularity. When she was fifteen Rose turned to the type of sex-and-comedy entertainment known as burlesque and began striptease lessons with a dancer known as Tessie the Tassel Whirler. Within two years she was performing at Minsky's Theater in New York and then moved on to the Ziegfeld Follies in 1936, before retiring from striptease the following year. She became something of a celebrity: the author Damon Runyon introduced her to writers and intellectuals, while the journalist and literary critic H. L. Mencken coined the work 'ecdysiast' to describe her métier. In 1942, when New York's burlesque theatres closed, she appeared in the Broadway show *Star and Garter* to rave reviews. She also featured in several films, including *Stage Door Canteen* (1943), and other stage shows followed, such as *Gypsy Rose Lee and*

Her American Beauties (1949) and *A Curious Evening with Gypsy Rose Lee* (1958). She had her own television talk show and was the author of several thrillers, including *The G-String Murders* (1943) and *Mother Finds a Body* (1944). Her autobiography, *Gypsy: A Memoir* (1957), became the basis for the hit Broadway musical *Gypsy*, which was later made into a film. (The National Legion of Decency declared the film 'objectionable', but many found it disappointingly tame!)

Gypsy Rose Lee commissioned this picture for publicity purposes from film-maker and photographer Ralph Steiner (1899–1986), who was her neighbour. In his autobiography Steiner recalled, 'The photograph was fun to do, but serious for Gypsy – she had to wear a costume weighing seventy pounds on a hot day, and it took her two hours to make up. But she knew the value of publicity and was willing to invest in it.'

J. Robert
Oppenheimer
(1904–67)
Scientist

Lisette Model, 1946
Gelatin silver print,
344 x 250mm
(13½ x 9¾")
NPG.82.143

Nuclear physicist Julius Robert Oppenheimer joined the team of government scientists charged in 1942 with developing the atomic bomb and, a year later, became director of the project's laboratory in Los Alamos, New Mexico. On 16 July 1945 he witnessed the explosion, at Alamogordo in the New Mexico desert, of the world's first atomic bomb. As he later recalled, it brought to mind a passage from the *Bhagavadgita*: 'I am become Death, the shatterer of Worlds.' He resigned in 1945, having argued for joint control of atomic energy with the Soviet Union. In 1946 he became chairman of the advisory committee of the newly formed civilian Atomic Energy Committee. The same year he rejoined the University of California at Berkeley, with which he had been associated for fifteen years, but left in 1947, when he was appointed director and professor of physics at the Institute for Advanced Study at Princeton, New Jersey. A leading opponent of the hydrogen bomb on moral and practical grounds, in 1953 he was suspended from nuclear research by a security board review. He had been charged by FBI chief J. Edgar Hoover with passing atomic secrets to the Soviet Union and, although various investigations found the accusation groundless, he remained under suspicion. It was only when President Kennedy invited him to the White House in 1962 that his reputation began to be restored.

Lisette Model (1906–83) photographed Oppenheimer in the summer of 1946, just after he returned to Berkeley. Her portrait appeared as part of a picture story for *Harper's Bazaar* entitled 'The Intellectual Climate of San Francisco'. Although she was best known as an artist and journalist, her time in San Francisco prepared the ground for a new career, and the following year she returned to teach at the California School of Fine Arts. Around 1950 she began an influential course at the New School for Social Research in New York, where her students included photographer Diane Arbus.

Henri Cartier-Bresson,
1947 (printed later)
Gelatin silver print,
358 x 240mm
(14⅛ x 9½")
NPG.89.196

In spring 1946, with only one of his books still in print, William Faulkner was rescued from oblivion by his friend Malcolm Cowley, the chronicler of American literary history, who compiled *The Portable Faulkner*. Accompanied by a biographical and critical essay, this sparked a resurgence of interest in his work, and his standing as one of the country's finest modern novelists was recognised. In 1949 he was awarded the Nobel Prize for Literature. His first novel, *Soldier's Pay*, was published in 1926 but received little attention. It was in his third, *Sartoris* (1929), that he introduced the mythical Yoknapatawpha County, based on Lafayette County, Mississippi, where he had grown up. This marked the start of a succession of works, sombre and elegiac in tone but lyrical in prose style, that, through their strong sense of place and wide sweep of characters, effectively charted the decline of the old South. They include *The Sound and the Fury* (1929), *As I Lay Dying* (1930), *Light in August* (1932), *Absalom, Absalom!* (1936), *The Hamlet* (1940) and *Intruder in the Dust* (1942). Faulkner also worked as a screenwriter in Hollywood, producing scripts for *To Have and Have Not* (1945), which saw Humphrey Bogart and Lauren Bacall's

first appearance together, and *The Big Sleep* (1946), in which they also starred. In accepting his Nobel Prize, which was not awarded until 1950, he emphasised the importance of 'the old verities and truths of the heart, the old universal truths lacking which any story is ephemeral and doomed – love and honour and pity and pride and compassion and sacrifice'.

Henri Cartier-Bresson (b.1908) is renowned for his use of fast film and a palm-sized Leica camera to capture what he has called the 'decisive moment'. In 1947, the Museum of Modern Art in New York, thinking that he had been killed during the Second World War, arranged a posthumous exhibition of his photographs. When they discovered that he had in fact survived, Cartier-Bresson was invited to install the show. On a trip across America with the writer John Malcolm Brinnin, he photographed Faulkner at his home in Oxford, Mississippi, just as the author was beginning to win a wide new readership.

Leonard Bernstein
(1918–90)
Musician

Irving Penn, 1947
Gelatin silver print,
242 x 194mm
(9½ x 7⅝")
NPG.90.125

A talented conductor, composer and pianist, Leonard Bernstein occupied a unique place in American musical culture, bridging the gap between serious and popular music. His big break came on 14 November 1943, when at the last minute he had to replace the ailing Bruno Walter as conductor of the New York Philharmonic. The concert, broadcast nationally on the radio, was well received, and soon orchestras worldwide were asking Bernstein to be their guest conductor. After working with orchestras in New York and Boston, in 1958 he became principal conductor at the New York Philharmonic, the first American-born holder of the post, and stayed there until 1969. He conducted the premiere of his first symphony, *Jeremiah*, in 1944 and was the piano soloist on the first performance of his second, *The Age of Anxiety*, in 1949. His third, *Kaddish*, was completed in 1963 and is dedicated 'To the Beloved Memory of John F. Kennedy'. He also composed for opera, ballet and film, including the Academy Award-winning *On the Waterfront* (1954), and made an enormous contribution to Broadway musicals with such works as *On the Town* (1944), *Wonderful Town* (1953) and *Candide* (1956). In 1957 he

collaborated on the groundbreaking musical *West Side Story*, which became another Academy Award-winning film (1961). He was a popular lecturer and wrote widely on music. Throughout his life he had worked to promote better international relations through music and in December 1989 he was asked to conduct the historic Berlin Celebration Concerts, held on both sides of the Berlin Wall as it was being dismantled.

Irving Penn (b.1917) started taking fashion photographs for *Vogue* after the Second World War, producing more than 100 covers. His work for the magazine also included portraits, which were noted for their formal elegance, simplified lighting and minimal settings, no doubt influenced by his fashion work. Taken a year earlier, at a time when Bernstein was winning acclaim as the energetic young music director of the New York City Symphony Orchestra, this picture was published in the 1 July 1948 issue of *Vogue*, in a portfolio of portraits by Penn entitled *Inside New York*.

Tennessee
Williams
(1911–83)
Playwright

W. Eugene Smith, 1948
Gelatin silver print,
315 x 267mm
(12⅜ x 10½")
NPG.93.364

Tennessee Williams's plays, which deal largely with problems revolving around sexuality, family life, society and religion, have been described as 'the greatest dramatic poetry in the American language' by fellow writer David Mamet. Born in Columbus, Mississippi, Williams was a shy and sickly child. His mother was obsessed by fantasies of genteel southern living, while his father was alternately distant and abusive. His older sister, Rose, spent most of her life in mental institutions, and his younger brother, Dakin, was their father's favourite. The conflicts Williams experienced as a child were played out again and again in his work. He wrote some thirty full-length plays, numerous short plays, two volumes of poetry and five volumes of essays and short stories. *The Glass Menagerie*, which opened on Broadway in 1945, was his first big success and was followed in 1947 by *A Streetcar Named Desire*, for which he won his first Pulitzer Prize. Other plays include *The Rose Tattoo* (1951), *Camino Real* (1953), *Cat on a Hot Tin Roof* (1955), which also won a Pulitzer Prize, *Orpheus Descending* (1957) and *Sweet Bird of Youth* (1959). These plays continue to be revived and many have been made into films. Williams claimed that

his main theme was the negative impact of conventional society upon the 'sensitive nonconformist individual'. With its examination of the struggle between the gentility of the old South and the brute force of the North, his work, like that of William Faulkner, fits into the genre known as 'Southern Gothic'.

Two months after *A Streetcar Named Desire* opened, the 16 February 1948 issue of *Life* magazine featured an eight-page profile of Williams, with photographs by W. Eugene Smith (1918–78). This was one of the photographs taken to accompany the piece, although it was not published. Renowned for his integrity as a photojournalist, Smith worked as a staff photographer with *Life* from 1939 to 1941, before going to the Pacific as a war correspondent for *Popular Photography*. He was badly wounded in 1945 and only after a long period of recuperation did he resume working at *Life* in 1947.

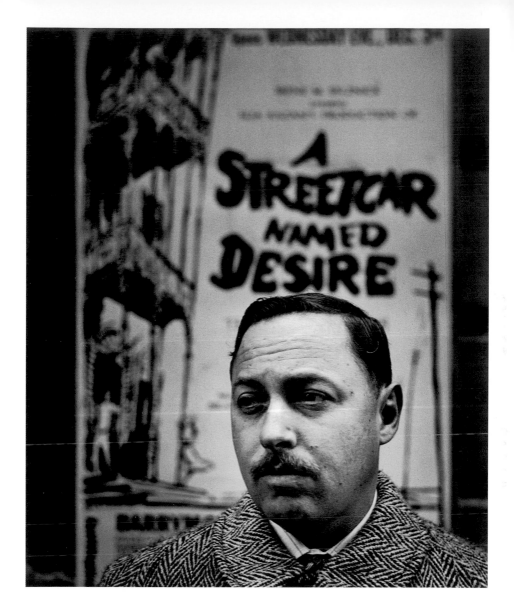

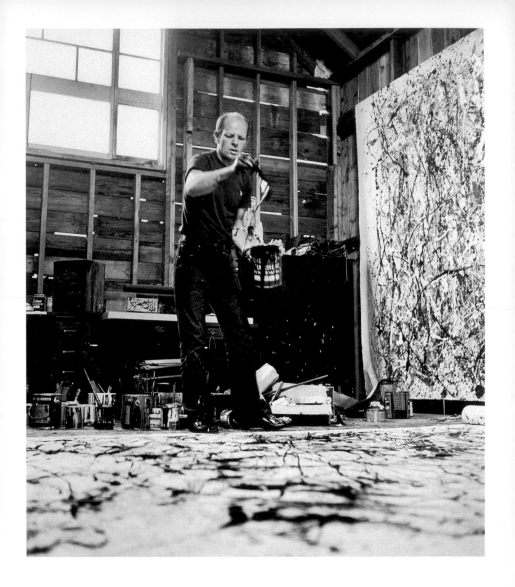

Jackson Pollock
(1912–56)
Artist

Hans Namuth, 1950
Gelatin silver print,
504 x 403mm
(19¾ x 15⅞")
Gift of the estate
of Hans Namuth
NPG.95.157

In the years immediately following the end of the Second World War the centre of artistic innovation moved from Paris to New York, mainly because of the activities of a small group of American painters known as Abstract Expressionists, among them Jackson Pollock. He was born in Cody, Wyoming, but spent his teenage years in Los Angeles and moved to New York in 1930. Shortly after arriving he enrolled at the Art Students League, where he came under the influence of regionalist painter Thomas Hart Benton. In the late 1930s he met the artist John Graham, who introduced him to a number of Surrealists. Having begun psychoanalysis in 1937, Pollock was particularly susceptible to their interest in the subconscious as a source of subject matter. In 1943 Peggy Guggenheim, who had just opened the Art of This Century gallery, gave Pollock his first one-man show and began providing him with a monthly stipend of $150. By the late 1940s his innovative drip paintings were being widely discussed in art journals and the popular press. Speaking of his work in 1951, he explained, 'My painting is direct…I want to express my feelings rather than illustrate them.' At the time of his death in a car accident, Pollock was probably America's most famous – or infamous – artist.

Hans Namuth (1915–90), who was born in Essen, Germany, emigrated to America in 1941 and had just resumed his career as a professional photographer when he met Pollock at an exhibition opening in Southampton, Long Island, in the summer of 1950. He expressed an interest in going to Pollock's studio to photograph him and, although initially reluctant, the artist eventually agreed. Between July and September Namuth took more than 500 photographs of Pollock at work. These seminal photographs, which provided a visual explanation of critic Harold Rosenberg's definition of Action Painting, changed the way the public viewed Pollock's paintings. They also changed Namuth's life, for while he continued to undertake a variety of photographic assignments after these landmark portraits, the major focus of his forty-year career became photographing creative personalities and in particular artists.

Frank Lloyd Wright
(1867–1959)
Architect

Berenice Abbott,
c.1950
Gelatin silver print,
243 x 194mm
(9½ x 7⅝")
NPG.76.99

America's best-known architect, Frank Lloyd Wright embraced modernism to express his vision for an ideal form of American living. Born in Richland Center, Wisconsin, his early life was nomadic and unsettled. After briefly studying civil engineering at the University of Wisconsin, in 1887 he went to Chicago, where he worked for the architect Louis Sullivan – one of the few influences he ever acknowledged. It was Sullivan who coined the phrase 'Form follows function', which Wright later recast as 'Form and function are one.' Sullivan also believed in an American architecture based on American themes rather than on tradition or European styles – another idea Wright would develop. In 1893 Wright established his own practice in Chicago and built his first masterpiece, the Winslow House, in River Forest, Illinois. He championed so-called 'organic architecture', which created a natural link between people and their environment, and is known for his low, prairie-style bungalows. He frequently lectured and wrote about architecture. He was particularly interested in the implications for architecture of Cubist ideas about space. Two portfolios of his work were published in Germany (1910 and 1911), bringing him international recognition and leading to his influence on other modernists, such as Walter Gropius and Ludwig Mies van der Rohe. Some of his best-known buildings include the earthquake-proof Imperial Hotel in Tokyo (1916–20), the Fallingwater weekend retreat at Mill Run, Pennsylvania (1936), the Johnson Wax office building in Racine, Wisconsin (1936) and the Guggenheim Museum in New York (1943–59). In all, he produced plans for more than 1,100 projects.

New Yorker Berenice Abbott (1898–1991) worked in Paris, first as Man Ray's assistant and then, by 1925, as a professional portrait photographer. While there she was captivated by the work of photographer Eugène Atget, whose style she later described as 'realism unadorned'. She returned to New York in 1929 and over the years produced a large body of work imbued with this modernist aesthetic. Her portraits are renowned for their clarity and precision, and for the natural poses and expressions of her subjects.

Gilbert Hovey
Grosvenor
(1875–1966) and
Elsie May Bell
Grosvenor
(1878–1964)
Editor and his wife

Irving Penn, 1951
(printed 1977)
Platinum-palladium print,
363 x 510mm
(14⅜ x 20⅛")
NPG.85.29

As the editor of the *National Geographic*, Gilbert Hovey Grosvenor, who later became president of the National Geographic Society and chairman of the board of managers, transformed the magazine from a relatively obscure, loss-making academic journal with just 1,000 subscribers to the dynamic, popular publication it is today, selling millions of copies throughout the world. Born and educated in Constantinople, Turkey, where his father taught, he was offered the editorship in 1898 by Alexander Graham Bell, the Society's second president and an old family friend – not to mention the father of his future wife, Elsie May. A pioneer in photojournalism, Grosvenor wrote in 1928, 'The National Geographic Society began to grow thirty years ago because we adopted the policy of printing many more and better pictures than any other publication. We have constantly kept ahead and we must continue to do so.' With this in mind, under Grosvenor's leadership the Society supported a wide range of land, sea and air expeditions and conducted many of its own. If one of his major contributions was to develop an extraordinary photographic service that greatly enhanced the magazine's appeal, another was the development of a map service that was used extensively by Allied forces during the Second World War. Grosvenor was associated with the Society for more than fifty years and in appreciation of this received numerous honorary degrees. His wife – the granddaughter, daughter, wife, mother and grandmother of Society presidents – was herself an explorer, and she designed the Society's flag, choosing colours to represent earth, sea and sky.

Photographer Irving Penn (b.1917) trained initially as an artist. He had drawings published in *Harper's Bazaar* in the late 1930s and spent 1942 painting in Mexico. The following year he joined *Vogue* as a designer and it was while there that he started taking photographs. His fashion work and his portraits appeared in *Vogue* after the war. As can be seen here and in the photograph of Leonard Bernstein, these portraits display the influence of his fashion work in their elegance and minimalism.

Rocky Marciano
(1923–69) and
'Jersey Joe' Walcott
(1914–94)
Boxers

Charles Hoff, 1952
Gelatin silver print,
190 x 239mm
(7½ x 9½")
NPG.91.72

On 23 September 1952 American heavyweight boxer Rocky Marciano, the 'Brockton Blockbuster', took the world title by knocking out defending champion 'Jersey Joe' Walcott in the thirteenth round. Born Rocco Marchegiano in Brockton, Massachusetts, he had initially dreamed of a career in major league baseball and did not take up boxing until he was serving in England during the Second World War. The power of his punches was never in doubt, but he was overweight and early bouts back in America after the war convinced him he needed to improve his fitness. He embarked on a rigorous training programme that included at least seven miles of roadwork a day and indoor sessions at the Brockton YMCA pool during which he would tread water while throwing underwater punches. He was soon ready to start his career as a professional, and success followed swiftly. After winning thirty-seven fights by knockouts, including his 1951 defeat of the ageing former champion Joe Louis – his childhood hero – he met Walcott for the heavyweight championship. Although he was knocked down in the first round and was behind on points for the first seven, he won by knocking out his opponent

with a powerful right – the punch he always referred to as his 'Susie Q'. He defended his title six times, winning five by knockouts. As a professional he won an unprecedented forty-nine consecutive fights, forty-three of them knockouts, but he was always prone to injury so, rather than risk serious mishap, he decided to retire in 1956. He died in a plane crash, but his hard-slugging style has become legendary, the inspiration for Hollywood films.

Charles Hoff (1905–75), a photo-journalist for the *New York Daily News* who built up an impressive reputation as a sports photographer from the 1930s to the 1960s, was renowned for juxtaposing human fragility and brutality. With the aid of strategically placed strobe lights, he captured remarkable shots that froze motion while retaining the depth of field.

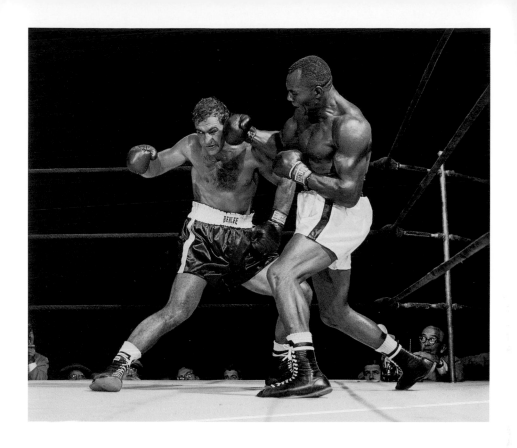

Leontyne Price
(b.1927)
Singer

Carl Van Vechten, 1953
Gelatin silver print,
239 x 184mm
(9½ x 7¼in)
NPG.91.67

Soprano Leontyne Price was the first African American opera singer to gain an international reputation. Born in Laurel, Mississippi, she sang in her local church choir as a child and in 1948 went to study at the Juilliard School in New York. She was chosen by composer Virgil Thomson to sing in a revival of his *Four Saints in Three Acts* in New York and Paris, and the success of her performance on Broadway in April 1952 brought her to the attention of Ira Gershwin. He was casting a revival of his brother George's opera *Porgy and Bess* and, after hearing Price's rendition of 'Summertime', offered her the female lead. From June 1952 to June 1954 she sang to packed houses on Broadway and on tour in America and Europe, constantly being singled out for praise. Paul Hume, for example, wrote in the *Washington Post* on 10 August 1952, 'Leontyne Price sings the most exciting and thrilling Bess we have heard…[She] will no doubt spend a long time in the role…[but] when she is available for other music, she will have a dramatic career.' He was right. In 1955 she made her television debut in NBC's production of Verdi's *Tosca*, after which she embarked on a major European tour, singing in Vienna

in 1959 and Milan in 1960. The next year she made her first appearance at the Metropolitan Opera House, New York, as Leonora in Verdi's *Il Trovatore* – the performance that established her as a prima donna. When the new Metropolitan Opera House was opened in 1966, she was chosen to create the role of Cleopatra in Samuel Barber's *Antony and Cleopatra*. She finally retired from opera in 1985.

This photograph of Price, in her role as Bess, was taken in New York on 19 May 1953 by Carl Van Vechten (1880–1964). He had been interested in music, particularly opera, and ballet from a young age, writing widely on both for many years as a journalist. His interest in photography blossomed in the 1930s, when he started taking photographs of friends and acquaintances in the fields of literature, art and entertainment.

Audrey Hepburn
(1929–93)
Actress

Philippe Halsman, 1955
Gelatin silver print,
349 x 270mm
(13¾ x 10⅝")
NPG.95.96

The epitome of Hollywood chic in the 1950s and 1960s, Audrey Hepburn became a major star with her first film, *Roman Holiday* (1953), for which she won an Academy Award as best actress. The following year she won a Tony Award for her Broadway performance in the play *Ondine*, in which one critic described her as 'a slender, elfin, and wistful beauty, alternately regal and childlike'. Born Edda van Heemstra Hepburn-Ruston in Brussels to an Anglo-Irish father and a Dutch baroness, she grew up mostly in London. Part of her childhood was spent trapped in Nazi-occupied Holland, where she was said to have carried notes for the Dutch resistance in her ballet shoes. After the war she returned to London, winning a scholarship to the Ballet Rambert school. In 1951 she was discovered by the French novelist Colette, who insisted Hepburn take the lead in the Broadway adaptation of her book *Gigi*. Enthusiastic reviews led to her role opposite Gregory Peck in *Roman Holiday*. Over the following years she starred in some twenty major films, including *Sabrina* (1954), *War and Peace* (1956), *Funny Face* (1957), *Love in the Afternoon* (1957), *The Nun's Story* (1959), *Breakfast at Tiffany's* (1961),

Charade (1963), *My Fair Lady* (1964) and *Wait Until Dark* (1967). She retired from films in 1968, but returned in *Robin and Marian* (1976). Her last major appearance was in the comedy *They All Laughed* (1980), though she had a cameo role in *Always* (1989). From 1988 she served as a goodwill ambassador for UNICEF, working with children in the Third World, and after her death was awarded the Jean Hersholt Humanitarian Award.

Latvian-born Philippe Halsman (1906–79) worked as a freelance photographer for *Life* and other leading magazines. He shot his first *Life* cover in 1942 and over the next thirty years produced a record 101 cover images for the popular weekly. This portrait is a variant of the colour image featured on the cover of the 18 July 1955 issue. It was taken when Hepburn was staying in a villa outside Rome, having just begun work on *War and Peace*.

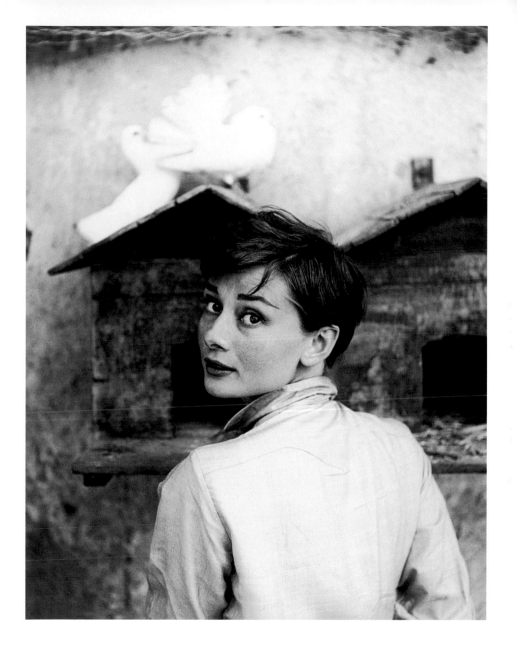

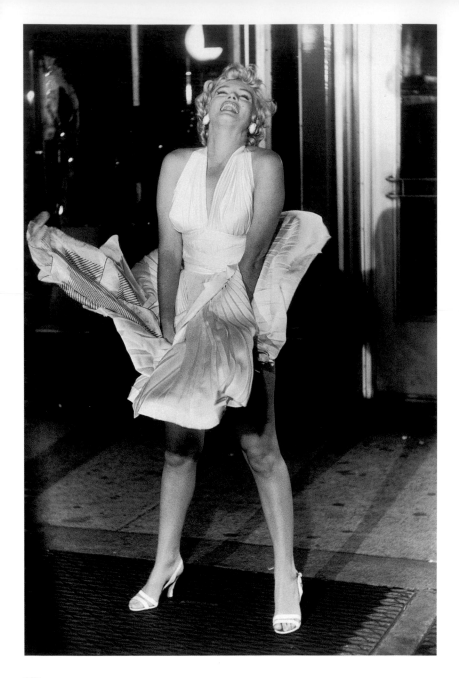

Marilyn Monroe
(1926–62)
Actress

Garry Winogrand, 1955
(printed 1983)
Gelatin silver print,
469 x 314mm
(18½ x 12⅜")
NPG.84.73

The ultimate Hollywood screen goddess, Marilyn Monroe managed to mix sexual allure with a childlike vulnerability. Born Norma Jean Baker in Los Angeles, the illegitimate daughter of a depressive mother, she spent most of her early life in foster homes and married for the first time at fourteen. She found work as a photographic model and by the age of twenty was appearing in national magazines. Small parts in films followed and she eventually signed with Columbia Pictures. A high-powered publicity campaign by the studio led to her first significant role, with Bette Davis in *All About Eve* (1950), and over the next few years she was cast as a sexy 'dumb blonde' in successful films such as *How to Marry a Millionaire* and *Gentlemen Prefer Blondes* (both 1953). In 1954 she married baseball star Joe DiMaggio, but they divorced within months. She developed her flair for light comedy in *The Seven Year Itch* (1955) but then, wanting more challenging roles, joined Lee Strasberg's Actors' Studio in New York that year. Two of her most popular films resulted, *Bus Stop* (1956) and, with Laurence Olivier, *The Prince and the Showgirl* (1957). In 1956 she converted to Judaism to marry the playwright Arthur Miller. *Some Like It Hot* (1959) was a glorious return to comedy, while her appearance in *The Misfits* (1961), written for her by Miller, won great acclaim. However, depressed and exhausted during filming, she was increasingly dependent on pills and alcohol to keep going. She divorced Miller just before the film opened and was later suspended by the studio for chronic lateness and absenteeism. She died after taking an overdose of sleeping tablets. The subject of endless speculation since her death, in life she never resolved the tensions between her glamorous screen image and reality.

Taken on the set of *The Seven Year Itch*, this photograph by Garry Winogrand (1928–84) typifies the seemingly spontaneous nature of his work – the result of his years as a photojournalist. The print is from the portfolio *15 Big Shots*, a collection of celebrity portraits that was published shortly before his death.

Robert Frost
(1874–1963)
Poet

Clara Sipprell,
c.1955
Gelatin silver print,
229 x 174mm
(9 x 6⅞")
Bequest of Phyllis Fenner
NPG.82.155

One of the most popular of twentieth-century American poets, Robert Frost is remarkable for the way his verse blends the colloquial and the traditional, incorporating country lore and wisdom while at the same time dealing with often troubling subject matter. In 1900 he settled with his wife, Elinor, and their young family on a New Hampshire farm where, over the next nine years, he wrote many of the poems that would make up his first published volumes. In 1912 they left America for Britain, settling in Beaconsfield. Within a few months of arriving, his first book of poems, *A Boy's Will* (1913), was published. He also met a number of poets, including Ezra Pound, who reviewed *A Boy's Will* and *North of Boston*, which followed in 1914, and, more importantly, Edward Thomas, who became a close friend. While many reviewers talked of Frost's simplicity and artlessness, it was Thomas who recognised his interest in the cadences of vernacular speech – his 'sound of sense'. Returning to America in 1915, Frost found that the publication there of *North of Boston* had made him a figure of great interest in literary circles. A third volume, *Mountain Interval*, published in 1916 but still drawing on

poems written in England and before, was equally well received and some of them, such as 'The Road Not Taken', 'An Old Man's Winter Night' and 'The Oven Bird', were among the best he ever wrote. He won the first of four Pulitzer Prizes in 1924 for his fourth book, *New Hampshire*, and followed it with *West-Running Brook* (1928) and *A Further Range* (1936), which also won a Pulitzer. His last truly significant collection, *A Witness Tree*, was published in 1942. He taught at Harvard (1939–43) and Amherst College (1949–63), but after the Second World War his output was much less prolific.

Clara Sipprell (1885–1975) enjoyed a long and productive career as a portraitist. As can be seen in the earlier photograph of Michel Fokine, her work has an atmospheric, contemplative quality well suited to her choice of subjects.

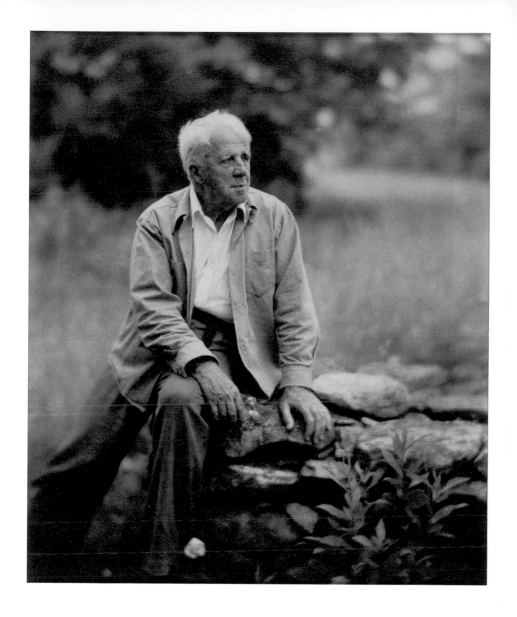

John F. Kennedy
(1917–63)
Thirty-fifth
President of the
United States

Robert Frank, 1956
Gelatin silver print,
350 x 237mm
(13¾ x 9¼")
NPG.84.266

John Fitzgerald Kennedy, the youngest man and the first Roman Catholic to be elected president, was determined to usher in a new era in politics. As he declared in his inaugural address in 1960, 'Ask not what your country can do for you – ask what you can do for your country.' Of Irish descent, he was born in Brookline, Massachusetts. He graduated from Harvard in 1940 and served in the navy during the war. In 1946 he was elected a Democratic representative for the Boston area, becoming a senator in 1953 – the year he married Jacqueline Bouvier. He almost won the Democratic nomination for vice-president in 1956 and in 1960 was a first-ballot nominee for president. Having been watched by millions in televised debates with Republican candidate Richard Nixon, he won by the narrowest of margins. With the help of his brother, Attorney General Robert Kennedy, he took action in support of civil rights proposing the bill that became the Civil Rights Act of 1964. Throughout his time in office, tension between America and the Soviet Union was acute. He had allowed a band of Cuban exiles to invade their homeland in an unsuccessful attempt to overthrow Castro, and soon after the Soviets turned their attention to West Berlin. Kennedy replied by reinforcing the Berlin garrison and generally increasing America's military strength, including new efforts in space. Moscow then attempted to install nuclear missiles in Cuba and in response, in October 1962, Kennedy threw a naval blockade around the island. The world was on the brink of nuclear war, but eventually the Soviets removed their missiles. Kennedy now contended (as he had done even since his inauguration) that both sides should slow the arms race and this led to a test ban treaty in 1963. His administration thus saw the beginnings of hope for equal rights in America and world peace, but on 22 November 1963 Kennedy was assassinated as his open-topped car drove through Dallas, Texas.

Robert Frank (b.1924) emigrated to New York from Switzerland, where he had worked with various photographers and film-makers. This picture was taken at the 1956 Democratic Convention, in the course of his cross-country expedition, supported by a 1955 Guggenheim Fellowship, to photograph America.

Louis Armstrong
(1901–71)
Jazz musician

Lisette Model,
c.1956
Gelatin silver print,
267 x 348mm
(10½ x 13⅝")
NPG.82.138

World-famous trumpeter, singer and
bandleader Louis 'Satchmo' Armstrong
grew up in the New Orleans red-light
district, Storyville, where jazz was born.
In trouble with the law by the age of
twelve, he was sent to the Jones Home
for Colored Waifs, and it was while
there that he learned to play the cornet.
At the time Joe 'King' Oliver was forging
a new sort of band music from blues
and ragtime, and by 1917 Armstrong
was playing in an Oliver-inspired group
at bars in New Orleans. In 1922 Oliver
asked him to join his Creole Jazz Band
in Chicago, where Armstrong's playing
made him a sensation. He moved to
New York to join Fletcher Henderson's
Harlem Orchestra and had recording
sessions with numerous blues singers,
including Bessie Smith. In 1925 he
returned to Chicago and made his
first Hot Five records – the band never
performed live but these records are
jazz classics. By now he had replaced
his cornet with a trumpet and was
regularly billed as the world's greatest
trumpeter. For many years he and
his various bands toured worldwide,
keeping up with changing tastes in jazz.
It was only his failing health that finally
forced the Louis Armstrong Allstars to
disband. He had great hits with his
version of 'Hello, Dolly!' (1963) and
'What a Wonderful World' (1968), and,
despite illness, continued playing and
recording until his death. In the words
of Dizzy Gillespie, 'If it weren't for [Louis
Armstrong], there wouldn't be any of us.'

Austrian-born photographer Lisette
Model (1906–83) worked in Paris before
leaving for New York in 1937. Her
work was well received in America and
appeared in such publications as *PM*,
Harper's Bazaar, *Vogue* and the *Saturday
Evening Post*. From 1950 she taught
at the influential New School for Social
Research, New York. Her work is
distinctive for the way subjects seem
to push out of the image – as seen
here and in the earlier portrait of J. Robert
Oppenheimer – and this, together with
the gritty, snapshot-like quality, reflects
her earlier contacts with the European
avant-garde movement.

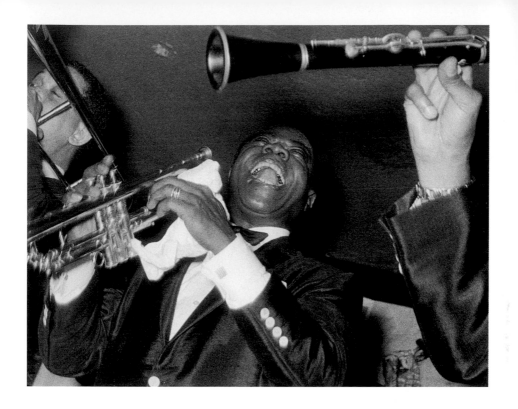

Martin Luther King Jr
(1929–68),
Coretta Scott King
(b.1927) and
Yolanda Denise King
(b.1955)
Civil rights leader,
his wife and daughter

Dan Weiner, 1956
Gelatin silver print,
277 x 355mm
(10⅞ x 14") image/sheet
NPG.94.253

A spellbinding orator and brilliant strategist, Martin Luther King was at the forefront of the civil rights movement in the 1950s and 1960s. Born in Atlanta, Georgia, the son of a Baptist minister, he studied theology and was ordained in 1948. After completing his studies at Boston University, in 1955 he set up his first black ministry at Montgomery, Alabama, and it was while there that, as president of the Montgomery Improvement Association, he led the successful 381-day boycott of segregated buses (1955–6). In 1957 he moved to Atlanta to run the Southern Christian Leadership Conference, which organised civil rights activities throughout the country. He espoused a philosophy of non-violent direct action, developing strategies for rational and non-destructive social change. His marches galvanised the movement, while his lectures and speeches sparked the nation's conscience. In August 1963 he led the great march on Washington, where he delivered his memorable 'I have a dream' speech at the Lincoln Memorial. The Voting Rights Act (1965) went before Congress as a result of his Selma to Montgomery march. In 1964 he was the youngest man, the second American and only the third black man to receive the Nobel Peace Prize. The same year he was awarded an honorary degree from Yale University and the Kennedy Peace Prize. He was assassinated by James Earl Ray on 4 April 1968 while standing on the balcony of the Lorraine Motel in Memphis, Tennessee. President Lyndon Johnson declared a day of mourning and flags were flown at half-mast on 9 April, when King was buried. Ray was arrested in London on 8 June 1968 and returned to stand trial in Memphis, where he was sentenced to nincty-nine years' imprisonment. Coretta Scott King carries on her husband's work through the Martin Luther King Jr. Center for Social Changes, Alabama.

A member of Magnum, Dan Weiner (1919–59) believed in the power of documentary photographs. He went to Montgomery in 1956 to document the bus boycott for *Collier's* magazine and took this picture on the steps of Dr King's Dexter Avenue Baptist Church, with the Alabama Capitol building behind.

Ansel Adams
(1902–84)
Photographer

Arnold Newman, 1976
Gelatin silver print,
370 x 287mm
(14½ x 11⅜")
NPG.89.184

Throughout a long and distinguished career, Ansel Adams married a visionary sense of the importance of the wilderness and its preservation with extraordinary technical expertise to create a body of work now regarded as one of the most significant photographic statements on the American landscape. Born in San Francisco, he planned a musical career until a trip to the Yosemite Valley in 1916 sparked his interest in photography. He returned every summer, exploring and taking photographs, and published his first portfolio in 1927. His decision to devote himself to photography came after seeing the work of Paul Strand, whom he met in 1930. His first important one-man show was held in 1931 and that year some of his photographs were exhibited at the Smithsonian Institution, Washington. In 1932 he and several other California-based photographers, including Edward Weston, founded Group f/64, committed to the perfect realisation of photographic vision through technically flawless prints. After meeting Alfred Stieglitz in 1933, he opened the Ansel Adams Gallery in San Francisco, and in 1935 he published the first of his many books dealing with photographic technique,

Making a Photograph. In 1939 he assisted in the foundation of the photographic department at the Museum of Modern Art, New York, where he also lectured and taught courses in photography in 1944–5. This was followed by involvement in one of the country's first departments of photography, at the California School of Fine Arts (later the San Francisco Art Institute), in 1946. He was awarded a Guggenheim Fellowship in 1948 to photograph National Park locations and monuments, and over the years a number of portfolios of important works appeared. In each image he produced, his aim was to modulate the range of tones from richest black to purest white in order to achieve perfect clarity.

Arnold Newman (b.1918), one of America's most respected portrait photographers, taught regularly at the summer photography workshops Adams organised in Yosemite, beginning in 1955. This portrait, which was taken at Adams's home in Carmel, California, shows him dressed for the darkroom.

Cesar Chavez
(1927–93)
Union leader

Richard Avedon, 1976
Gelatin silver print,
255 x 202mm
(10⅛ x 7⅞")
NPG.89.83.16

Cesar Chavez founded and led the United Farm Workers (UFW), the first successful union for farm workers in American history. Born near Yuma, Arizona, he became a migrant worker at the age of ten when his father lost their farm during the Depression and, like thousands of others, the Chavez family took to the road. By 1952 he was involved with the Community Service Organization, a self-help group, and was soon a full-time organiser. In 1962 he and his family moved to Delano, California, where he founded the National Farm Workers Association, and three years later its members joined in a strike against local grape growers for better working conditions. In 1966, near the start of Chavez's successful five-year strike and consumer boycott, the striking unions merged under his leadership to form the UFW. Like Martin Luther King, they espoused principles of non-violent direct action, as Chavez's twenty-five-day fast in 1968 reaffirmed. By 1970 the boycott had convinced most growers to sign contracts with the UFW, but there was trouble again when agreements came up for renegotiation in 1973. Chavez called for a new boycott and by 1975 a poll showed that 17 million American

adults were with him. Eventually the 1975 Agricultural Labor Relations Act was passed, and by the early 1980s farm workers in the thousands were employed under UFW contracts, with protected pay and conditions. Until his death Chavez was fighting for the rights of farm workers and in recognition of his efforts he received the Aguila Azteca (Aztec Eagle), Mexico's highest award presented to people of Mexican heritage, in 1991 and the Presidential Medal of Freedom, America's highest civilian honour, posthumously in 1994.

Richard Avedon (b.1923), who began his career in fashion photography working for *Harper's Bazaar*, later became better known for his intense, sharply focused portraits. In 1976 *Rolling Stone* commissioned him to photograph 'the broad group of men and women…who constitute the political leadership of America' as a Bicentennial project. The resulting sixty-nine portraits, entitled *The Family 1976*, were published in the 21 October 1976 issue of the magazine.

Truman Capote
(1924–84)
Author

Arnold Newman, 1977
Gelatin silver print,
207 x 335mm
(8⅛ x 13⅛")
NPG.91.89.29

A conspicuous figure on the American literary scene, Truman Capote established his reputation with the publication of his first novel, *Other Voices, Other Rooms*, in 1948. Born Truman Streckfus Persons in New Orleans, he was sent to live with relatives in rural Alabama after his parents' divorce. In 1935 he changed his surname to that of his mother's new husband. He was educated on the East Coast, but continued to visit the South throughout his childhood, his experiences there providing inspiration for many of his books. His literary talent was recognised and encouraged at school in Connecticut and, after a short spell as a copy boy at the *New Yorker*, he started writing full-time. Returning to live with relatives, he published several short stories before *Other Voices, Other Rooms*. Throughout the 1950s he wrote short stories, travel pieces, features and interviews for a number of magazines, including the *New Yorker*. In 1958 his second novel, *Breakfast at Tiffany's*, was published (the film version, starring Audrey Hepburn, came out in 1961). In 1959 he began research on the Clutter family murders in Kansas, which formed the basis of *In Cold Blood*. It was published in serial form in the *New Yorker* in 1965 and as a book later the same year. Dubbed by the author a 'non-fiction novel', it became a best-seller. The new genre, while critically controversial, has nevertheless been accepted as an important contribution to American literature. Meanwhile Capote was becoming something of a personality. His social life fascinated the media and he appeared frequently on TV. While literary critics praised his work, his fame was in large part due to this constant public presence. His novel, *Music for Chameleons*, was published in 1980 and during the 1970s excerpts from a novel in progress, *Answered Prayers*, appeared in *Esquire*. They excited the ferocious disapproval of the rich élite that they depicted.

Photographer Arnold Newman (b.1918) is renowned for pioneering a style that became known as 'environmental portraiture', placing his subject in a carefully composed setting to capture the essence of his or her work and personality. From the late 1930s on, this was the approach he used when photographing major artists, writers, actors, composers and politicians from around the world.

Richard Avedon
(b.1923)
Photographer

Self-portrait, 1978
Dye transfer print,
361 x 269mm
(14⅛ x 10½")
NPG.93.94

With his imaginative and innovative camera work, Richard Avedon helped elevate fashion photography to an art form, while his rejection of the traditional studio-mannequin look in favour of real-life settings and more animated models allowed him to convey a sense of character. Born in New York, he dropped out of school and joined the Merchant Marines' photographic section. On returning in 1944, he took a job as a photographer in a department store and in two years had been 'discovered' by an art director at *Harper's Bazaar*. He started working for them and a number of other magazines, including *Vogue* and *Look*. Even though he made most of his living during the early years from advertising work, his real passion was portraiture, and as his fame grew, so did his opportunity to meet and photograph more people. In addition to his work for magazines, he has collaborated on a number of books of portraits: for example, in 1959 he worked with Truman Capote, documenting some of the most famous and important people of the century. However, he does not restrict himself to celebrities and has also produced series of images of patients in mental hospitals, drifters, carnival workers and working-class Americans. His work has been exhibited in museums and galleries worldwide and in 1989 he was awarded an honorary doctorate from the Royal College of Art in London. In 1992 he became staff photographer for the *New Yorker*.

This self-portrait appeared on the cover of *Newsweek* on 16 October 1978 to mark his retrospective at the Metropolitan Museum of Art in New York. The exhibition contained a series of increasingly complex projects that went far beyond the scope of his fashion work, including portraits of his dying father and a sequence of images of artists and politicians. Explaining his philosophy of portraiture, he has said, 'A sitting is an exchange of feeling. The picture is when those feelings meet.'

Bill Cosby
(b.1937)
Comedian, actor

James VanDerZee, 1980
Gelatin silver print,
250 x 201mm
(9¾ x 7⅞")
NPG.94.38

With a career encompassing comedy, acting, recording and publishing, Bill Cosby is one of the most popular and influential media personalities of the last forty years. After serving in the navy, he enrolled at Temple University – in his home town of Philadelphia – hoping to become a teacher. To support himself through college, he worked in a bar, and it was here that his comedy career began. Word of his talent spread to New York and he was soon performing in Greenwich Village clubs. His breakthrough came when he landed a guest spot on *The Tonight Show*. The civil rights movement was at its height and Cosby was unique among black comedians in his approach: 'I don't think you can bring the races together by joking about the differences between them. I'd rather talk about the similarities, about what's universal in their experiences.' In 1965 he made the transition from stand-up comedian to actor with the series *I Spy*, which changed the face of television by casting a black man alongside a white man as his equal. Film roles and more TV followed, but it was as the star and chief architect of the weekly sitcom *The Cosby Show* that he, in the words of *Time* magazine, 'dominated the medium as no star has since the days of Lucille Ball and Milton Berle'. With its gentle humour, upbeat message and cross-cultural appeal, *The Cosby Show* – described by Coretta Scott King as 'the most positive portrayal of black family life that has ever been broadcast' – ran from 1984 to 1992. Cosby is also involved with a number of charities, concentrating particularly on black education, social services and civil rights.

An eminent black photographer, James VanDerZee (1886–1983), lived in Harlem and opened his first photographic studio, Guarantee Photos, there in 1916. For more than fifty years he worked as a photojournalist and portrait and society photographer, his main interest to reveal the glamour of Harlem, the cultural capital of black America. Bill Cosby, who admired his work enormously, was VanDerZee's first client when the photographer returned to work in 1980.

Index

Illustrations are shown in *italic*
and colour type

Abbott, Berenice 23, 256, *257*
Adams, Ansel (Newman) 276, *277*
Adams, John Quincy 20, 71
Adamson, Robert 23, *170*, 171
Agee, James (Evans) 23
Aldrich, Nelson (Zorn) *122*, 123
Alexander, John White 16, 116, *117*
Allston, Washington 52
Arbus, Diane 247
Armstrong, Louis (Model) 11, 272, *273*
ARTnews 147, 159
Atget, Eugène 256
Avedon, Richard 23, *278*, 279, *282*, 283

Badger, Thomas 16, *58*, 59
Ball, Lucille (Warnecke) *242*, 243
Bancroft, George (Mayall) 20, *174*, 175
Bankhead, Tallulah (John) 17, *134*, 135
Barnum, P. T. (S. or M. Root) 15, 20, *176*, *177*
Bartlett, Paul W. (Pearce) 11, *112*, *113*
Beaton, Cecil 23
Beaux, Cecilia 9, 16, *114*, 115
Benbridge, Henry *34*, 35
Benton, Thomas Hart 11, 16, *128*, *129*, 255
Bergman, Ingrid (Lynes) *238*, 239
Berkeley, George (Smibert) 8, 17, 28, *29*
Bernstein, Leonard (Penn) *250*, 251
Biberman, Edward 11, *144*, *145*
Black, James Wallace 21, *198*, 199
Blanche, Jacques-Émile 17, *118*, 119
Bonnat, Léon 16, 112
Bouché, René 17, 148, *149*
Boughton, Alice 23
Brady, Mathew (and studio) 20, 21, 22, *178*, 179, 187, *190*, 191, 192, *193*
Brassaï, Geyula Halász 23
Brown, John 191; portrait (Washington) 10, 20, *172*, *173*
Brownson, Orestes (Healy) *90*, 91
Bull, Clarence Sinclair *234*, 235

Calder, Alexander (Kertész) 23, 220, *21*
Calhoun, John C. (Healy) 10, *70*, 71
Camera Work 208, 211, 228
Cameron, Julia Margaret 23, *25*, 196, *197*
Capa, Robert 236, *237*
Capote, Truman 283; portrait (Newman) *280*, *281*

Carolus-Duran, Charles 16, 111
Cartier-Bresson, Henri 23, 220, 248, *249*
Carver, George W. (Reyneau) 12, 15, *140*, *141*
Cassatt, Mary 16; portrait (Degas) 100, *101*
Castle, Irene (de Meyer) 21, 212, *213*
Catlin, George (Fisk) *74*, 75
Channing, Francis (Allston) 52
Chavez, Cesar (Avedon) *278*, 279
Chickering, Jonas (Southworth and Hawes) 15, 20, 180, *181*
Clay, Henry 71; portrait (Neagle) *66*, 67
Coburn, Alvin Langdon 21, *22*
Copland, Aaron (Lynes) *226*, 227
Copley, John S. 11, 16, 28, *30*, 31, 36, *37*
Cosby, Bill (VanDerZee) 284, *285*
Cosgrave, John O'Hara 203
Couture, Thomas 95
Crockett, Davy (Harding) 9, 64, *65*
Cunningham, Imogen 24
Cushing, Frank H. (Black) 21, *198*, 199
Custer, General George (anon.) *182*, 183
Czedekowski, Boleslaw Jan 17, *19*

Daguerre, Louis-Jacques-Mandé 20
Dahl-Wolfe, Louise 240, *241*
Davis, Jefferson 187; portrait (Brady) 21, *22*
Degas, Edgar 100, *101*, 119
de Kooning, Elaine 18, *142*, 143, *146*, 147
de Kooning, Willem 17, 143, 147, 159
Dickens, Charles: *American Notes* 10
Disdéri, André Adolphe-Eugène 23, *25*
Douglass, Frederick (anon.) 68, *69*
Douglass, Robert 68
Dow, Arthur Wesley 211
Duplessis, Joseph S. 9, 12, 40, *41*

Eakins, Thomas 11, 16, 99, 108, *109*
Eastman, George (Nadar) 23, *25*
Edwin, David 51
Eliot, T. S. (Kelly) 152, *153*
Elwell, William S. 16, 72, *73*
Eugene, Frank 207
Evans, Walker 23
Everett, Edward (Adamson and Hill) 23, *170*, 171

Faulkner, William 252; portrait (Cartier-Bresson) 23, 248, *249*
Fields, James T. (Cameron) 23, 196, *197*
Fisher, Alanson 76, *77*
Fisher, Mary F. K. (Stanford) 166, 167
Fisk, William *74*, 75
Fokine, Michel (Siprell) *214*, 215
Frank, Robert *270*, 271
Franklin, Benjamin 11, 39; portrait (Duplessis) 9, 12, 40, *41*
Fredricks, Charles DeForest 184, *185*
Freer, Charles Lang 208
Freund, Gisèle 24
Frost, Robert (Siprell) 268, *269*
Furuseth, Andrew (Lange) 23

Gable, Clark (Bull) *234*, 235
Gardner, Alexander 11, 22, 179, *186*, 187, *194*, 195
Garrison, William L. (Jocelyn) 62, 63
Garvan, Francis P. (de Lászlo) *126*, 127
Genthe, Arnold *202*, 203
Gérôme, Jean-Léon 16, 100

Gershwin, George (Kaufmann) 136, *137*
Gilder, Richard W. (Beaux) 9, *114*, 115
Gilpin, Laura 23
Gore, Christopher 55
Gorky, Arshile 147
Graham, Martha (Meltsner) *138*, 139
Greaves, Henry 96
Greaves, Walter 96, *97*
Green, Anne (C. W. Peale) 32, *33*
Greenberg, Clement 147, 159
Greenhow, Rose (Gardner) *186*, 187
Greenwood, John 28
Grosvenor, Gilbert and Elsie (Penn) *258*, 259
Guggenheim, Peggy 255; portrait (Ray) 23, 216, *217*
Gurney, Jeremiah 184

Halsman, Philippe 23, 264, *265*
Hammond, Elisha 68
Harding, Chester 9, 64, 72, *65*
Harlow, Jean (Bull) *234*, 235
Harper's Bazaar 23, 216, 219, 227, 239, 240, 247, 259, 277, 279, 283
Harte, Bret 17; portrait (Pettie) *102*, 103
Hawes, Josiah Johnson 15, 20, 180, *181*
Hawthorne, Nathaniel (Leutze) 86, 87
Healy, George P. A. 10, 21, *70*, 71, *90*, 91, 92, *93*
Heenan, John (Fredricks) 184, *185*
Hemingway, Ernest (Capa) 236, *237*
Hepburn, Audrey (Halsman) 11, 264, *265*
Herkomer, Sir Hubert von 9, 17, *104*, *105*
Hess, Tom 143
Hicks, Edward 80
Hicks, Thomas 80, *81*
Hill, David Octavius 23, *170*, 171
Hine, Lewis 211, 228
Hoff, Charles 260, *261*
Hopwood, J., Jr 59
Horne, Lena (Biberman) 11, *144*, *145*
Hughes, Edward 17, 106, 107
Hunt, William Morris 84
Huntington, Daniel 12, 82, 83, 92
Hurd, Henriette Wyeth 155, 156
Hurd, Peter 18, *154*, 155

Inman, Henry 16, 60, *61*, 83

Jackson, Andrew 71, 79
Jackson, Michael (Warhol) 11, 15, *164*, 165
Jacobi, Lotte 24
James, Henry 16, 84, 95, 115; portrait (Blanche) 17, *118*, 119
James, William (La Farge) 9, 84, *85*
Jay, John (Stuart and Trumbull) *38*, 39
Jocelyn, Nathaniel 62, 63
Jocelyn, Simeon Smith 63
John, Augustus 17, *134*, 135
Johnson, George 188
Johnston, Frances Benjamin 23

Käsebier, Gertrude 21, 204, *205*
Katz, Alex 18, *162*, 163
Kaufmann, Arthur 136, *137*
Kelly, Sir Gerald 152, 153
Kennedy, John F. 143, 151; portrait *270*, 271
Kertész, André 23, 220, *221*
King, Charles Bird 60
King, Clarence (Selleck) 21, 188, *189*

King, Coretta Scott 284; portrait (Weiner) 274, 275
King, Martin Luther (Weiner) 274, 275
King, Rufus (Stuart) 54, 55
Kirstein, Lincoln (J. Wyeth) 9, 11, 156, 157
Krasnow, Peter 132, 133
Kühn, Heinrich 21, 206, 207

La Farge, John 9, 84, 85
Lange, Dorothea 23
Langner, Lawrence 120
László, Philip Alexius de 17, 126, 127
Lauder, Robert Scott 103
Lee, Gypsy Rose (Steiner) 23, 244, 245
Lee, General Robert E. 21, 172; portrait (Brady) 190, 191
Leutze, Emanuel Gottlieb 86, 87
Life magazine 23, 236, 252, 264
Lincoln, Abraham 76, 92; portrait (Gardner) 11, 21, 194, 195
Lodge, Henry Cabot (Sargent) 110, 111
London, Jack (Genthe) 202, 203
Longfellow, Henry Wadsworth 196; portrait (Cameron) 23, 25
Longworth, Alice Roosevelt (Hurd) 154, 155
Low, Juliette Gordon (Hughes) 17, 106, 107
Lynes, George Platt 226, 227, 238, 239

MacDonald-Wright, Stanton 120, 124, 125
McKenna, Rollie 24
McKenney, Thomas Loraine 60
Madison, Dolley (Elwell) 72, 73
Maracci, Carmelita (Weston) 23, 232, 233
Marciano, Rocky (Hoff) 260, 261
Maxham, Benjamin D. 19, 20
Maxwell, Elsa (Bouché) 148, 149
May, Edward Harrison 17, 94, 95
Mayall, John 20, 174, 175
Meltsner, Paul 138, 139
Men of Progress (Schussele) 88, 89
Meyer, Baron Adolph de 21, 212, 213
Millais, Sir John Everett 107
Miller, Henry (Brassaï) 23
Mirror of Taste, The 12, 51
Model, Lisette 24, 246, 247, 272, 273
Monroe, Marilyn (Winogrand) 11, 266, 267
Moore, Marianne (Zorach) 12, 130, 131
Morgan, John P. (Steichen) 21
Morse, Samuel 52, 53, 83, 179
Muray, Nickolas 218, 219
Muybridge, Eadweard 188

Nadar, Paul 23, 25
Namuth, Hans 23, 254, 255
Native Americans 21, 60, 61, 75, 183, 198, 199
Neagle, John 66, 67
Neel, Alice 160, 161
New York Daily News 243, 260
New Yorker 147, 283
Newman, Arnold 23, 276, 277, 280, 281

O'Keeffe, Georgia (Stieglitz) 208, 216; (Strand) 23, 210, 211
Oliver, Andrew (Copley) 30, 31
Oppenheimer, J. Robert (Model) 246, 247
Osgood, Samuel Stillman 64
Owens, Jesse (Riefenstahl) 23

Page, William 179
Palmer, J. 59
Patton, General George S. (Czedekowski) 17, 19
Paul, Thomas (Badger) 58, 59
Peabody, George (Disdéri) 23, 25
Peale, Charles Willson 16, 32, 33, 42, 43, 47, 48
Peale, Rembrandt 12, 47, 48, 49, 50, 51
Peale, Rubens (Rembrandt Peale) 48, 49
Pearce, Charles Sprague 11, 16, 112, 113
Penn, Irving 23, 250, 251, 258, 259
Pettie, John 17, 102, 103
Pinckney, Charles C. (Benbridge) 34, 35
Pollock, Jackson 17, 18, 216; portraits (Namuth) 23, 254, 255
Porter, Fairfield 12, 18, 143, 158, 159
Price, Leontyne (Van Vechten) 262, 263

Ray, Man 23, 216, 217, 227, 256
Read, Thomas Buchanan 98, 99
Reyneau, Betsy Graves 12, 15, 140, 141
Rhoades, Katharine N. (Stieglitz) 21, 208, 209
Richardson, H. H. (von Herkomer) 9, 104, 105
Riefenstahl, Leni 23
Ringgold, Samuel (Vanderlyn) 56, 57
Rivera, Diego 132
Robeson, Paul (Steichen) 222, 223
Root, Marcus and Samuel 15, 20, 176, 177
Rosenberg, Harold 143, 255; portrait (E. de Kooning) 18, 146, 147
Rothko, Mark 17, 18, 216
Ruskin, John 96
Ruth, George H. 'Babe' (Muray) 218, 219

Sandburg, Carl (Smith) 150, 151
Sanders, Joop 143
Sargent, John Singer 11, 16, 17, 110, 111
Sartain, John 67, 88
Schussele, Christian 88, 89
Scott, Winfield (Weir) 78, 79
Selleck, Silas 21, 188, 189
Sequoyah (Inman) 60, 61
Sheeler, Charles 132
Sheridan, Philip H. (Read) 98, 99
Sherman, General William (Brady) 192, 193; (Healy) 10, 21, 92, 93
Sickert, Walter 119
Simonson, Lee 16, 120, 121
Sipprell, Clara 23, 214, 215, 268, 269
Smibert, John 8, 17, 28, 29
Smith, Bessie 272; portrait (Van Vechten) 230, 231
Smith, W. Eugene 252, 253
Smith, William A. 150, 151
Snow, Carmel (Beaton) 23
Solomon, Rosalind 24
Southworth, Albert Sands 15, 20, 180, 181
Stanford, Ginny 166, 167
Steichen, Edward 21, 206, 207, 222, 223
Steinberg, Saul 147
Steiner, Ralph 15, 23, 228, 229, 244, 245
Stieglitz, Alfred 21, 159, 204, 207, 208, 209, 211, 216, 228, 276; portrait (Coburn) 21, 22
Stowe, Harriet Beecher 196; portrait (Fisher) 76, 77
Strand, Paul 23, 210, 211, 132, 276; portrait (Steiner) 15, 228, 229

Stuart, Gilbert 12, 13, 16, 38, 39, 44, 45, 46, 47, 54, 55, 56
Swartz, John 200, 201

Taylor, Bayard (Hicks) 80, 81
Tennyson, Alfred, Lord 23, 196
Thoreau, David H. (Maxham) 19, 20
Time magazine 15, 163, 164
Tracy, Spencer (Dahl-Wolfe) 240, 241
Trumbull, John 38, 39, 55
Tudor-Hart, E. P. 124
Twain, Mark 115; portrait (Alexander) 116, 117

Ulmann, Doris 23-4
Updike, John (Katz) 162, 163

Van Vechten, Carl 230, 231, 262, 263
Vanderlyn, John 16, 56, 57
VanDerZee, James 284, 285
Vanity Fair 207, 223
Verplanck, Gulian (Huntington) 12, 82, 83
Vogue 23, 148, 207, 212, 216, 223, 227, 239, 251, 259, 272, 283

Walcott, 'Jersey Joe' (Hoff) 260, 261
Warhol, Andy 15, 18, 164, 165
Warnecke, Harry 242, 243
Washington, Augustus 10, 20, 172, 173
Washington, George 8-9, 11; (Stuart) 12, 13, 44, 45, 47
Washington, Martha (Stuart) 46, 47
Weiner, Dan 274, 275
Weir, Robert Walter 78, 79, 96
West, Benjamin 16, 43, 52
Weston, Edward 23, 232, 233; portrait (Krasnow) 132, 133
Wharton, Edith 119; portrait (May) 17, 94, 95
Whistler, James M. 16, 116, 119; portrait (Greaves) 96, 97
White, Stanford (Käsebier) 21, 204, 205
Whitman, Walt 108, 115
Wild Bunch, The (Swartz) 21, 200, 201
Williams, Talcott (Eakins) 108, 109
Williams, Tennessee (W. E. Smith) 252, 253
Winogrand, Garry 156, 266
Wood, Juliana Westray (R. Peale) 12, 50, 51
Wright, Frank L. (Abbott) 256, 257
Wright, William H. 16; portrait (MacDonald-Wright) 124, 125
Wyeth, Andrew 156
Wyeth, Jamie 9, 156, 157
Wyeth, N. C. 155, 156

Zorach, Marguerite 12, 16, 130, 131
Zorn, Anders 17, 122, 123

Picture Credits